THE CULTURAL SPACE OF THE ARTS

AND THE INFELICITIES OF REDUCTIONISM

COLUMBIA THEMES IN PHILOSOPHY, SOCIAL CRITICISM, AND THE ARTS

JOSEPH MARGOLIS

THE CULTURAL SPACE OF THE ARTS

AND THE INFELICITIES OF REDUCTIONISM

COLUMBIA UNIVERSITY PRESS NEW YORK

COLUMBIA UNIVERSITY PRESS

Publishers Since 1893

New York Chichester, West Sussex

Library of Congress Cataloging-in-Publication Data

Margolis, Joseph, 1924–

 The cultural space of the arts and the infelicities of reductionism / Joseph Margolis.

 p. cm.—(Columbia themes in philosophy, social criticism, and the arts)

 Includes bibliographical references (p.) and index.

 ISBN 978-0-231-14728-6 (cloth : alk. paper)—ISBN 978-0-231-52537-4 (ebook)

 1. Aesthetics. 2. Art—Philosophy. 3. Reductionism. 4. Intentionalism.

I. Title. II. Series.

 BH39.M3934 2010

 111'.85—dc22

2009405012

References to Internet Web sites (URLs) were accurate at the time of writing.

Neither the author nor Columbia University Press is responsible for URLs that may have expired or changed since the manuscript was prepared.

against our own bewitchments

CONTENTS

PREFACE

When I first began writing on topics in the philosophy of art, ana-
lytic aesthetics was just coming into its own, as with the pioneer ef-
forts of Monroe Beardsley and like-minded archivists. But it had
already begun to replace the leading European figures of the post-
Kantian and post-Hegelian tradition, that is, figures like Benedetto
Croce and Robin Collingwood, so-called Idealists, who, it should
be said, continue to be admired and consulted down to the present
day. It was a turbulent time philosophically, and the formation of
a small academy of Anglo-American professionals associated with
a newly minted journal was probably barely noticed in the larger
philosophical community. It was a period that witnessed the eclipse
of the Vienna Circle; the seeming demise and unexpected recovery
of pragmatism; the strong showing of a distinctly American brand
of analytic philosophy under the fresh impetus of W. V. Quine's
immensely influential account of the analytic/synthetic distinction;
the rise of notably extreme forms of reductionism in spite of the

acknowledged failure of its classic European originals in the first half of the twentieth century; the general absence of large new philosophical movements after the Second World War, both in the United States and Europe, capable of ranking with the grander movements of early modern philosophy; and the continually recycled influence (therefore) of figures like Heidegger, Wittgenstein, Cassirer, Lukács, and the Frankfurt Critical school, in aesthetics and other specialties straddling the divide produced by World War II and sustained in that perception to this day.

Analytic philosophy has always had a strong affinity for the sciences and conceptual options bordering on reductionisms of the scientistic kind. Aesthetics is simply the last of the philosophical "disciplines" to have tried its hand at testing the resources of reductionism's generally acknowledged program. It's an irony that it should have arrived so late in the postwar age to take up the call in its own right—that is, in the most strenuous, the least concessive, field of application possible: the fine arts. But it has curbed its undertaking ingeniously along the lines of what, sometimes problematically, I shall call "piecemeal reductionism," by which I mean the pursuit of limited reductive strategies or strategies instrumentally favorable to a full-blown reductionism that it never actually attempts to achieve and never supposed was really needed—and, indeed, could never have been actually successful. It's a term of art, used loosely at times, eccentrically, a convenient catch-all and something of a provocation.

Viewed this way—in effect, dysfunctionally—the most salient recent work in Anglo-American analytic aesthetics appears to collect around the pole of piecemeal reductionism. It's a fascination that has attracted a large number of the strongest discussants in the analytic lists—in effect, in the whole of English-language aesthetics and the philosophy of art. It knows its comrades by their practice, but its manifestos are more than coy and indirect; it exerts an attraction that is hardly acknowledged in a public way. I'm convinced, however, that its imputed thesis cannot be sustained on philosophical grounds

and that its actual appeal impoverishes the conceptual resources of the field. As far as I know, it has hardly been subjected, as a clear-cut movement, to a thorough examination of its prospects and apparent successes. Were it not for the importance of its principal adherents, we might refuse to legitimate the "piecemeal" category itself. As it is, we must still come to terms with a widespread philosophical disorder.

No one whom I associate with the movement has actually bothered to work out an explicit or coherent version of reductionism; but all those so qualified are weakest at the point at which their doctrines yield in the direction of the movement's attraction to reductive strategies or to theories that make very little sense unless they are read as serving the reductive cause or a larger scientism.

I don't mind acknowledging in this sense that the "movement" is often a movement manqué. But wherever that seems to be a fair correction, the heuristic remains tellingly effective and true to its assigned mission. Were it not for the fact that a goodly number of the ablest and most prominent analytic aestheticians of our time have been caught in the bramble of piecemeal reductionism, I would probably have proceeded in another way. As it is, I take aesthetics and the philosophy of art to be important not only in terms of its usual local topics but even more in the sense that its local topics collect in an unusually perspicuous way some of the most important puzzles of Western philosophy.

In fact, I find it difficult to treat aesthetics as no more than an autonomous discipline. Its great strength lies in posing its own best questions in a way that often serves the larger inquiries of a "philosophical anthropology" more powerfully and more intuitively than nearly any similar specialty. I'm struck by the fact that the specialist questions of the philosophy of mind, the philosophy of language, the philosophy of the human sciences, epistemology, and moral and political philosophy have by and large failed to facilitate a commanding breakthrough against the pretensions of reductionism and scientism.

The radical possibilities of aesthetics mirror, in my opinion, the radical possibilities of a proper analysis of the human condition itself. I have no wish to distort the inquiries of the first, but I see no way to proceed without attending to the second.

What I offer, then, is a frank assessment, a modest first pass from an opponent's perspective (I mean an opponent of reductionism, not of analytic rigor) cast as scrupulously as I've found it possible to do. The issue is of considerable importance, since Western conceptual preferences in every field of inquiry are now in an early stage of testing their mettle in a global market where mere conviction and local idiosyncrasy are likely to look like extravagances that we can ill afford. I think there is something of a hothouse quality in much of contemporary philosophy—not merely in aesthetics, although certainly there in spades. Piecemeal reductionism is a sign, I would say, of something quite important that risks going wildly (perhaps even dangerously) astray.

This is much too indirect a hint for what I have in mind. Let me add a little more detail to fix our bearings before I actually begin the tale. The authors I collect as "piecemeal reductionists" are usually not, I would say, true reductionists in that strict sense championed for instance by the young Rudolf Carnap in the heyday of early positivism. First of all, *they already know* that the strong forms of reductionism failed utterly; second, they have no pretensions of their own about fashioning more compelling arguments than the ones that have already failed, and they see no need for additional such arguments in meeting the usual puzzles posed by our interests in the fine arts. If there are any piecemeal theorists who are also true reductionists, they must be closet members of the clan—there may be one or two, though I doubt it—and there are none among those I have in mind who are the least bit exercised by their own habit of replacing philosophical argument by partisan dictum. They see nothing wrong in this, which may be read as an implied (quite unintended) endorsement of Richard Rorty's so-called postmodernist or

"post-philosophical" policies. The piecemeal cohort would of course reject this characterization to a man.

Put more pointedly: what I shall try to show in as spare a way as I can is that the piecemeal theorists follow an example set by the most influential forms of reductionism practiced by analytic philosophers in the second half of the twentieth century, which is also the period of the greatest influence and penetration on the part of American philosophy worldwide. They ride a fashion that has already crested and collapsed; and they exploit the obvious convenience of its would-be economies as proper economies, though they never redeem them (as they rightly should). In this sense, they are philosophical isolationists of a sort, bland and insistent by turns, who colonize as widely as they can without admitting the need to answer questions of legitimation.

I mean to signal in no uncertain way that the small study I offer here confirms a serious disregard among recent aestheticians for the rigors of philosophical argument that have always been the jewels of Western philosophy; and that, in proceeding thus, piecemeal reductionism has simply guided itself by a remarkably widespread practice among the most admired and influential American philosophers of the period (reductionists or not), who have made a respectable canon of "doing philosophy by dictum" rather than by engaging one's opponents in straightforward argument and counterargument.

I see a troubling development here that proceeds as follows: first, to recover and promote a doctrine believed to be particularly promising (possibly even "true") though it cannot make its way by force of fair argument (reductionism); second, to do so, for maximal gain, by "piecemeal" means wherever the strongest claims are unlikely to gain adherents without compelling debate and where fresh arguments are plainly lacking; and third, to restrict, as far as possible, subsequent readings of the (first-order) data (to be analyzed) to the terms of the (second-order) reductionism thereby adopted. The result, I say, is a double dose of conceptual impoverishment: in one sense it threatens the admirable discipline of philosophy itself by making certain key

arguments inessential to its own work; and, in another, it marginalizes, begins to render invisible or unmarked, the instant relevance of those most familiar idioms of ours (first- and second-order) by which we effectively plumb the entire world of human culture and history—and which, indeed, have always posed a mortal challenge to the supposed adequacy of the strongest forms of reductionism.

I remind myself here of the well-known Chinese example: namely, that in modernizing the system of ideograms in the Chinese language (reducing the number of ideograms drastically), the Maoist regime is said to have made the bare reading of the Chinese classics all but impossible for students trained only in the new notation. I am unsure of what is strictly true regarding the simplified system the Maoists produced: I have it only on hearsay. But I have no doubt at all about the impoverishing results of piecemeal reductionism. The analysis I offer suggests a deeper and darker kind of cultural loss than the advocates of piecemeal reductionism are likely to favor.

Still, I'm willing to venture a penny summary of the difference between reductionism proper and piecemeal reductionism. Within the bounds of the philosophy of art, piecemeal reductionism, I would say, intends to draw without let on all descriptive and explanatory conceptual resources normally called into play in empirical accounts of culture, the human mind, and the arts, *provided* only that, in doing that, it can demonstrate (to its own satisfaction) that it can in principle avoid or defeat or stalemate or neutralize whatever threats to reductionism proper the use of the concepts in question are likely to engender—with specific regard to a thoroughgoing materialism and extensionalism. In that sense, piecemeal reductionism is motivated in the scientist way, though it is not committed to vindicating reductionism itself. It means to demonstrate just how our first- and second-order concerns in the arts may be brought into line with reductionism in an improved (but not necessarily decisive) way.

It differs, then, from reductionism proper in that it never, or almost never, pursues reductionism itself; proceeds on the unsecured

assumption that reductionism may yet prevail; and postpones, indefinitely, the need to produce a favorable reckoning of whatever reductionist doctrines may be needed to secure its own specialized claims. It's as if piecemeal reductionism confined itself to providing a conceptual account of artworks that was noticeably more congenial to a full-blown reductionism than would otherwise be thought possible in the light of unanswered questions—for instance, by bypassing intractable "intentional" complexities that would otherwise resist any extensional treatment. It attempts to show that it's worthwhile pursuing "piecemeal" strategies against the day when a deeper reductionism might be validated. The upshot is that opposition to such strategies needs to demonstrate, in turn, why they may be fairly deemed to be unacceptably impoverishing, implausible, question-begging, self-defeating, incompatible with more powerful or more compelling analyses, dependent on empirically false premises, or something of the sort. It obviously also means that some counterarguments may not and need not actually confront the deeper doctrines of reductionism proper. Debate may therefore invite a certain argumentative presumption, even a disdain for argument itself—but not always. I allow a certain classificatory opportunism here, for the sake of introducing a community of views that rarely betray explicit alliances.

To make this part of my story as clear as possible, I offer—still within the body of my brief—some "first words" and a small aside (an "interlude") to show just how this (double) impoverishment proceeds full strength. The aside will, in any case, help to explain what I mean by "reductionism" and "piecemeal reductionism," how the piecemeal strategy derives from the other in its inventive way, and something of the sense of just how our understanding of the dense complexities of art and culture—and philosophy—are actually threatened and diminished by it. The matter must be rightly weighed, but I'm unwilling to allow it to distract us from the main event.

For the moment, then, I'd be quite content to have provoked, by this slim study, an open inquiry regarding contemporary directions

in aesthetics that, in time, may lead us back to the larger question of how to integrate nature and culture in a single vision. I believe our better prospects lie there. If we can come that far by a transparent device, we can also, if we wish, retire the artificial category needed here.

The book's argument is based on an intuition sketched, but not completely fathomed, in an invited paper, "Piecemeal Reductionism in the Analysis of Art and Culture," presented at the XVIth International Congress of Aesthetics (2004) in Rio de Janeiro. I have had the advantage of some excellent suggestions and comments from several friends and colleagues: Lydia Goehr, Gregg Horowitz, and John Gibson in particular. I owe Ruth Brooks a continuing word of thanks for another piece of patience and skill in bringing a sprawling manuscript into good order.

THE CULTURAL SPACE OF THE ARTS

AND THE INFELICITIES OF REDUCTIONISM

FIRST WORDS

The argument that follows has a kind of "diagonal" force: it cuts across entrenched distinctions to reveal unsuspected conceptual linkages that are otherwise too easily ignored. That is to say, the argument is essentially heuristic and not a little confrontational, a stab at escaping the most familiar canonical limits, a way of assembling a number of distinct lines of analysis under the guise of a provisional unity that is bound to be contested. Ad hoc classifications can never be far from fiction, as we discover when we find ourselves obliged to improvise working distinctions very different from whatever we allow ourselves to trust at the start of a given inquiry. I anticipate such strains as the price of taking the historicity of thinking seriously in a field as quarrelsome as aesthetics.

I proceed under the assurance of a number of guiding intuitions that may seem very far removed at first from the analysis of the usual local questions that belong to the work of aesthetics and the philosophy of art: the definition of an artwork for instance, the nature of

aesthetic properties, differences between the perception of paintings and the understanding of poetry, the role of imagination. But I'm persuaded that the analysis of the arts (or, say, of politics or science, for that matter) and the analysis of the human mind cannot be disjoined at any point—for reasons so fundamental that they rarely take explicit form in the body of the best-known and most admired theories; and that only when these separate inquiries are rightly united can each part succeed in its own way: by forming a single effort to achieve an understanding of what it is to be a human self or person, which every well-formed inquiry will finally require. Each must be fitted to the other to yield an acceptable account of the natural and human sciences, or of the sciences and the self-interpreting arts, or, more inclusively still, of the linkage and the difference between physical nature and human culture and history. If you allow the challenge without yet endorsing it, you won't find it strange to begin a probe of the usual puzzles posed by the fine arts from the vantage of a seemingly remote glance at certain standard philosophical questions about the mind.

I hope to persuade you that the detour is an economy of unexpected power: first, in the way of solving an influential, narrowly defined set of puzzles about the arts by drawing attention to their conceptual (not easily perceived) dependence on the answer to wider questions in the philosophy of mind; and, second, in the way of confirming the conceptual unity of the entire human world, in which the anticipated puzzles occupy their accustomed niches and are thereby made legible and open to being decisively settled, which the more formulaic divisions of philosophical labor seem unable or unwilling to attempt.

I have misgivings about the autonomy of aesthetics and the philosophy of mind; hence, I take the argument that follows to be a demonstration of sorts of the gains of a holist temperament in philosophy that does not rely on any actual holist fixities.

The process begins very naturally by bearing witness to what any of us find we sense persistently as a kind of conceptual injustice in the effort to resolve apparently important issues—very much in the way political injustice is perceived as a nagging presence. I take the conceptual difference between being a physical thing and, say, a stretch of speech or a human act or artwork to be absolutely fundamental to the inquiries of an entire family of disciplines, without yet insisting on any single or secure answer to our best questions. There is, plainly, an element of prejudice in every fair-minded sense of justice. From there, history gradually builds plural, virtual, interpenetrating, transient, memorable, larger architectures of ideas that command our continuing attention and loyalty and that (somewhere, once upon a time) had inscribed an initial confrontation. I think there cannot be another way of proceeding effectively.

In short, I mean to tempt you with at least one unadorned philosophical intuition—possibly several—introduced without any partisan rationale, which I find compelling, inexhaustible, profound, entirely adequate to its challenge; at the same time it's as ordinary and as obvious as anything I can think of that might be equally fruitful. I shall try to make it yield a picture of the entire human world as convincing as any we could possibly construct—within the bounds of which the puzzles and contested views I have in mind seem to dissolve more readily than otherwise. Those views provide the argument's initial animus: they justify the invented (perhaps even cooked) category "piecemeal reductionism," which I shall feature and which, rightly developed, begins to signal the connections between aesthetics and the philosophy of mind and the philosophy of science that contribute to a plausible sense of approaching philosophical closure. The "piecemeal" puzzles in question begin to loosen (as I've observed) as the larger linkages become stronger and clearer. In this way a potentially minor skirmish becomes the source of a very substantial correction.

I acknowledge, then, first of all, the good sense of the following pre-philosophical intuition: that we human beings, and only we, hear and understand speech spontaneously in as assured a way as ever we hear and discern sound. I rely on this remarkably strategic dictum with a confidence I cannot entirely explain, except to say that I see no way of escaping its huge charge. However inchoate its full significance may be, I take it to be a test of sorts of every tenable account of the human world—a fortiori, of the arts: it touches on what must be admitted to be true of the human condition itself, which (in my opinion) no viable philosophy can fail to address. In this sense, artworks possess discernible properties conformable with the intuition mentioned, which cannot itself be admitted without admitting the conceptual match—or, "metaphysical adequation"—between our actually producing artworks and our unique ability (as agents or selves) to do just that. But, of course, if the conjecture is trustworthy at all—and the intuition about speech affirms (obliquely) that it is—then it cannot remain a surprise that the important puzzles about the arts (that I have in mind) may be neatly solved in the way I suggest. We will bring them close to solution by outflanking those now-salient doctrines that I've tagged "piecemeal reductionism," by drawing on some unmarked implications in their would-be defense that expose the "injustice" of their opposition to my initial intuition and, in doing that, invite the resources of larger theories of mind or science or language or culture or history that accord with the clue just mentioned—or with other corollary intuitions. The force of this strategy may not be immediately apparent and the opening intuition's authority may need to be adjusted. But the entire approach makes a very good beginning and explains the pertinence of attempting an analysis of the arts from the distance of an arguably extraneous appeal. In any case, "piecemeal reductionism" is no more than a term of art for whatever in the large opposes my initial executive intuition.

To put the point less mysteriously: I shall treat artworks, like speech and deeds, as what human agents are uniquely capable of "ut-

tering" (and understanding); I shall show that that cannot be explained without a suitable theory of what it is to be a human self; and I shall argue that the decisive pivot of a defensible account of the human condition must come to terms with the consequences of the extraordinary fact that we hear and understand speech as "naturally" as we hear sound—which may be not unfairly read as harboring (very nearly) a compressed theory of what it is to be a self or person.

I mean, in saying this, to indicate how easily my first intuition leads us into the philosophical thickets that surround the "piecemeal" program. Alternatively put: this intuition affects in an essential way the viability of any philosophy of art at the same time (and for the same reason) it affects the fortunes of any philosophy of mind. What, we must ask ourselves, explains the capacity to speak, to produce artworks, to act, to think in the human way? There's the obvious clue to what serves as common ground for our philosophical specialties: the presence of the human self and how we should understand its remarkable powers. Think only of the stunning fact that the newborn human infant masters the ability, very, very quickly, to acquire any natural language and its attendant culture simply from what we may call the "primate" resources of *Homo sapiens* (still unique among the other primates), which, initially at least, do not yet entail the presence of anything that might be called a self.[1] To be blunt, this means that the human infant performs in the most ordinary way the astonishing feat of learning a first language—which, as far as we know, cannot be explained on biological grounds alone from primate capacities (*pace* Chomsky[2]), however rapidly they themselves are being transformed in the process of learning that language; a child's mastery is not, finally, the work of mere primate intelligence but of such intelligence progressively transformed into the artifactually reflexive, encultured competences that we associate with the human self—a fortiori, with the creation of artworks.

Here, I venture a fresh conjecture, at once a philosophical and a scientific guess—an answer to the riddle of my initial intuition and

itself very much like a corollary intuition; although to insist on its being that would be a mistake that might easily place in jeopardy all that has already been gathered in these opening remarks. I do believe the conjecture I have in mind is, at this late date, very nearly ineluctable; but if it is, it's not because of an intuition like the one about speech but rather because of the effective lesson of the great failures of twentieth-century scientistic philosophies of mind,[3] the continuing discoveries of post-Darwinian evolution, the articulation of the continuum between the primate biology of prehuman and of human species, and empirically reasonable speculations about the emergence of true language and those cultural formations that are specifically dependent on the mastery of language.

I have always been struck by the remarkable fact that the greatest of the humane philosophers of the eighteenth century—David Hume and Immanuel Kant—both failed to provide a compelling theory of the human self: Hume, in his correct report that he couldn't find the "idea" of the self among his sensory impressions; Kant, in his obvious inability (in §16 of the first *Critique*) to formulate an account of the Transcendental Ego, which he says, as he must, accompanies and introduces the categories of the understanding. In a way, Hume and Kant jointly confirm the exhaustion of the resources of philosophies that have not yet extended to the entirely new possibilities offered by cultural (or geistlich) and Darwinian sources (or to the marriage of the Darwinian and the geistlich).

That is: I don't believe it's possible to construct a convincing theory of the self that does not depend on emergent aptitudes, at the human level, that cannot in principle be reduced to biological processes alone. All of the more plausible accounts of the human person—from Aristotle to Reid to the post-Kantian idealists and beyond—in effect enlarge the scope of the biological to include (innocently enough) what we would now regard as culturally formed, or else invent out of whole cloth would-be cognitive and related pow-

ers (think of Kant himself, Fichte, Husserl, not to mention Descartes) that have no biology at all.

Nevertheless, it's only by reviewing the failure of reductionist philosophies of mind that we are led to consider what may well be the only option left to us: namely, that the human self is what Marjorie Grene compellingly calls a "natural artifact"—meaning by that (a claim she shares with Helmuth Plessner) that *Homo sapiens* is evolutionarily endowed with the capacity to acquire further capacities that cannot be developed by purely biological processes.[4] *Homo sapiens* is, as it were, incompletely formed at birth in a way that only the mastery of the enculturing powers of language and of what language makes possible is able to complete. Simply put: the self is an artifactual, hybrid, "second-natured," evolving, sui generis competence of a reflexive and reflexively effective kind that, as it matures, becomes stable and recognizable enough to count as the individuated (let us say, nominalized) site of that same competence, as it is routinely manifested in the very space of human culture.

Speech and art are, from this point of view, two of the principal forms of "utterance" characteristic of our world. So selves or persons are themselves artifacts in very much the same sense in which speech and art are! But, of course, if that is true, then it becomes impossible to propose a theory of art that privileges persons or selves in any way that surpasses the metaphysical peculiarities of speech and art— meaning by "metaphysical" here no more than to limn the conceptually novel aptitudes of persons and the attributes of artworks that set them apart from the limited properties of mere physical things in the way I've suggested earlier. Here I merely note the fact (which I shall consider in a pointed way) that piecemeal reductionism regularly neglects any such finding—and fails to protect itself against its implied challenge. I am persuaded that that yields an effective reductio of the piecemeal program. But here at least it confirms the reasonableness of addressing the puzzles of aesthetics from a perspective

that considers the close connection between the philosophy of art and the philosophy of mind. That will occupy us in an especially pointed way with the connection between piecemeal reductionism and what, independently, has come to be called "intentionalism."

I think we are entitled now to take advantage of the standard schematism developed in the philosophy of mind and the philosophy of science that distinguishes between eliminativism, reductionism, and dualism, most notably in versions of the unity of science program and among the influential contributions of figures like Wilfrid Sellars, the early Rudolf Carnap, Paul Oppenheim and the early Hilary Putnam, Carl Hempel, Herbert Feigl, Daniel Dennett, Paul Churchland, Jaegwon Kim, David Chalmers—to mention a small company of record. These theorists are not usually occupied with the narrower questions that arise in aesthetics and the philosophy of art, but are nevertheless much occupied with the puzzles of the philosophy of mind that, as I've been hinting, have substantially shaped the parent doctrines (broadly speaking, versions of reductionism) that have in turn spawned the organizing themes of the "piecemeal" views favored among recent philosophies of art.

That is already an unlikely turn of events, since the extreme options championed by the theorists just mentioned often threaten any reference at all (unless figuratively) to the very world of human culture. In spite of what might easily be construed as an auto-da-fé, a cluster of much-admired aestheticians have indeed been tempted in a number of ways (and for different gains) to adopt bits and pieces of the extreme doctrines more plausibly favored in the philosophy of mind and the physical sciences. The oddity of all this may intrigue you. But the point of bothering to mention this at all is simply that the puzzle spreads through the most influential work of recent Anglo-American philosophies of art and begins to lend support to argumentative strategies that in the end cannot be hospitable to the central issues of aesthetics itself.

I shall make a fresh start with the part of the story that concerns aesthetics and the philosophy of art directly. Here we need only a brief sketch of the essential problems confronting the three principal views of mind that scientism has seriously addressed. The score thus far is rather bleak. Dualism is usually treated as a conceptual scandal; eliminativism seems incapable of avoiding a paradox that threatens the very meaning of its supposed viability; and reductionism in the canonical sense has never been convincingly carried out in any way promising enough to encourage us to think that a greater effort might bring us closer to success. Doubtless, the strong forms of scientism will continue to attract their usual enthusiasts, which is harmless enough. But it is essential to a proper assessment of what the piecemeal theorists in aesthetics suppose they might accomplish (by their conceptual economies) to have a sense of what's actually feasible among the failed strategies of the classic forms of scientism. I'll come to that in a moment. But let me run ahead of the story to say as mildly as I can that the "piecemeal" use of the principal strategies leads predictably (as far as I can see) to paradox, conceptual impoverishment, and the constant threat of incoherence. There's hardly any gain to be salvaged. These verdicts will certainly be among my findings in what follows. But even there, it is the sense of what needs to be adequately recovered and explained—what risks appearing useless, irrelevant, impenetrable, too problematic—that drives my inquiry, not the assured outcome of another failed movement. We must see clearly what exactly it is that the failed strategy threatens to drive out of sight.

I associate the potential loss and the counterforce of philosophical recovery with the right analysis of the self. That's to say: if the principal forms of scientism (in the philosophy of mind and the philosophy of science) cannot but fail, then what do we mean by the recovery of the sui generis explanatory innovations tethered to the emergence of language, culture, history, and art, which anti-scientism

argues scientism fails to reckon with? The answer I offer—but cannot do full justice to for the moment—is again that the self is a "natural artifact," an emergent, indissolubly hybrid transform of the biological powers that distinguish *Homo sapiens* uniquely, both at the primate level and at the level at which, finally, primate communication turns into true language. The self is the intractable pons of every form of reductionism, the site of encultured aptitudes—of biology "penetrated" by culture and its own historicized forms of change— entrenched then as our "second nature." Art, speech, and deed count as the principal forms of second-natured "utterance" native to the artifactual self. If reductionism fails, then the irreducibly novel forms of meaning, signification, symbolic and semiotic function, representation, expression, creativity, interpretation, and the like—which, by a term of art, I collect as the forms of "Intentionality" (the defining powers of the cultural world)—also define the sui generis forms of human utterance in all their variety.[5]

To invoke the theory of the self (surpassing but including biological embodiment) is, then, to admit the conceptual need for a descriptive and explanatory idiom, addressed to the arts and other cultural things, that exceeds the limitations of all our scientistic resources without exceeding the bounds of nature. It means, very simply, that we cannot rightly speak of artworks, selves, deeds, languages, histories, and the like if we confine ourselves to the analytic strategies of classic reductionism—or the piracies of piecemeal reductionism. Pressed further, it means that we cannot even speak of the physical world if we cannot bring all that into accord with the self's intelligibilizing power. There's the point of the intended reductio.

I need only a few choice texts from the scientistic literature to mark our bearings in the philosophy of mind; I'll return in a later section I call "Interlude" to catch up the loose ends of this part of the tale, before completing the analysis of the piecemeal program. But here, to get clear about the "three" sorts of analysis favored by sci-

entism, I'll draw largely on the pertinent views of Wilfrid Sellars and Jaegwon Kim. Sellars has formulated what is perhaps the clearest approximation to the eliminativist extreme that we have, in his discussion of what he calls "the manifest image" and "the scientific image": that is, what, after Sellars, has come to be called the "folk-theoretical" conception of man (as by Churchland)[6] opposing the most unyielding version of the old eliminativism. It's a mark of Sellars's grasp of the deep paradox of the latter that he speaks of two "images," not a completed eliminativism; for, of course, the notion of an image makes no sense except in the context of a percipient and intelligent creature, but a true eliminativism would refuse the very existence or reality of the "manifest" world. The very legibility of eliminativism under eliminativist terms would have to be viewed as a mystery to us now!

Here, then, is a short passage cobbled together from two of Sellars's papers, the sense of which remains perfectly transparent vis-à-vis the eliminativist paradox:

A person [Sellars famously says—it's not certain that he affirms it] can almost be defined as a being that has intentions. Thus the conceptual framework of persons ["the manifest image"] is not something that needs to be reconciled with the scientific image [eliminative scientism], but rather something to be joined to it. Thus, to complete the scientific image we need to enrich it not with more ways of saying what is the case, but with the language of community and individual intentions. . . . But to do so is, if only in imagination, to transcend the dualism of the manifest and scientific images of man-of-the-world. . . . According to the view I am proposing, correspondence rules would appear in the material mode as statements to the effect that the objects of the observational framework do not really exist—there really are no such things. They envisage the abandonment of a sense and its denotation.[7]

Sellars makes a virtue of an impossibility: what sense could we make of what would remain intelligible to us on the condition that persons do not exist? The piecemeal theorist cannot gain any possible advantage from this sort of scientism.

What, then, of reductionism? If you agree with me that reductionism has never succeeded and shows no signs of strengthening its challenge, you may also agree with me that dualism is simply reductionism failed. Jaegwon Kim's much-admired version of scientism, which he names "supervenientism" (more recently, "conditional physical reductionism") and which, in effect, is pretty well the current or at least a leading, very nearly vestigial form of the unity of science program—hence, then, committed to the classic program of reductionism and yet tolerant at the same time in admitting unreduced "mental causes" into our ontology—can do double duty in providing examples of reductionism proper and of a compatible dualism at the same time. Consider the following formulation, for instance, which may be Kim's leanest and most elegant version of the supervenientist thesis:

Mental properties supervene on physical properties, in that necessarily, for any mental property M, if anything has M at time t, there exists a physical base (or subvenient) property P such that it has P at t, and necessarily anything that has P at a time has M at that time.[8]

This is quite trim, but it misses an essential complication: Kim nowhere shows that "necessarily anything that has P at a time has M at that time." He cannot, for elementary reasons, show this, and he cannot show that the necessity he affirms is either analytic or causal or nomological. Consider only that one can play chess in indefinitely many ways; but if you've put your opponent's king in check (M, let us say), there is no obvious basis on which to show that necessarily you've moved your queen in this or that particular physical way (say, P), or

that if you've moved the queen in a certain physical way then necessarily you must have placed the king in check. Surely, all of that is entirely contingent and uncertain. You cannot even begin to say either of these things pertinently, until it is known that you have put the king in check by moving your queen in the particular way you have. That is, you cannot formulate the pertinent regularity dualistically at all: you can only proceed in accord with the world of certain complex events in which the chess move can be identified (as such) as embodied in the specific physical move you've made. We have no reliable way of reducing the culturally significant act of moving the queen to the mere physical movement of the object we happen to call the queen or to interpret the act provisionally as due to a conjunction of separate physical and mental events—that can then be reduced in accord with the formula Kim supplies. Kim's entire strategy obliges us to restrict our analysis to what has already been shown to fail in the hierarchized accounts of the unity of science. Kim has perhaps conflated too quickly the difference between an "algorithm" and a "heuristic."[9] Alternatively put: he conflates top-down factorial analyses with bottom-up compositional ones; there's no reason to think these very different kinds of analysis arrive at the same necessary finding.

I must mention one final adjustment before we turn to our topic directly. It will in fact bear, as we shall see later, on the linkage between piecemeal reductionism and what is now called intentionalism, which also has a history in the philosophy of mind. The young Australian philosopher David Chalmers, who had been a fairly standard advocate of reductionism in the mind/body setting, broke with conventional loyalties by resurrecting the special puzzle of "consciousness" as an issue distinct from that of a reductive account of cognitive and allied competences. Chalmers separated the "easy problems of consciousness" from the "hard problems of consciousness":

The easy problems of consciousness are those that seem directly susceptible to the standard methods of cognitive science,

whereby a phenomenon is explained in terms of computational or neural mechanisms. The hard problems are those that seem to resist these methods.[10]

It's very easy to be misled here (innocently enough) by Chalmers's use of the term "phenomenon": Chalmers is not speaking of an event that must have a phenomenal or phenomenological character as such; he's speaking rather of events in general (which, loosely, might be called "phenomena," in being discernible by human beings in some pertinent way)—which, as it happens, bear on the exercise of cognitive abilities. The reason this is worth mentioning is that what Chalmers calls the "easy problems of consciousness" do not necessarily involve consciousness at all (in its quotidian sense)—otherwise, on Chalmers's usage, "consciousness" need not have any specifically phenomenal or phenomenological "content."

It's entirely clear, however, that, on Chalmers's view, the "easy problems" are readily met—have already been promisingly met—in "functional" terms, that is, in terms of "any causal role in the production of behavior that a system might perform":

> How do we explain the performance of a function? By specifying a mechanism that performs the function. Here, neurophysiological and cognitive modelling are perfect for the task.

Hence, even "reportability," being "awake," the ability to "use . . . information in directing behavior in an appropriate way" are purely functional distinctions.[11] If these count as "conscious" states or behavior, then (on Chalmers's view) they are "easy" because they need not be conscious states or events at all in order to be functionally adequate to their tasks.

Chalmers includes among the "easy" problems "the ability to discriminate, categorize, and react to environmental stimuli," "the inte-

gration of information by a cognitive system," "the reportability of mental states," "the ability of a system to access its own internal states," "the focus of attention," "the deliberate control of behavior," "the difference between wakefulness and sleep." These "phenomena," he says, "are associated with the notion of consciousness"; nevertheless, they do not entail consciousness in the "hard" sense:

> The really hard problem of consciousness is the problem of experience. When we think and perceive, there is a whir of information-processing, but there is also a subjective aspect. As [Thomas] Nagel has put it, there is something it is like to be a conscious organism. This subjective aspect is experience. When we see, for example, we experience visual sensations: the felt quality of redness, the experience of dark and light, the quality of depth in a visual field.[12]

I find two difficulties in Chalmers's account, though what he offers is a rather courageous confrontation with the exceptionless "functionalism" of the scientistic cohort.[13] First of all, insofar as Chalmers champions a functional treatment of the cognitive competences of human subjects, he needs to explain why he regards the "neurophysiological and cognitive modelling" of ordinary cognitive examples that plainly implicate the "hard problem" as something other than (something independent of) a parasitic simplification of the more robust paradigms (involving consciousness) applied to cases that he then says may be merely functionally described; and, for another, he nowhere shows that what he calls the hard problem may be rightly construed as a "compositional" (bottom-up : dualistic) problem as opposed to a "factorial" (top-down : embodied) problem. But if this is admitted, then Chalmers has really provided little more than an analogue of Kim's failed supervenience model. The first option is conceptually dependent on (but no longer relevant to) the

resolution of the hard problem; and the second option is allowed only in the dualistic form that Chalmers invokes in defining the "easy" problems. There is no interesting difference between the easy and the hard problems.

The provisional conclusion that I draw is that the piecemeal reductionists cannot point to any robust account in the philosophy of mind or the philosophy of science that would justify their conceptual economies in aesthetics and the philosophy of art. The texts I draw from Sellars, Kim, and Chalmers effectively define the essential unsolved problems of the principal options of any scientistic analysis of mind. A fortiori, they set the theorizing of piecemeal reductionism adrift. I now turn to bringing the collected evidence to bear on related efforts in the philosophy of art; also, on what it would take to replace them effectively; and, finally, on what we would gain thereby.

CHAPTER 1

PIECEMEAL REDUCTIONISM

A SENSE OF THE ISSUE

Late twentieth-century Anglo-American philosophies of art have been gathering force in a fairly straightforward way in favor of a much-diminished run of descriptive and explanatory concepts that, if fully developed, would yield a distinct dualism between physical nature and human culture or even a complete reduction of the second to the first. They usually stop short at the analysis of inner mental states and the bearing of intentions on bodily movements in ways that might (then) be made to count as the exercise of craft abilities. This is easy enough to say but not quite so easy to explain: the strategy has an alien ring.

Nothing of the completely reductionist sort has actually appeared as yet in the philosophy of art, though it is certainly close to the will-o'-the-wisp of the most daring work of the late century's analytic philosophies of science and mind. Aesthetics has come late to the philosophical table. But it can hardly be denied that, particularly with regard to painting and music (literature poses a distinctly

different version of the problem), the idea that artworks are, finally, "mere physical things"—to which we impute whatever culturally informed properties we require, drawn from "external sources" pointedly described in mentalistic terms ("authors' intentions," audiences' sensibilities) augmented by a knowledge of craft practices often strictly (dependently) tethered to those same sources—is an idea that may plausibly be taken to be the nerve of certain strong proposals of the last decades of the twentieth century and the beginning of the new century. Still, in taking up the temptation of such a movement, after a delay of about forty or fifty years beyond the documented infelicities and final failure of the strong reductionisms of the first half of the century that were essentially addressed to issues in the philosophy of mind and the philosophy of science, we realize that the second movement, the one before us now, cannot claim or count on the philosophical innocence of the original. We must account in a different way for the *return* to strategies known to be all but exhausted.

I applaud the movement's daring as well as its canny hesitations: for, of course, the philosophy of art is bound to address the most florid and commanding blooms of encultured imagination that one could name; and these, we may suppose, must challenge in the deepest way the conceptual ingenuities of the movement before us. And yet, although I admire the movement's daring, I see no palpable gains in the offing. On the contrary, I treat the undertaking as a failure, because it is demonstrably incoherent and impoverished and philosophically evasive—for reasons already apparent in the heyday of the positivisms and unity of science programs of the early phases of the twentieth century. The classic reductionisms were not usually incoherent: they simply failed to make their case convincingly. But the aestheticians I have in mind are noticeably unwilling to risk their own programmatic analyses by any sustained effort at recovering the reductive strategy and demonstrating its advantage when applied to artists' intentions, audiences' sensibilities, or the properties of art-

works themselves. But *that*, precisely, would have been an essential part of reductionism's original purpose.

In any event, that is my charge: analytic aesthetics has gone seriously astray in advocating a certain doctrinal craziness that had already been exhausted by its grander champions in the 1930s. Reductionism requires a connective argument of its own—and risks incoherence otherwise—but pursues a unifying logic almost entirely by *obiter dictum*. Also, by its own zeal it leads us, inadvertently, to a dawning sense of how its own doctrines actually prevent our ever admitting the conceptual minima needed to sustain any discourse about the fine arts, the human self, or the cultural world at all. The result (among the piecemeal cohort) has been to favor a dualistic practice ("dividing" mind and matter) that is somehow treated as a form of loyalty to a deeper reductionism (if it could go so far) that it simultaneously shrinks from, since the dualism is also meant to block the need to bother with completing any genuine form of reductionism.

Here then, by a term of art, I name this abortive movement—which has all but dominated recent analytic aesthetics—"piecemeal reductionism," because it avoids acknowledging the barest need for conceptual closure on reductionism proper, without which it fails outright but which it never actually seeks. I take notice also of the bearing of an independent, allied strategy, a "new intentionalism," widely favored by the piecemeal cohort, who find in it a viable "dualism" that may be substituted for a full-scale reductionism. The entire movement sustains a most unlikely history.

For the moment, let me say that I do not suppose that all those theorists I collect under the double heading of piecemeal reductionism and intentionalism actually endorse the central thesis in the same way or to the same degree. The movement is something of a motley. I see it rising opportunistically from certain incipient economies pressed into service by a particularly astute early analyst, Monroe Beardsley, abetted eccentrically (and unintentionally) by another clever philosopher of art, Nelson Goodman, neither of whom would

have willingly subscribed to anything like the doctrines I've just laid out. In fact, I don't really believe either Beardsley or Goodman would rightly count as members of the intended "piecemeal" company; their work bears on its inception by entirely indirect means: Beardsley's, perhaps because of his unyielding insistence on a strict bivalent logic and a counterpart use of the excluded middle with respect to interpretive claims, plus his informal tendency to treat the perception of artworks in empiricist terms shorn (as far as possible) of intentional complexities and his disallowing intentionalist criticism (in the mentalistic sense) while admitting the pertinence of artists' intentions; and Goodman's, because of his explicit refusal to depart from an all-purpose extensionalism applied semiotically rather than ontically in the spirit of a deeper scientism.

No. The charter members plainly include a trio of fine minds: Arthur Danto most notably, Richard Wollheim, and Kendall Walton. From these, by various declensions marked by an increasing tolerance of what I'm calling piecemeal reductionism—which is to say, the tendency to claim the advantages of reductionism "here but not there" and to tolerate the precarious dualism of intentionalism "there but not here"—a steady stream of younger champions has now formed, sometimes more zealous than their predecessors insofar as their commitment varies inversely with their willingness to redeem their promissory notes. The most recent leading figures that I make out here are surely Noël Carroll and Jerrold Levinson: doctrinally, Levinson is the more explicit of the two; Carroll is much more circumspect. Both are intentionalists; but Levinson is more clearly drawn to piecemeal reductionism than Carroll, though intentionalism without a deliberate drift toward reductionism is a little odd—a bit like undermining one's own career.

This forms a tidy basket of fresh talents and new options. There are also a large number of even younger partisans to consider. But I daresay the original theories never get off the ground philosophically, although they have certainly attracted a good many convinced en-

thusiasts. They still do, but I'm persuaded that they've simply gone astray. You must realize that the late "scientisms" spawned by the extraordinary example set by W. V. Quine in the late 40s and 50s (which had no equal in influence in Quine's lifetime) constitute the largest flurry of reductionistic ventures the Eurocentric world had ever seen, going well beyond Quine's project, which was itself a deliberately diminished—a failed, impoverished, and ultimately incoherent—program that also drew its own energies from the more robust ventures of the first half of the twentieth century.[1]

In fact, the aestheticians implicitly follow the clever practice Quine seemed to validate—which appears incipiently in Rudolf Carnap even before Quine and even more boldly in Donald Davidson after Quine—the practice, that is, of discounting the need for any explicit theory of truth or meaning or knowledge or mind or intentionality or cultural history or what finally is real, in directly invoking the reductive idiom as if that had already been confirmed. As far as I can see, the innovations tendered by the philosophers of art I've mentioned are entirely occupied with the application of general strategies already in use—*not* with their actual defense. They break no new ground in the way of reductionism itself. Consequently, their adherence to the piecemeal strategy is often inexplicit, sometimes more of a disposition than a doctrine actually championed.

The matter is important, inherently controversial, diversely treated in the pertinent literature—and definitely in need of being carefully sorted. The practice I have in mind almost never attempts to eliminate the cultural world altogether, or reduce it to physical things completely. So it is not a true form of reductionism in the sense we rightly associate with (say) the work of the early Vienna Circle, when Rudolf Carnap and Moritz Schlick first joined forces. The Vienna Circle was, of course, a startlingly short-lived movement. Nevertheless, a number of strong aestheticians of the second half of the century—attracted, I suppose, to the seeming rigor of something like these earlier currents but unwilling or unable to un-

dertake the resolution of their own conceptual difficulties—have opted instead to support what must have seemed to them a fashionable and easily defended middle way. I don't believe I've ever seen the strategy explicitly laid out by its present champions, but I daresay there is no strategy by which it *can* succeed. Its best-known versions demonstrably fail and the objectives of its partisans are best served by ingenious forms of indirection. I believe that to expose these applications in the arts is simply to clear the philosophical air.

It would hardly be unfair to say that the entire company favors something like the following policy: whatever is required in advancing the best work of the physical, psychological, and behavioral sciences in accord with the spirit of the original scientisms of the early phases of the previous century should be privileged in the philosophical analysis of the arts; whatever departs in a fundamental way from what is standardly admitted there as the entities and forms of knowledge posited in the inquiries mentioned should be denied admittance altogether or reinterpreted uncompromisingly so as to bring it into line with the effective rule; and where we must still be flexible, or must temporize, it would be better to err on the side of the canonical economies, or, failing that, to collect whatever is still too recalcitrant (perhaps too concessive for an early Carnapian psychology or a Hempelian history) within a holding space defined by the incompletely analyzed remainder of the pertinent data—notably, the mental, the intentional, the cultural, the historical, the traditional, and the craft powers and processes of the specifically human world. All this yields a dualism in the service of a soft reductionism that is itself more style than substance. That is precisely what I call piecemeal reductionism, which I say cannot possibly work.

It is the evidence of a persistent and unresolved dualism—often ingeniously obscured—I would say, that yields the most convincing confirmation of the "piecemeal" intent and its infelicities. You will find it, for instance, in one of its most skillfully managed forms in Arthur Danto's analysis of the bearing of Wittgenstein's account (in

Philosophical Investigations) of the "difference" between my raising my arm and my arm's rising *on* Danto's own clever analogy regarding the difference between an artwork (a painting, say) and a "mere real thing" (say, a physical canvas covered with paint), which Danto develops in his important book *The Transfiguration of the Commonplace*. There, Danto reads Wittgenstein (mistakenly, I would say) as holding that, "ontologically," there is no difference between the two occurrences—they are one and the same—so that, as Danto says, when we subtract the movement from the action, what "is left over" (as far as Wittgenstein is concerned) is "zero." From Danto's point of view, this signifies that both reductionism and dualism may be set aside *if* we agree to treat the charge as rhetorically "effective"; so that treating physical things figuratively or metaphorically (or rhetorically) in the required way *is* to "make" them artworks. (*This*, therefore, trumps Wittgenstein—by way of a soft reductionism.)

Physical things then are "transfigured" but not actually transformed. That *is* Danto's solution all right, but not Wittgenstein's (on textual grounds, which hardly conform with Danto's reading of Wittgenstein).[2] Danto takes the "ontological" options (read literally) to be both exhaustive and exhausted; hence, he sees only a figurative choice (apparently still ontological) that can be externally fitted to "mere real things"—yielding the entire world of the arts, and possibly then the entire world of culture and history.

But that cannot possibly work. For Danto requires actual human persons to make the rhetoric of the artworld possible and plausible. But if persons are actual (actually real), must not speech be real as well? Must not raising one's arm be real? Music and painting? History? If all this follows, the "rhetorical turn" can have no point or purpose—or if we suppose it can, then we will never escape its self-referential incoherence. I hasten to add that Danto may actually have changed his mind (in some of his later statements) regarding the right analysis of Wittgenstein's splendid riddle about raising one's arm. (I'm certain he did change his mind—and surely he did so

by the time he published *The Body/Body Problem*.) But then he also gives us to understand that the "two" accounts are really one and the same, that he's never changed his view about the "science" of art. The entire thesis threatens to unravel. I confine my remarks initially to a reading of *Transfiguration* in the context of "The Artworld" paper, in which (read together) Danto's best-known formulations are first given.[3]

Since we must still speak of art, we have no choice but to follow Danto's lead. Nevertheless, the rhetorical idiom obscures a deeper dualism: for if *a person* raises his arm ("utters" an action, as I shall say—and shall explain), then the action must be informed in some further regard by the *agent's* actual purpose or intent. Saying *that* would no longer be merely figurative, unless, per impossibile, to speak of selves or persons were also a piece of transfigurative rhetoric! Danto nowhere addresses the problem, which is entirely characteristic of the "piecemeal" strategy. For if he admitted the reflexive nature of the problem of the metaphysical status of the self, he would have defeated his entire line of inquiry regarding the arts. For his part, Wittgenstein does not (as Danto believes he does) speak of an action as a thing (*Gegenstand*); he speaks rather of the *fact* of raising one's arm (*Tatsache*). And of *this* he says very plainly: the difference "is not a *something*, but not a *nothing* either."[4] Wittgenstein, of course, would not call this metaphysics, but *we* can if we wish—with good reason and to good advantage. This gives you a penny glimpse into the kind of reasoning I mean to expose.

I can spare another half-penny here. In an early paper of his, Jerrold Levinson, distancing himself from the views of both Danto and George Dickie, whom he links as advocates of the "institutional theory of art," offers the following plan for the definition of art:

> In this essay I would like to begin to develop an alternative to the institutional theory of art, albeit one that is clearly inspired by it. What I will retain from that theory is the crucial idea that

artworkhood is not an intrinsic exhibited property of a thing, but rather a matter of being related in the right way to human activity and thought. However, I propose to construe this relation solely in terms of the *intention* of an *independent individual* (or individuals)—as opposed to an overt *act* (that of conferring the status of a candidate for appreciation) performed in an *institutional setting* constituted by many individuals—where the intention makes reference (either transparently or opaquely) to the *history of art* (what art has been) as opposed to that murky and somewhat exclusive institution, the *artworld*.[5]

You begin to see here how "piecemeal reductionism" and "intentionalism" are suited to one another, how they risk incoherence together, how both are drawn to dualism, and how Levinson hardly escapes either Dickie or Danto in cleaving to a mentalistic reading of an artist's or audience's "intention." (I suggest you keep this confession of Levinson's in mind as we proceed.)

My claims, then, are that a good number of strong philosophers of art—recent and influential—are distinctly of the "piecemeal" sort; that they cannot make their case coherently or compellingly on piecemeal grounds alone; that they could never succeed unless they could also validate a thoroughly reductive account of all that belongs to the cultural world—particularly the analysis of what it is to be a person or self; that there is no such valid or promising reductionism at the present time and none in the offing; and that, as a consequence, the entire strategy is bound to fail. Its strongest variants may be shown to have failed already, and its more recent versions provide no grounds or resources strong enough to recover what had already been lost or defeated in the work of its best champions.

I offer two summary objections here: one, that the "new" aestheticians cannot make their accounts coherent; the other, that their own economies impoverish the very resources by which alone their questions may be answered. I see no reason to soften these charges.

Let them stand or fall as they may. The philosophy of art risks too much already in yielding in their direction.

My counterclaim is equally straightforward: the problems the piecemeal theorists address require an unrestricted sense of the public standing of the entire cultural world to which persons, language, and the arts belong; but that is precisely what is not admitted among the canonical strategies favoring reductionism. The trick is not so much to deny the very existence of "mind and culture" (as, famously, Wilfrid Sellars does in his eliminativist extremes) as to deny (or, perhaps better, stonewall against admitting) that mind and culture are ever discernibly manifested in a public way that is pertinent to our grasp of history, language, thought and intention, the arts, and ordinary human communication. This is not yet an answer, of course, but it is the key to the piecemeal theorists' paradoxes, reductios, stalemates, false claims, simulations of solutions—all of which are readily avoided by a perfectly plausible alternative analytic strategy.

Let me offer a few exemplary texts to start us off—to introduce some of the principal players. At the beginning of his much-debated Mellon lectures, *Painting as an Art*, Richard Wollheim makes the following rather startling pronouncement:

> Most of the criticisms of existing art-history are already conceded, some directly, some only indirectly, in the name it goes by: "*art*-history," "art-*history*." Standardly we do not call the objective study of an art the history of that art. We call it criticism. We talk of literary criticism, of musical criticism, of dance criticism. What then is the specific feature of the visual arts, something which must be over and above the general way in which all the arts are connected with a tradition, and which has, allegedly, the consequence that, if we are to understand painting or sculpture, or graphic art, we must reach an historical understanding of them? I do not know, and, given the small progress that art-history has made in explaining the visual arts,

I am inclined to think that the belief that there is such a feature is itself something that needs historical explanation: it is an historical accident.[6]

I take this to be an evasion of an essential issue, no matter how convinced Wollheim may have been that the term "art-history" conveys the mistaken impression of a bona fide and distinct discipline. His dismissal is hardly an argument, but it's almost all he says on the matter. You see this at once when you read a bit further: Wollheim is explicitly opposed to the hermeneutic approach to the arts—along with iconography and structuralism and semiotics, which sometimes includes "art-historical" considerations in an essential way, whereas the first two "disciplines" regularly do.[7] You see that the rejection of "art-history" cannot be separated from the defense of Wollheim's own position regarding the theory of painting. I suggest that Wollheim's purpose in opposing "art-history" includes at the very least the need to block the admission of historicity, that is, the fact of the evolving transformations of thinking and perception as artifacts of history itself—which, of course, would ensure the pertinence of the discipline at once, as well as its bearing on the objectivity of "criticism" and the interpretive complexities of dualism, mentalism, intentionalism, and the like.

My intuition is that to admit the descriptive and explanatory role of "history" in the sense of historicity—that is, in the sense of the inherently historical nature of thought itself (hence, of creativity in the arts)—is, effectively, to introduce a run of concepts that play a unique role in the cultural disciplines normally not available in the analysis of physics *or* the psychological or behavioral disciplines construed as open in principle to some straightforward reductionism.[8] Of course, Thomas Kuhn had already made a compelling case for treating the "history of science" as a distinct discipline that actually alters our picture of the objective powers of scientific inquiry,[9] which begins to suggest that "music criticism" under historicized condi-

tions (as with Theodor Adorno) might well be a fair analogue of "art history" as a form of criticism.[10] Wollheim is bent on cleansing the stables.

It's worth reminding ourselves that Hegel had long ago made a decisive case for treating the "history of philosophy" as a proper form of philosophy—in his *Lectures on the History of Philosophy*.[11] Wollheim says nothing about any of this. His unguarded rejection of art history sounds hollow—tendentious, I would say: perhaps the too-easy denial of an established discipline that happens to admit historical processes as objectively present in the cultural world, entirely ready to be invoked in a critical way that could never be convincingly set aside in favor of artists' or interpreters' intentions—or such intentions separated from their evolving cultural milieus. Bear in mind that I'm merely offering for the moment specimens of the "piecemeal" orientation. We still need an analysis and an argument. But Wollheim's would-be economy is hardly innocent, since it prejudges the very issues it pretends to examine. For example, if you approve the suggestion I've just offered against Wollheim's economy, it will prove impossible to treat the "mentalistic" side of the arts in the dualistic way the piecemeal theorists characteristically prefer; and if that could be shown, the entire piecemeal strategy would collapse at a stroke.

I'll add a bit more from Wollheim's text to round out our sense of the state of play. Here's his central thesis—or something very near to it:

> The artist paints in order to produce a certain experience in the mind of the spectator. . . . He paints so as to produce a pleasurable experience. But my claim is that, equally, when he aims to produce content or meaning, which is his major aim, he also paints so as to produce a certain experience.[12]

You are likely to read this passage insouciantly, reading the term "experience" and the reference to the mind as benignly vacuous mark-

ers. But you would be wrong to do so. You must ask yourself whether Wollheim means to avoid saying outright that a painter paints meaningful, meaningfully structured paintings . . . that may also give us pleasure. Why does he favor his unlikely roundabout (his mentalistic) locutions if it is not for the sake of strengthening (without toil) his well-known claim (nowhere seriously defended) that paintings are simply physical objects?[13] If this is an example of how painters' intentions are construed by the new intentionalists, why should we rely on their sort of dualism? It seems an obvious dodge—that is, if you suppose we can appeal to "inner" intentions only by way of "outward criteria" or public manifestations. There's a clever contrivance here that aims at the systematic compartmentalization of artworks as physical objects (recall Wollheim's remarks about art history) and the appreciation of art itself as no more than what, in viewing paintings, is restricted to the causal effect Wollheim calls "experience." That is dualism at its deftest.

If you think about this carefully, you will not fail to see that Wollheim has cleverly divided the question of what a painting is: everything having to do with *applying pigment to canvas* (call that "painting") will (he insinuates) be rightly described and analyzed in materialist terms; everything else having to do with *the expressive, representational, semiotic, and similar properties imputed to the canvas in order to recover what we usually say of paintings* will be projected from our knowledge of the mental life of the artist (his intentions, feelings, motivation for his craft practice, and the like), supplemented by similar details about would-be viewers. These two aspects of paintings are thought to be linked in causal ways to the production of painted physical canvases that inherently lack intentional properties altogether (since canvases lack mentalistic attributes of any kind): only a thoroughgoing reductionism could possibly be persuaded of the coherence of such an account. Notice that Wollheim nowhere speaks of an artist's intending to produce anything that publicly *possessed* expressive, symbolic, representational, or similar properties. It looks as if he would view any

such idiom as conceptually problematic, although what is problematic in the dualist sense about his own idiom seems to be blithely accepted. (Bear in mind that if an artwork possessed any of the kinds of properties just mentioned, "art-history" would have to be invoked.)

The painter, Wollheim says, arranges paint on a canvas in order to *produce a certain experience* in a viewer. I concede that a painter might well be pleased to produce this or that pleasurable experience, but he surely (ordinarily) wants a viewer's experience to accord with what he's actually produced in or as his painting—that is, to accord with the actual expressive, representational, or similarly structured public work *that is his painting*—which might then serve to guide or govern any suitably informed response or experience on the viewer's part.

At any rate, that is the fair claim of any reasonable challenge to Wollheim's theory, or to theories like it. Otherwise, a viewer will be confronted with no more than physical canvases that inherently lack meanings or intentional structures of their own! The "dualist" methodology will fail if there is no reliable way to recover these culturally or intentionally informed attributes. And, of course, if none can be recovered, we will have impoverished our sense of the encultured world.

Broadly speaking, Wollheim believes he can recover all that's needed by appealing to mentalistic data. But what if, per Wittgenstein, inner mental states were in need of outward manifestations or criteria? The entire piecemeal strategy would utterly collapse—because, of course, the new intentionalism would collapse. The piecemeal strategy would collapse because the dualism would collapse: the dualism would either be solipsistic (hence, incoherent) or question-begging (hence, incapable of gaining its objective). Tertium non datur.

In fact, in the preface to his *Lectures*, Wollheim identifies his choice of topic in terms that are made carefully congruent with the sense of what I've just cited: "I would talk about two things [he says]: the

conversion of the materials of painting into a medium [without reference to intentional features] and the way in which this medium could be so manipulated [he means causally] as to give rise to meaning [to yield a sense of meaning in responsive percipient *minds*]; and I would do all this through a study of a few painters who were close to my heart."[14] There you have an exemplary instance of piecemeal reductionism: think of the phrasing "give rise to meaning"! (Superb deception.)

What I believe happens in Wollheim's account—and, one way or another, in the accounts of all the "piecemeal reductionists"—is this: the real presence of an actual cultural world (including selves and artworks) is simply denied or suppressed or, still more ingeniously, characterized as derived or projected *from data about artists' minds*, which have been allowed to remain in a sort of metaphysical limbo for the time being (but are nowhere redeemed); so that everything needed in the *cultural* way is thought to be recoverable *psychologistically* or by (unexplained) behavioral means that may well be psychologically informed in the same way artworks are. To this I say: (i) the cultural cannot be conceptually derived from the psychological, except by an impossible solipsism;[15] (ii) on "piecemeal" grounds, selves, artworks, histories, traditions seem to be fictions of some sort generated (somehow) from figurative descriptions of the human world—possibly generated at some deeper, more fundamental level of reality than cultural phenomena could ever claim to occupy (in the brain perhaps);[16] and (iii) the conceptual resources canonically assigned within the terms of the philosophy of art may, as a result, be either incoherent or impoverished or both. I doubt I can speak more plainly.

Let me add, redundantly, the small warning that it pays to look very closely at the precise choice of idiom our specimen theorists favor in their seemingly innocent and unmarked way, in introducing or scanning the issues they ask us to consider. Ask yourself what kinds of attributions *they* never enlist, that *you* would find it very natural to feature, possibly even to treat as unavoidable.

Here, now, is an example very different from Wollheim's but committed as well, although more tangentially, to piecemeal reductionism. In one of his recent books, Gregory Currie introduces the interesting category of the *documentary* as a distinct genre: his examples are drawn from photographs and cinematic images, also from tapes of sound and speech. (Documentaries can of course appear in other media.) Currie's account depends very heavily—fatally, I would say—on a principled disjunction between what he calls "traces" and "testimonies": the first he holds to be essential to "documentary," rightly defined in purely physical terms; whereas testimony (incorporating description, analysis, interpretation, and the like) belongs to the intentional narrative of a documentary, which brings it entirely within the cultural world. For my part, I doubt—I more than doubt—that there can be documentary "traces" that are identified on merely physical or causal grounds alone, grounds that are not already infected by "testimony" or the narrative of a would-be documentary. What else could ensure their narrative relevance?

On Currie's view, *traces* are entirely physical, contextless, without intentional content as such, subject only to the forces of physical causality, however subsequently used; whereas *testimony* is inherently contexted, open to pertinent interpretation, always possessing intentional content that must be judged relevant and suitable to the documentary narratives it is said to belong to. The trouble is, Currie also introduces the idea of "trace content"—that is, he alleges that the intentional import of a photographic image or a fragment of taped conversation somehow acquires its valid standing as an authentic trace (*of* these or those events) *for* this or that documentary solely on physical grounds. I must protest: surely that's impossible *and* incoherent, goes completely against actual practice, is utterly unconvincing—and actually undermines his own distinction. The objection against Currie's view of "trace content" is conditional here; for Currie tries to distinguish trace content as perceptual but not intentional. He's entitled to another inning.

Leni Riefenstahl's *Triumph of the Will* affords a good example of what I have in mind. Imagine, for instance, that some bits of Hitler's conversations were accidentally taped (somewhere) and misidentified; they would not belong to the right time and place if they were to be added (for temporal reasons alone) to any documentary of the Reichstag rally (1934), though they might make a perfectly coherent sequence for another documentary or they might even be included in a Reichstag documentary if they could be suitably included in a piece of *testimony*. I think Currie could never decide the question regarding the first possibility, and he would reject the second as irrelevant or unfavorable to his thesis. Or, imagine that the tapes were cropped or placed in a sequence of other would-be traces or testimonies in order to convey a false impression of their documentary worth: Currie cannot tell us how to proceed here—according to his own lights. There simply *is* no neutral "image" or "representation" to rely on, but that's precisely what Currie means to capture.

A would-be trace—alleged to have "trace content" (effectively, "nonconceptual" trace content), a photograph or taped bit of speech, say, indexed only in mechanical ways—could never be rightly thus identified or characterized if it were not also reasonably imputed a suitable hermeneutic or intentional import of its own. Admitting no more than that would already violate Currie's "piecemeal" account. It would not, I allow, be initially unreasonable to propose that nothing could be conceded to be a documentary trace that was not deemed to have been "produced" by sheer physical causes independent (in the relevant sense) of artists' intentions and interpreters' contexts. But it would be a conceptual mistake nevertheless to insist on anything of the kind. A "trace" without "trace content" would be no more than a mere physical *effect*, not a "trace" at all, in the sense pertinent to documentary; and, there, very likely (as far as practice is concerned), genuine traces would not need to be entirely independent of executive intention. Gilbert Stuart's portraits of Washington (who posed for his pictures, all three of them) are, to my mind,

proper documentary traces (if you wish to save Currie's term). I see no essential difference here favoring Lincoln's photographic portraits. Nor is there anything to be said against the filmed documentaries of birds nesting in the trunk of a tree, where the entire interior of the tree has been outfitted with a camera (hollowed out, provided with a false back that seems to disturb nothing) in order to catch the birds' family life. The same goes for the newly discovered diaries and letters of eyewitnesses to Washington's campaigns in Trenton and Princeton relating to the larger campaign involving the Delaware crossing: that they are also testimony doesn't seem to be problematic at all—it's the normal circumstance.

We never arrive at a perceptually or experientially neutral ground, with respect either to perception itself or to "information." Currie has been misled by the self-contradictory notion of "the purely photographic, or causally induced, representational content of a film image."[17] There is no such representation. A *representation* is inherently an interpreted image: Currie's notion is anomalous. I do see what he is driving at, though: *if* he could free representations from the intentionally freighted world of human culture (what I prefer to designate as "Intentional"—meaning by the capital "I" to signify an objectively accessible order of expressive, representational, semiotized things that cannot be cast in merely mentalistic or merely physicalistic terms), then the intentionalists would be home-free! They would be able to model pictorial representation, and even visual and auditory perception, in ways that would blunt the fatal import of ever admitting that we hear speech directly—see pictorial representations, hear expressive, semiotically informed, even quoted musical materials, without reference at all to the supposed advantages of the piecemeal strategy.[18]

Currie confuses and conflates two very different senses of "trace." That an image is produced mechanically has nothing to do with its being perceived within conceptual constraints; furthermore, to see something *as* a representation is to see it in a conceptually well-

formed way. I venture to say that there *is* no image that humans can report that (for perfectly trivial reasons) is not conceptually constrained by their cultural experience, constrained (first) within an intentional (or Intentional) context of some kind. Currie needs something very much stronger if he is to make his "piecemeal" account of documentary viable at all. It would have been a coup if he'd actually succeeded. But, of course, he has not succeeded—and he could not. "Traces" cannot be "documentary" traces if they lack "conceptual content" in some pertinent documentary respect; they cannot be more than "effects" not yet marked as traces. (Documentaries are, inherently, cultural constructions; so are *their* "traces.")

Nevertheless, in opposing Currie's account, I don't mean to disallow what he's noticed about what he calls a trace; or, for that matter, whatever may be the facts about "nonconceptual" sensory perception. It's just that neither of these notions is, or can be, confirmed independently of the more ramified (Intentionally freighted) "second" notion of a trace and the corresponding notion of visual and auditory perception. There's the sticking point. What holds here of representations and perceptions holds as well of "information," though information is said to obtain below the level of reportable perception even where it is also reportable.

Consider these remarks of Currie's:

> To be a documentary the thing in question [a cinematic image, say] must consist partly of traces. . . . *Casablanca* fails to be a documentary, because while the images are traces of, and hence represent Bogart and Bergman their trace content fails to cohere with the narrative the film presents to us.[19]

This shows, unmistakably, that Currie confuses the two senses of "trace." I see no reason why the film, in whole or part, might not be made a part of an (admittedly unwieldy) documentary about the actors' careers: there need be no problem of "coherence" here. (Here,

"coherence" is itself a documentary consideration.) Currie goes on to say, disastrously (but understandably):

> Trace content is intrinsic to the image, whereas narrative content is, as we would expect, heavily dependent on the context that surrounds the image. Trace content is non-conceptual, while narrative content is conceptual. . . . The trace content of a cinematic image is independent of context.[20]

What Currie says here may be irenically conceded to hold of a "trace" in the *first* sense of "trace" (that is, in the diminished and dependent sense); otherwise, it is incoherent on its face, since the first sense of "trace" (phenomenal but nonconceptual, let us say) is dependent on the second. But you see the ingenious linking of the notion of "trace" and "nonconceptual" visual images ("trace content"). Its nonconceptual "content" cannot be determined, except dependently, *from* what we can report we see (or report by related means). But that puts perception squarely within the cultural world. The piecemeal reductionist must oppose the concession—but he can't. I claim that that effectively anticipates the complete collapse of all the best-known versions of piecemeal reductionism in the philosophy of art. Reportable human perception is thoroughly "penetrated" in Intentional ways. It must, in *this* sense, be "phenomenological," not merely "phenomenal"—not necessarily, of course, in Husserl's sense but at least in Hegel's (the sense Hegel provides in the *Phenomenology*).[21]

Currie presses us to admit that perception, unlike belief, may be—often is—nonconceptual:

> There used to be support for the proposition that perceptions really are beliefs. But this view has given way, and many philosophers draw a sharp distinction between the two on the grounds that, while beliefs must have conceptual content, perceptions need not. To credit someone with a belief is to credit them with

concepts necessary for a description of how that belief represents the world. But someone can have a perceptual experience which represents the world in a certain way, yet lack the concepts necessary to say what way the world is represented as being. We can say that the contents of beliefs are conceptual, while the contents of perceptions are non-conceptual.[22]

But that cannot possibly help, even if you allow it. It can only return us to the previous muddle, for it's the *same* muddle. The very idea of the "nonconceptual" content of perceptions attributed to normal percipients is itself *conceptually dependent* on the fully *reportable* content of normal perceptual experience. To think otherwise is to suppose (as with David Marr, for instance, and, in the context of aesthetics, with Domenic Lopes) that there is a run of *phenomenally* "objective" sensory perception that we are entitled to assume as given, that does not in any evidentiary way depend on our capacity for *phenomenological* avowals.[23] There's an intolerable lacuna there. Nonconceptual perception and information are themselves conceptually parasitic abstractions (for analytic or causal advantage) *from* thoroughly reportable experience. The situation regarding *our* nonconceptual perception is closely akin to our attributing determinate, nonconceptual perceptions to sublinguistic animals and prelinguistic infants.

The percipient in question (a prelinguistic child, say) *may* be said to see a photographic representation of its mother, because *we* infer that he sees what *we* see (or something close to it). Currie rides roughshod over the entire history of the philosophy of perception that runs at least from Kant to Hegel against the Cartesian world. There is no neutral nonconceptual or noncontexted representational image that we can identify *perceptually* that could possibly render Currie's account of a documentary coherent and viable.

There's also no mistaking what Currie is driving at: "A photograph is a trace of its subject, while a painting is testimony of it."[24] But, of course, if you construe "trace" intentionally (or Intentionally), then

Stuart's portraits of Washington *are* (documentary) traces every bit as much as are Matthew Brady's photographs of Lincoln—since, we must remember, there is no "trace content" in Currie's sense except derivatively (which Currie would be unwilling to concede). In short: documentary traces are always parts of testimony. The fact is that the "proper" contours and unity of the "nonconceptual" image are assumed to accord precisely with what we identify Intentionally in what we report; but that's to say, they are fully intentional at first but phenomenal theory erases the admission while preserving the tell-tale concordance.

Currie continues: "Traces of all kinds are, as Kendall Walton has pointed out, in a certain sense, independent of intention."[25] I see what he means; but he's made too much of a small detail that cannot fail to depend on perceptual and similar contexts, however important it may be thought to be for documentary. Certainly, a camera may be tripped without a photographer's intention ever playing a determinative role in producing the image; certainly, the causal process remains "automatic" even where a photograph is staged (as in a photographic portrait). But Currie has made the wrong connection. What is independent of intention here does not really bear on the image's intentional (Intentional) standing: it is never independent of the narrative or interpretive context in which it is selected as the image it is said to be. A Diane Arbus photograph *is* a trace precisely because, having been arranged to represent its subject in a certain way, the photograph does just that and is judged, because of that, to have the hermeneutic import that it has. (I don't deny, of course, that the documentary standing of an Arbus photograph may be challenged.)

That's precisely why a trace cannot be contextless. Currie correctly notes that "there cannot be paintings which are the product of nature below the threshold of intentionality."[26] But if so, then "traces" cannot escape intentionality either. The sense in which documentary rests on "nature" is not a sense that serves any viable form of piecemeal reductionism.

Let me mention, finally—though without proper analysis here—what is undoubtedly the most famous variant of the piecemeal strategy: Arthur Danto's well-known pronouncement from his "Artworld" paper:

> To see something as art requires something the eye cannot descry—an atmosphere of artistic theory, a knowledge of the history of art: an artworld.[27]

Read straightforwardly, Danto's remark signifies that we never actually *see* artworks, except in the attenuated sense in which we (say we) see "*something*" *else* (that is *not* or not yet an artwork) *as* an artwork. But, on Danto's view, to do *that* requires that the second sense of "see" is penetrated (informed) by theory and a knowledge of history and cultural tradition, which, for their part, *cannot* rightly be said *to be seen.*

If, then—as I believe Danto means to say, in saying what I've cited (and cited earlier)—*what* is actually seen is never more than a physical canvas covered with paint, then either *all* the problematic, Intentionally or culturally freighted attributions we make of *artworks* never answer to what is seen, or else *to* "*see*" a physical thing *as* an artwork requires an altogether different sense of "see," a figurative sense that is not a mode of actual sensory perception at all! I think that *is* what Danto means (in "The Artworld" paper). But if it is, then why not say straight out that, just as we hear speech—hardly figuratively—*we see the Intentionally freighted structures of paintings*? Our perceptions are Intentionally *penetrated.* Danto neglects to address this question, though I admit it is difficult to believe. (As I say—and said earlier—Danto seems to have changed his mind over the years in a rather fundamental way, though not transparently.)

You will have noticed that Danto does not explain what he understands by "seeing," except that its sense precludes our ever seeing paintings as paintings. But if so, then Danto must mean (he offers no

supporting argument) that perception proper precludes intentional (or Intentional) complexities. *But the counterpart can't be true of hearing speech.* (Think also of sign language.) At the very least, Danto owes us an explanation of the pertinent sense of "see." You cannot fail to notice here a strong convergence between Danto and Wollheim from different first moves. They converge considerably on painting. Wollheim thinks of literature and music in a different way, of course, as abstract rather than as material objects. This maneuver, however, generates its own difficulties: for one thing, it strengthens the sense of the cultural or Intentional complexity of literature and music (involving verbal texts and scores), which must affect our account of painting; and, for another, Wollheim's argument leads to the unmanageable paradox of speaking of artworks as abstract "types" (which are said to exist).[28]

Danto must mean to confine "see" in some sense that approaches an empiricist limit of some kind (some sort of phenomenalism, let us say, that precludes actually *seeing* Intentional features). But that surely runs the risk of colliding with his avowed Hegelian sympathies; and, besides, if the Wittgensteinian lesson offered earlier holds, then inner mental states stand in need of outward behavioral criteria, and the perception of behavior will thus be confronted in the same Intentionally freighted way. There's no escape here: there's only a regress of an untenable sort. The fact is, there's a perfectly ordinary sense in which we hear speech, see meaningful behavior, read what is written, see pictorial representations. It's simply the familiar sense in which we report—perceptually—how-the-world-appears-to-us (our *Erscheinungen*, to adopt Hegel's useful idiom). As you see, this idea is at least as natural as the other and plainly more serviceable: because it completely obviates the contorted, entirely unnecessary implications of Danto's formula. (Bear in mind the parallel with Currie's theory.)

Hegel acknowledges the sort of seeing needed as perceptual—construed in a phenomenological sense. This has the advantage of

absorbing everything that can be defensibly drawn from the phenomenal sense Danto seems to favor, but without disallowing our ability to report perceptually the *Intentional features of what we see*—at least as readily as what is admitted to be merely phenomenal and non-Intentional.[29]

Furthermore, if we consider this possibility, then we must ask ourselves whether it might be true that Danto simply collects the data of our powers of phenomenological perception, erases all the Intentionally freighted perceptual data, and then restores them (derivatively and dependently) as whatever (he alleges) belongs to our inner mental life or to what, by reference to that life, may be imputed to external behavior (painting a painting, say) or to what we take to be a "painting" (a mere physical canvas viewed *as* a painting).

It's hard to believe that this is a serious proposal; it's also hard to find any viable alternative in what Danto actually claims. There's an unacceptable paradox at every turn. I take the analysis to amount to a reductio—primarily because, catching up Wittgenstein's lesson, the world of public culture cannot be reduced to anything mentalistic *and* because the mental itself stands in need of cultural criteria. (I'm suggesting that Wittgenstein *is* regularly addressing the distinctive features of the world of human culture. Danto seems to preclude the possibility *or* to regard Wittgenstein as a garden-variety reductionist.)

You realize that in putting things this way, Danto is *never* obliged to disallow any Intentionally freighted (or phenomenological) perception: he needs only to hold tight to the "saving" provision that *any* such attribution remains, in principle, analyzable in terms of the *rhetoric* of his "Artworld" model! There's the "advantage" of his account over Wollheim's—but it's finally no more than a cosmetic gain. Because, of course, Danto *trades* on the public accessibility of what he confines to the intentional, inner, mentalistic life of painters and those who view and appreciate paintings: that is, he insists on a problematic redundancy—a clause too many!

On my own account, the very idea of a self or person is the idea of an enlanguaged and encultured agent—hybrid, "second-natured," in the sense that language and culture (internalized in infancy) manifest certain sui generis ("Intentional") properties that cannot rightly be ascribed to mere physical things, except by rhetorical means or by courtesy or something of the sort. Speech itself, science, knowledge, the very ability to produce artworks already belong to the problematic cultural world. One way or another, piecemeal theorists assign these distinctions to the inner mental life and intentionally informed behavior of human beings, in terms intended to be hospitable to the prospects of reductionism. Any yielding here, in the direction of nonreductive materialism, would spell defeat for the piecemeal reductionist.

Notice, also, that if what I've just said about the initial formation of selves or persons is close to the truth, then the piecemeal reductionist's strategy (like that of the true reductionist) puts the entire question of our reflexive understanding of our world (and ourselves) at mortal risk. There's an additional worry about the danger of conceptual impoverishment that the "new" aestheticians have been too careless about.

The contest to be considered, therefore, concerns, quite simply, the adequacy or inadequacy of any form of the piecemeal strategy vis-à-vis the fine arts. The answer wanted bears on what conceptual resources must then be drawn from the cultural world—which we may suppose cannot be effectively replaced or approximated from the side of mental intentions or the like—because the piecemeal strategy already implicates (and depends on) our own "second-natured" formation within the same cultural world from which the initial data must also be drawn. Mentalism without behavioral "criteria" (or their public kin in the cultural world) cannot be more than solipsism; and reductive behaviorism (whether Quinean or Skinnerian) risks losing the mental altogether. The bare admission of human behavior, of the craft labors of the human artist, implicates *their* per-

ceptual standing—phenomenologically. There can be no escape there. How, for instance, could we hope to establish the pertinence and adequacy of the piecemeal alternative if we could not first establish the aptness of the public avowal and affirmation of thoughts, meanings, intentions, sensory experience, and inmost feelings? Surely the first is a problematic displacement of the second.

The arts, then, constitute a very strong test of what to regard as an adequate system of conceptual distinctions fitted to the entire range of human reflection. For example, against reductive tendencies, I would argue that it makes better sense to claim that our theories of *physical* nature are themselves limited posits that *presuppose* all the resources of the cultural world than to insist that, if we are to understand the cultural world, it must be possible in principle to reduce that world (piecemeal or completely) to the terms of the physical world. A problem seemingly local to aesthetics begins to loom, and begins to dominate the theory of perception itself.

I regard the piecemeal theorists as something of a danger because, with the best will in the world, their seductive strategies unnecessarily impoverish the conceptual resources we need in order to understand the whole of the intelligible world. The irony is that they proceed from the richest stratum of cultural life and move directly to explore the possibilities of capturing all of that by devices that refuse to attribute directly to artworks properties of any order richer or more complex than what they deem sufficient for the description and explanation of the inanimate and precultural world. Why is that?

It's true that they "restore" whatever they find essential to the expressive, representational, symbolic, and semiotic dimensions of cultural life. But they do so only within the confines of inner mental states and only by dubious means. Accordingly, they fall back to a remarkably sanguine dualism—a "methodological" dualism, so to say, to support a doubtful scruple regarding mentalistic and material properties. They also fail to take due notice of the fact that the physical sciences are themselves constituted by culturally apt inquirers.

There's the charge. There is no way to confine meaning, intention, or appreciation to inner experience alone, that is, without acknowledging the usual public manifestations in behavior, deed, speech, production, creation, and other modes of human "utterance." In fact, to say this much is hardly more than to repeat Wittgenstein's well-known lesson: viz., that inner experience stands in need of outward criteria.[30] But if we adopted Wittgenstein's caution, we could never admit the piecemeal policy; the intelligibility of intentional attributions would require the instant admission of an intentionally (Intentionally) qualified public world; and that would render the dualistic paraphrase completely redundant and profoundly paradoxical.

The whole affair would be a house of cards. The piecemeal theorists reclaim in their private world what they deny in the public world; but they've already borrowed their distinctions from the world they turn their backs on. The result is a convenient mystery. For we can never say just where they draw their supple distinctions from, and yet of course these distinctions are all too familiar and possess whatever fluency we usually claim. (Recall Wollheim's argument about "pleasurable experience.")

In effect, piecemeal champions generate the whole of our cultural resources from merely psychological gifts, or else they pretend that the cultural world is itself no more than what an aggregate of cooperating minds can produce: traditions, for instance, genres, institutions, practices.[31] But if you concede that natural languages cannot be produced by any "social contract," you realize that language is already a public and collective achievement, not an aggregative one of any kind, and that the emergence of enlanguaged and encultured selves already presupposes the prior presence of a public culture.[32] That, I suggest, is the nerve of Hegel's innovation, though Hegel himself is a pre-Darwinian.

The correctives are quite important, though they may seem too slight to mention (perhaps even unnecessary) to the convinced re-

ductionist: namely, that there cannot be a total and coherent disjunction between mentally private and materially public things; that the craft intentions of artists, however psychologically construed, are already culturally transformed in publicly legible ways. The key, as with so many issues, is, of course, language itself; for language cannot be invented by any initial (languageless) aggregate of conscious creatures: language is inherently the collective property of an aggregate of encultured creatures who cannot fail to have been transformed by internalizing their home language. What this signifies includes both the emergent, sui generis, hybrid, public world of Intentionally structured selves and things (deeds, words, artworks, for instance) *and* the impossibility of freeing the would-be intentional content of inner mental states *from* the Intentional distinctions that already belong to the *public* world they must first consult.

The answer to the piecemeal reductionist requires a complete analysis of the cultural world and its relationship to physical nature. There's the deeper lesson. We begin with what appears to be no more than a local skirmish among philosophical partisans, but it turns into a contest between two very large opposing philosophical visions. We must prepare the ground with care here, but we are well advised by the *Entfremdung* of the "piecemeal" idiom. The intuitive difference comes to this: the "reductionists" ask us accusingly why we suppose that, on entering a museum, we can simply see what we've come to see. There's the simplest clue for settling the dispute. My charge, then, is that the options the piecemeal strategies champion against the "folk" conception I've been shepherding are unequal to their task.

What remains is to find a natural way to collect the intended lesson compellingly. It invites a more tactful, second beginning—and more patience in the telling. But I do indeed mean to confirm the verdict now openly announced.

CHAPTER 2

THE NEW INTENTIONALISM

Let me begin again, with a suggestive but uninterpreted image—without explicit reference to what has already been said: we shall of course rejoin the argument soon enough but may delay a little to gain an advantage by a small detour. There are a good many disparate lines of unfinished inquiry that must be brought together here to constitute a proper account. I'd like to exploit their initial scatter so that the argument's larger unity may glide into view in a gradual and unforced way. Its outcome has, of course, already been anticipated, and it is the argument rather than the image that we finally require. But I invite you to pretend that it has still to be discovered: it's the less than secret thread of the entire story that's wanted—it's worth some patience and it can't be hurried.

Well then, before completing the draft of the brief now before you, I happened to hear the remarkable young violinist, Joshua Bell, in a televised concert at Lincoln Center, in New York City. I had never heard Bell play before; his way of penetrating the music bowled

me over. What struck me was that in Bell's hands, the score might almost have been a disembodied "utterance," a performance waiting to be brought to life by the breath of a magician who transforms himself at will into an incarnate voice that sings that particular song as if giving expression to his own soul—and does so altogether effortlessly again and again, moving from one inert piece to another across the entire expanse of Western music. I'm aware, of course, that this way of speaking is too purple to be trusted, though it's hardly inapt applied heuristically to individual artworks, whether at the point of original creation or composition or performance or at those more problematic, often silent and inexplicit moments involving listeners, readers, viewers, and the like, whom we jumble together as the designated audience.[1] (Viewed otherwise, the occasion is of no particular importance.)

I see in this image nearly all the pertinent distinctions anyone (certainly I) might hope to lay bare in surveying the arts and our ways of understanding them.[2] No doubt I shall have to play its melody in another key. (I'll keep this first approximation brief, therefore.) But it's not the image I prize; it's the conceptual economy we gain from its presumption—in turning to theorize about the arts as opposed to mere physical things. It prompts me to keep certain of the arts' essential features in mind that might otherwise be too easily ignored—for example, the following two linked sine qua nons: one, that to grasp the nature of an artwork is to understand the sense in which it exists and flourishes only as a thing peculiar to the world of human culture; the other, that an artwork intrinsically possesses, for the reason just given, a run of attributes that belong, paradigmatically and exclusively, to that same public world—for instance, meaning, intentionality, expressivity, representationality, horizonal or perspectived significance—in short, what we may call the *geistlich* features of the intelligible world, if, for the sake of brevity, I may draw here on Hegel's idiom.[3]

I name all such attributes "Intentional," meaning by that to hold to the following rule: "the Intentional = the culturally significant and/or significative." The "intentional," taken in the generic sense casually favored in Anglo-American philosophy, is only loosely associated with the work of Franz Brentano and Edmund Husserl, who are largely responsible for its classic recovery and elaboration; it signifies (in the English-language tradition) the well-known phenomenon of "aboutness" viewed as the mental or psychological dimension of human life cast in naturalistic terms, whether reductively or not and whether dualistically or not. I freely admit that there are strenuous difficulties with Brentano's and Husserl's theories; also, I appeal to Hegel only in the sparest and most attenuated way.

I admit all these unsorted complexities at the start. But for reasons that should become clear as we proceed, I allow for both an empiricist (or phenomenalist) reading of perception and experience and for a fuller phenomenological reading that concedes the direct perception of Intentionally freighted phenomena—for instance, for hearing speech and seeing pictorial representations—wherever such options can be shown to be independently viable. (Hence, also, for hearing the expressive powers of music.) I favor a naturalistic treatment of phenomenology (thus construed) as a worthwhile economy—against Husserl and beyond Brentano, so to say—speaking informally and more in accord with Hegel's spacious conception than with theirs (directed against the phenomenal cast of Kant's first *Critique*). But the decisive innovation I count on is just this: first, that the "Intentional" includes the "intentional," wherever human perception and experience are inseparably "penetrated" by culturally informed resources (language, preeminently, as in perceptual reportage) and where precultural or subcultural perception or experience is (as it must be) anthropocentrically modeled on the human (that is, modeled on what is reportedly perceived); and, second, that the Intentional ranges over the objective order of the cultural world (art-

works, actions, histories, traditions, practices) in ways that are not inherently mentalistic at all or not reducible to the merely psychological aptitudes of the human world. Intentionality, thus conceived, precludes the usual forms of solipsism and skepticism. (This counts against the piecemeal strategy: think, for example, of the public standing of the expressive and representational aspects of Michelangelo's *Pietà*.)

No theory of art that ignores or slights these sine qua nons can possibly succeed (I say)—though that has to be shown. The realism of the cultural world confirms the grounds on which alone the attributes in question (Intentional attributes) belong to artworks and belong to them intrinsically. But though it is our closest world—our home, really—it's a sprawling world that resists easy analysis. By the same token, we cannot yield easily to any reductionism or piecemeal reductionism wherever we appear to risk the rich resources of cultural analysis: to do so would impoverish our capacity for self-understanding; here, understanding the arts is, finally, a form of self-understanding. This is the precise import of construing our understanding of artworks (or speech or action) as understanding our own "utterances" (even if they are not the specific utterances of our own particular careers). We understand ourselves as encultured transforms of our biological powers; accordingly, we understand our utterances (producing artworks, for our present purpose) as the work of certain transformed animal powers (the native gifts of *Homo sapiens*) "magically" informed by sharing an enculturing ("second-naturing") history. We take ourselves and others to be the idiolectically diverse members of a common cultural aggregate or of a mixed aggregate capable of bilingual and bicultural communication and exchange: constructed hybrids, in effect, spontaneously generated by the emerging mastery of one or another natural language and its associated culture by the infant members of *Homo sapiens*.

My insistence on the Intentional would make no sense if the cultural world, which includes selves, languages, histories, artworks,

deeds, technologies, norms, traditions, institutions, sciences, and re-
ligions, were not itself a novel order of reality that has gradually
evolved from the inanimate and subhuman world in a sui generis but
perfectly natural way. Its precise pathways are empirically uncertain,
though no one finds the conjecture implausible, if it is admitted at
all.[4] I insist further that cultural emergence cannot be reduced in
physicalist terms, cannot appear except through physical incarna-
tion, and brings into play attributes very different from those already
admitted in the inanimate or merely biological or incipiently con-
scious world.[5] Quite simply, these are just the kind of attributes art-
works characteristically instantiate. I say we cannot make sense of
the arts without them. But to say so is to subsume the arts entirely
within the hybrid, "second-natured," constructed, sui generis world
we call the cultural. So that, on the gathering argument, reduction-
ism and dualism cannot fail to impoverish the conceptual resources
by which we understand ourselves (and our modes of utterance).
The analysis of the arts, then, ensures the need for a certain concep-
tual amplitude, one that the piecemeal cohort regularly scants.

Beginning thus, I contest the growing fashion in recent aesthetics
and the philosophy of art to build, bottom-up, an adequate theory of
artworks (and other cultural things) *from* an account of mere physical
things and their "adequated" (non-Intentional) properties. That
way of proceeding has, for an extended interval, become very nearly
the dominant strain of theorizing in contemporary analytic aesthet-
ics—hardly a necessary beginning, to be sure, since analytic rigor and
"analytic" doctrine can easily be separated. Partial and piecemeal
strategies of the regressive sort (already mentioned) appear, how-
ever, in a number of guises that are not always easy to detect; and, in
any case, reductionism's attraction rarely goes to completion. Quite
often the piecemeal variants content themselves with economies
that remain vulnerable even where they go undetected and even
where the full-blooded reductionism on which they depend cannot
possibly be secured.

Short of completing the reduction needed, piecemeal theories appear to be dualistic; or, if they seem not to be—if (say) they permit description in Intentional terms—they are bound to have taken a wrong turn (not infrequently, a solipsistic turn), or they may be greatly impoverished since, like Quinean and Skinnerian behaviorism, they must drastically scant (or deny) the public standing of the mental in all of our "folk" idioms. We lose too much, thereby, of what a robust understanding of the arts and culture requires. We must find a version of what we admit as natural or naturalistic that is also capable of incorporating the discernible phenomena of our culturally emergent world as opposed to the theoretical constraints of reductionism and dualism: a version, that is, that accommodates culturally transformed forms of mental life without privileging the mentalistic; that favors the reportable forms of phenomenological experience over the phenomenal, without rejecting the latter's relevance; that absorbs the "intentional" within the space of the "Intentional"; that allows for the historicizing of thought itself; and that vouchsafes the public nature of the entire cultural world.

I've sketched the image before the argument, because, quite frankly, it has the ring of truth about it and a touch of charm. I mean, however, to press the argument rather than the image; but, by either route, I shall draw on the same intuitions about how to view the arts themselves. Wherever we intend to break out of a well-entrenched conceptual trap, we must mind our philosophical footing. The trap I hope to elude is extraordinarily popular among recent Anglo-American philosophies of art. (I'm speaking of a genuinely important mistake.) I'm content to leave the matter to your judgment, but I must ask for a bit of patience. The image captures a right perception that's worth the bother, and the argument intended is its own raison d'être. Together, the two may spare us a tedious labor. Read as an enthymeme, the counterargument goes this way: if human selves cannot be satisfactorily analyzed in terms of a model confined to inanimate physical objects or to living organisms below the level of linguistic and cultural

competence, then the corresponding analysis of artworks won't work either, even if a full-blown reductionism is never explicitly invoked. As I say, "piecemeal reductionism" is quick to claim the conceptual advantages of a fashionable but clearly problematic economy without actually committing or needing to commit to the full reductionism on which its own coherence finally depends.

The result is a deliberately partitioned reductive account of artworks (initially exempting literature, because literature does not directly address the perceptual senses as painting and music do and because of the special difficulties of construing language in physicalist terms). The piecemeal gain (paradigmatically restricted to the sensorily grounded arts) is then joined to a compensatingly lax (dualistic) treatment of the work of creative artists and appreciative audiences confined in the strictest way along psychologistic or mentalistic lines. The literary arts may then be viewed analogously, on the assumption (or something close to the assumption) that our grasping linguistic and linguistically mediated meanings (think of understanding poetry and fiction) may also be cast in mentalistic terms. It's rather difficult to think of a plausible modern version of this idea, unless H. P. Grice's "intentional" theory of meaning fits the bill. (I shall return to Grice's theory shortly.) In any case, the very idea of "locating" the meanings of linguistic or literary texts is known to present itself as an extraordinary puzzle that we continually solve with breathtaking ease.

It needs to be made absolutely clear that a piecemeal reductionism is not a diminished form of reductionism: it depends on the supposed validity of the latter's arguments and it draws on its reputation; but, as opposed to the coherence of reductionism proper (whatever the ineffectiveness of reductionism's proofs), piecemeal reductionism is saddled, faute de mieux, with the insuperable weaknesses of dualism and solipsism. It fails before it ever begins, and we must regard it as a very different doctrine from the parental forms of reductionism. (To admit these blemishes, however, is to raise ques-

tions as to why anyone would choose to go the piecemeal way. Presumably, there are advantages to be gained that might be saved even if we eventually superseded the piecemeal strategy, though I confess I don't know what they could possibly be.)

I permit myself two targets here, drawn from two aspects of the general doctrine I've been calling piecemeal reductionism. The doctrine itself has its roots in the strong materialisms of twentieth-century analytic philosophy, which I believe have failed for entirely independent reasons.[6] Those reasons are not my direct concern here, but the linkage draws attention to the notably late flowering of the cognate strategies among the philosophies of art that I'm reviewing now. In any case, I mean to feature the conceptual poverty of bottom-up theories about the nature and attributes of artworks and the reductio of the new "intentionalism" that bottom-up theories offer as the single most promising maneuver by which to advance their common cause. There are a goodly number of strong partisans of this conviction who are worth a careful hearing; I touch on the views of several and promise a simple challenge. Here, success should yield a friendly ground for further gains along the lines of recovering the full resources of the cultural world.

In naming my initial premises "sine qua nons," I have already begun to convert my original image into the argument promised. The premises (the sine qua nons) are essentially all that's needed, although they require a closer look from time to time. In any case, if you allow them any inning at all, it should be perfectly fair to ask ourselves to explain just how properties usually ascribed to art-works—paintings most instructively—could possibly be identified in purely physical terms, as, say, early in his career, Richard Wollheim quixotically affirms.[7] I don't believe it can be done coherently; and Wollheim nowhere attempts to formulate a compelling brief. No one, as far as I know, ever has. Consider that it's more than unlikely that a nomological "bridge" could ever be constructed between the aesthetically pertinent attributes featured in the criticism of the arts

and any set of mere physical properties; such that the predicates of the first could for that reason be reductively replaced by those of the second. (Think of this as the gist of Danto's gloss on Wittgenstein's §621, in the *Investigations*.)

Wollheim is, of course, an important figure to get clear about. And there are others to consider in order to gain a reasonably firm sense of just how widespread the "piecemeal" strategy has now become. In fact, a knockdown argument against the entire company would require a thick account of the systematic differences between physical and cultural things, which I shall only sample here. It would be too much to expect a fully rounded argument in the present setting, although I've made the effort often enough elsewhere.[8] Here I would be content to show that something close to my original image and premises would be needed and would tell against the piecemeal option.

If you ask then, why, in explaining the distinctive nature of artworks, we must posit the problematic world of human culture and history, the answer comes back easily enough: well, an adequate analysis of selves (ourselves) implicates the very same world and makes the other (the art world) possible. No properties of the cultural kind apply, we say, to mere physical things (unless by courtesy), although the world that includes artworks and selves (also, the world of language, history, and tradition) is indissolubly bound to the physical world in ways we have never completely fathomed—ways, I would say, that require an analysis of the cultural world itself *if we are ever to understand the physical world!*

The history of Western philosophy has hardly completed any such account. In any event, it makes no sense to treat artworks as mere physical things wherever we resist treating human selves reductively; and it makes no sense to treat selves as mere physical things if we have no way of showing that that's true. Just consider that there is no successful physicalist reduction of speech and language, although the very existence of the cultural world (a fortiori, the existence of

selves) depends on—is paradigmatically realized in—the emergence of language. There's a reductio lurking there.

My opening metaphor suggests that an artwork is in some sense "brought to life"—something resembling more a cry traced to an originating voice than an inert piece of matter or a sound or a patch of color—although our usual categories fail us here and although art plainly "inhabits" matter in the same cultural world in which we locate and identify ourselves (collectively) as selves. As a consequence, my image is more literal than figurative, although it needs a clearer formulation. For at its source, an artwork *is* the living "utterance" of a living craftsman who transforms material things into cultural artifacts that can be vivified again and again through the various forms of human agency—reading a novel, for instance, or performing or listening to the performance of a piece of music.

That a melody discernibly possesses expressive properties hardly establishes that such properties must be psychological or mental in any literal-minded sense: it's enough that they are properties local to the work of human musicians capable of manifesting *their* expressive powers in psychologically informed behavior *as well as* by producing the inherently expressive music that they do. There you have an answer to "intentionalism"'s puzzle, too compressed for the moment to be properly parsed, although it is perfectly adequate to its purpose, as we shall see.

"Utterance" is a notion bridging (and meant to bridge) the conceptual gap between my opening image and intuition and their analysis in the way of yielding a congruent theory of what an artwork actually is—from which I mean then to draw a further argument opposing all the forms of what I've termed (perhaps too easily) "piecemeal reductionism."

The reductionist (regarding artworks) characteristically disjoins the physical denotatum that is said to be the work of art in question (describable in physical terms alone, as with Wollheim) or is some physical object rightly *treated as an artwork* (by way of suitable rhetori-

cal redescriptions or imputations, as with Arthur Danto[9]) from whatever, independently or externally, is pertinently true of the thoughts and intentionally informed craft activities of the artists and audiences said to have produced them. This begins to identify the usual methodological "dualism" that defines the piecemeal reductionism of recent analytic aesthetics. (You may see its vulnerability more clearly now.)

I introduce "utterance," then, as a term of art: to range, without strain, over any and every culturally informed and culturally qualified action and activity, as speaking, baking bread, making love, dancing, playing the piano, painting a painting: hence, by an obvious nominalization, a term to range as well over all the discernible products, objects, phenomena, outcomes of utterance (in its primary sense) that we characterize, in the same culturally qualified way, as artworks, conversations, actions, deeds, manufactured goods, histories, traditions, institutions.

For convenience, then, I collect all culturally qualified attributes and things under "Intentional" (where "Intentional" $=_{df}$ "cultural"), meant now to draw attention to the strict similarities that hold among such attributes, for instance, their being: emergent in pertinently sui generis ways; not reducible in physicalist terms; hybrid, second-natured, metaphysically transformed, inherently meaningful, significative, or intentionally freighted; hence also, capable of incorporating the "intentional" or mental or experiential or psychological at the human level—that is, in the sense loosely identified as "aboutness" in the views of Brentano and Roderick Chisholm (though not, as in Chisholm's way, inhospitable to phenomenology).[10]

There are, in fact, two very large conceptual gains facilitated by this natural adjustment that answer to the two sine qua nons offered a moment ago: one, that among humans the mental (or psychological) is itself encultured, "penetrated," made Intentional, transformed, given a "second nature," by way of our coming to function as the enlanguaged selves we are; the other, that the expressive, semi-

otic, and similar features of artworks needn't be construed psychologistically merely because they are "uttered" by enlanguaged "minds" (or selves). To allow this double reading, which needs still to be supported, is effectively to defeat the recent turn toward the "intentionalism" now favored by analytic philosophers of art who are committed as well to piecemeal reductionism. "Intentionality" (in the sense I favor) is *an entirely public matter*; the "new intentionalism" in aesthetics is not: it makes public claims of course, but privileges mental or private intentions. It risks intolerable paradox thereby.

To favor the new intentionalism without also subscribing to the piecemeal strategy is plainly pointless: a sort of self-imposed conceptual poverty that has no purpose or rationale of its own. You see, of course, that piecemeal reductionism cannot be reconciled with the conception of art I have in mind: there cannot be a viable disjunction between human agents (selves, artists, composers, performers) and what they "utter" in the way of Intentionally qualified work; the very meaning of the latter is cultural rather than psychologistic, entirely public rather than private, intrinsically Intentional rather than relational in the causal way.

My paradigm here is speech itself: for only speaking agents utter speech, and speech is the preeminent exemplar of meaningful (Intentional) utterance. There simply is no successful physicalist (or purely causal) account of speech, though causality cannot be irrelevant. Music and painting, then, are rightly taken to be cognate forms of utterance, that is, intrinsically Intentional on the strength of the argument that still waits to be fully formed. (I trust it's clear that machine-generated voices are themselves Intentionally as well as causally dependent on the human paradigm.)

In any case, we may safely affirm that there can be no *external* relationship between a subject and a subject's pain. In particular, there can be no causal relation between the "two" (in anything like the Humean sense), although to say so is not to preclude causally relevant processes and external relations at some suitable level of

analysis. The upshot is as simple as it is powerful: inner intentions and mental motivation internal to the exercise of craft capacities cannot be related to the uttering of artworks in directly causal or external ways; they are themselves ingredient in the very uttering of actions. "Uttering" is too close to agents (selves) to be causally explained in accord with the externalist (or Humean) canon of causality; but uttering (in the sense of effective agency) is itself an Intentionally emergent form of causality. Mind/body interactionism cannot escape the dualistic trap. "Mind" is indissolubly incarnate in "body," so that the bare "action" of the "merely" mental on bodily processes cannot be directly causal, though incarnate mind (or mind construed as inherently, indissolubly incarnate) can indeed exert a causal force on purely physical processes. Correspondingly, "action" is, in the first instance, what, effectively, is predicated of agents as their active agency; nominalized, it is still not separable—as its "products," its creations, what it manufactures, are usually said to be. It is in this predicative sense that action does not conform to the Humean model of causality, although it is itself a distinct form of causality and although standard (external) causal sequences can be drawn (with due care) from its histories.

When, therefore, the "intentionalists" insist on assigning all Intentionally freighted attributes to the work of disembodied minds alone, what they say is not only dualistic and incoherent but (if allowed at all) completely otiose: for they cannot possibly do more than assign to an inner mental source—dualistically or solipsistically—what is already publicly entailed *by* the *non*-causal linkage between creative artist and uttered artwork. (Recall Kim.) There's an insuperable reductio there. Pissarro did indeed influence the Impressionists in causally pertinent ways; but the Impressionists themselves, suitably informed thereby, did not simply "produce" (in the causal way, externally) what they thus "uttered": *their brushwork* (as painters) did, indeed, cause a great number of canvases to be covered with paint in such a way that we judge that Monet, for instance,

painted (that is, uttered) the *Haystack* series. But the brushwork caused the canvases to be painted only derivatively, as ingredient in the action uttered.

The reductionist with respect to painting and music, who might or might not wish to avail himself of the convenient notion of "uttering" a work of art, might still try to argue that speaking is completely unlike crafting a painting in the respect at issue; so that he could in principle try to apply a methodological (*not* yet a metaphysical) "dualism" to the analysis of a painting and its properties (as with Danto)—drawn from the "intentional" (the mental) life and psychologically enabling craft of the artist responsible for the work itself. Jerrold Levinson, for one, favors such a view, which he hopes will adequately accommodate our art-historical interests:

> If we review the principal arts, it is natural to think that the artwork in such artforms is simply a particular physical object—a piece of colored canvas, a hunk of bronze, a marked-up sheet of paper. . . . [But we may also say] that a painting or sculpture is not a brute object, on the order of a hunk, mass, or conglomeration, but rather a specifically articulated one; if, for example, a painting is a piece of canvas and an amount of paint, it is only that canvas and that paint *conditioned and configured* in a specific way, and preserving a certain appearance, and not those things *simpliciter*, in any state or arrangement.[11]

But this won't do, unless (what neither Levinson nor anyone else has shown) the pertinent Intentional properties can be reduced to physical properties or can rightly be imputed along supervenientist lines (confined to the mental, dualistically construed).[12]

Generically, utterance is Intentionally informed action or activity, as well as the upshot or outcome or product of such activity. Both sorts of ascription invoke the same link between agent and utterance, though they do so in very different ways. Analytic intentionalism, a

doctrine very different from that of Romantic or hermeneutic intentionalism, insists—without adequate argument—on there being *no more than an external (a causal) relationship* between artist's psychological intentions and the dependent "Intentional" attributes thereupon ascribed to physical objects qua artworks—which explains at a stroke the close connection between reductionism and intentionalism at the present time. But, in insisting on such an external linkage, the argument betrays the conceptual weakness of both doctrines. For of course the only way the reductionist could possibly impute nonreducible Intentional properties to "mere physical things" (even allowing for Levinson's qualifications) would require projecting them "onto" physical-objects-regarded-as-artworks in (say) the context of appreciation: that is, in accord with the intentional (mentalistic) features of the artist's craft or an audience's acceptable responses to the other— *neither of which is confined, descriptively, in non-Intentional terms*, and neither of which is matched to what is publicly discernible as the actual properties of artworks.

That is precisely what the methodological "dualism" of recent theories of aesthetic criticism (so-called intentionalism) signifies. Such theories risk their entire undertaking on the philosophical fortunes of one or another sort of solipsism. For if they concede that mentalistic resources make no sense if separated from public manifestations in the cultural world, they will have plausibly obviated the need for their own self-impoverishing regress or for any effective use of it.

E. D. Hirsch, refining Schleiermacher's original discovery—to the effect that any merely psychological or mentalistic reading of intentions cannot but be inherently inadequate to the hermeneutic task— proposes (by way of an Aristotelian analogy) some further constitutive genre-governed features *internal* to both artworks and artist's intentions, in order, precisely, to explain the objective adequacy of the practice of Romantic interpretation.[13] Accordingly, Hirsch cannot be a reductionist in the sense in question, and cannot (and would

not wish to) treat (what I've termed) the Intentional features of literature in terms restricted to reportable (mentalistic) intent. He thinks instead of a publicly shared culture within the terms of which intentional (Intentional) structures may be pertinently and objectively discerned.

Noël Carroll offers the following claims:

> The meaning of a particular language token is explained by means of certain of a speaker's intentions. . . . Likewise, in interpreting or explaining nonverbal behavior, we typically advert to the agent's intentions. . . .
>
> When we read a literary text or contemplate a painting, we enter a relationship with its creator that is roughly analogous to a conversation.[14]

He conflates too easily what are very different matters (and the lessons that may be drawn from them): viz., our being able to understand an ordinary conversation and our coming to understand a novel or a poem. Peter Lamarque has put the pertinent objection to this maneuver in a trim way: "Literary works, apart from the question of intention, are not treated as though they were contributions to a conversation."[15] Just so.

More than that, even if we analogized our treatment of artworks and conversations, we would not be able to show that a mentalistic treatment of intentions or of the Intentional features of language could possibly be free of paradox and the threat of incoherence. Carroll, who seems to be responding to Levinson's initiatives, does not (as far as I know) counter the threat. But then, what, in the light of Beardsley's well-known objections, could he possibly intend by his intentionalism?

Carroll's objections to anti-intentionalism (against the very different views of Roland Barthes and Monroe Beardsley principally) are meant (*a*) to counter the would-be priority of maximizing "aes-

thetic pleasure" vis-à-vis art by going beyond an artist's supposed intentions in determining the meaning of a particular work, as well as (b) to counter the supposed "ontological" disjunction between artworks and conversations.

But this is to attack certain quite local issues that have their small plusses and minuses; it doesn't bear at all on the conceptual relationship between psychological *intentions* and the publicly accessible *Intentional* structures of artworks. I don't believe the designation "aesthetic" is (I should add) ever clear enough to allow us to draw a demarcation line between "aesthetic" and "nonaesthetic" interests; and the differences in the role of intentions in understanding conversations and in understanding artworks may be readily drawn in a perfectly reasonable way without at all insisting on an ontological disjunction between the two or the need to "mentalize" intentions in either case. On the contrary, it's what is *ontologically common* to conversations and artworks—namely, their being "cultural" (second-natured, hybrid) rather than purely "natural" (or physical) phenomena—that justifies challenging Carroll's conception of the methodology of literary and nonliterary criticism. That's precisely why construing artworks (and conversations) *as* different forms of "utterance" strengthens the argument against Carroll—it certainly doesn't weaken it. (Unlike Levinson, however, Carroll never quite commits himself solidly enough on the ontological issue the "piecemeal" company features, though, as we've just seen, he tenders his convictions.)

The intentionalist line of analysis Levinson and Carroll favor (the recent Anglo-American version) has probably been misled by the remarkably influential notion of "utterance"—very different from the one I favor—introduced by H. P. Grice in an attempt to understand the intentional structure of constative and conversational discourse *entirely* in psychological or mentalistic terms. In effect, dialectically. (Grice's model is also problematic for reasons quite extraneous to the question before us here.[16]) The piecemeal reductionist's use of

intentionalism appears in a pointedly explicit way in Danto's well-known theory of the "artworld."[17]

But let us consider that Carroll's urging some sort of parity—with respect to intentions—between conversation, literature, and the nonliterary arts itself threatens to subvert the very tenability of the reductionist thesis (that is, *if* we agree to treat hearing and understanding speech as indisputable examples of culturally informed perception and discernment). For if we understand the Intentional structure of speech (a fortiori, the "intentional" aboutness of speaking in a public way), we can always eliminate or drastically reduce our reliance on merely mentalistic intuitions; and if we place the entire burden of meaning on the recovery of inner intentions (as, apparently, with Grice), speech itself will dwindle to mere marks or sounds! Grice himself is, of course, an intentionalist of the most extreme sort; and Carroll is simply insufficiently explicit to be relied on at all, although he obviously goes some distance in favor of the new intentionalism. Viewed in these terms, Hirsch is not an "intentionalist" at all, since *he* favors the public world of Intentional structures. He *is*, of course, a Romantic theorist nonetheless. (That is, an "intentionalist" of a very different kind. Beardsley was not entirely clear on the issue.)

My use of the word "utterance" as a term of art is hardly uncontested, but we obviously know exactly what to add to fix its import unforgettably. Hence, we allow occasionally florid images like the one I favored at the start of these last reflections. It's hardly wrong to do so, though it's certainly no more than a suggestive figure, not yet an analysis.

When, for instance, I greet you with obvious delight, it is my words and gestures issuing as my voice and bodily utterance that legibly manifest the "feeling" that you discern—even if I mean to deceive you and even if I do! Whatever my intentions psychologically, I draw on the resources of a common culture to make those feelings known in a public way—not necessarily mine (in any mentalistic

sense), given the condition just mentioned. The expression is "intentional" in a double sense therefore: it's what I intend to convey (by Intentional means) *by* what I "utter," but it's also what our cultural resources permit me *to* utter as determinably meaningful when rightly discerned by suitably qualified selves—publicly Intentional, therefore, in a second, a more restricted, a *non*-psychologistic sense that obviously need not disallow the other, although it effectively replaces the other's supposed criterial pertinence in objective criticism. We need both idioms for different though compatible reasons, but they are hardly the same and hardly function in the same way. Our tolerance for mentalism in perceptual and would-be explanatory contexts goes in entirely different directions.

Methodologically, the psychologistic account is both defective (as Romantic hermeneutics demonstrates) and redundant, dependent, or never more than marginally instructive (as the acknowledgment of the Intentional world itself confirms). Furthermore, this is as true of conversation as it is of literary language: roughly, the "mentalistic" in critical usage is pretty well confined to the narrowly personal, the idiosyncratic, the idiolectic, where the "intentional" (as merely private) proves to be too problematic to be captured by the regularities of the "Intentional" in any straightforward way.

Nevertheless, the strategies for determining the intentional even here require a thorough dependence on the resources of cultural analysis: there simply is no independent evidentiary resource known as the "mental" that is free of our public culture. Grice's intentionalism is simply too primitive to be *criterially* invoked—in the familiar way in which analytic philosophies of language tend (as, also, in John Searle's speech-act theory) to fall back to the unabashedly mentalistic or, when called to account for the cultural world itself, to do so in openly solipsistic terms.[18] First-person discourse is not inherently mentalistic at all (*pace* Daniel Dennett[19]), and the admission of the interpretive dimension of meaning in both language and nonlinguistic semiotics (as in Charles Peirce and Umberto Eco) takes a thoroughly

public form just where it is admitted to be intentional. The "new intentionalism" is simply the expression of an old-fashioned obiter dictum: it has no new arguments to offer.

The second sense of the intentional (given just above) is not a psychological or mentalistic sense at all; and the first is never merely psychological, since, as in singing, or appreciating the singing of a song, even the psychological aspect of expression is, normally, structured in accord with the resources of the second sense of the "intentional." We simply integrate the intentional structure of uttering a song and the culturally significant structure of the uttered song itself—*both* Intentionally qualified, though in rather different ways. There is no paradox there: think, for clarity's sake, of Billy Holliday's singing one of her splendid blues. (Singing the blues is not a kind of sobbing.)

You begin to see the plausibility of bringing singing into accord with conversation, but it's still a mistake if formulated in Carroll's way. There's also no conflict here with Wittgenstein's well-known account of "natural pain behavior."[20] For Wittgenstein is primarily interested in the "natural," initially unlearned (non-Intentional, though still intentional) "outward" expression of an "inner" mental state. (Symptomatically, this is the principal Wittgensteinian text that Danto is unwilling to endorse.) Wherever we *learn* to replace such natural expressiveness by a culturally fashioned form of expression, we find that we must invoke something akin to the distinctions I've already suggested. If so, then piecemeal reductionism must fail.

Danto treats Wittgenstein as a reductionist of the behaviorist sort. He treats himself as opposed to reductionism, simply because, on a technicality, artworks "exist" only by way of a rhetorical courtesy that precludes the possibility of any literal identity between artworks and material objects. Nevertheless, Danto is much closer to reductionism than Wittgenstein, because Wittgenstein does treat actions (and would treat artworks) as Intentionally qualified—discernibly so, within a public culture. (But this is hardly Wittgenstein's way of speaking.)

The corrective intuition completely precludes the nonsense question posed by those who worry Eduard Hanslick's worry:[21] namely, how a human being's psychological feelings ever inhabit a piece of music. They never do! Or, we admit them per equivocation, as by conflating primary utterance and what is thereby uttered.

This is hardly an inappropriate economy: first, because both the uttering of a song and the uttered song are Intentionally qualified (though in different ways); and because a song is heard as an indissoluble unity, not as a literal conjunction of uttering and uttered; and, finally, it's entirely reasonable, following Wittgenstein, to discern, in the rendering of a song at least on *some* occasions, perceptual grounds for construing a song as the outward expression of an inner mental state.

But if so, then it hardly follows that a song's aesthetic properties are in any way obliged to conform with a singer's "psychological intent" (the singer's contingent personal feelings, say), as strong intentionalists are likely to insist. Compare the singing of the *Marseillaise* in the streets of Paris immediately after the city's liberation in World War II and Charles Aznavour's canny command of his sentimental songs. (Think also of Sarah Bernhardt!) The mental and the cultural can never be disjoined in the arts—or in human life itself. It is for that very reason that the cultural trumps the purely mentalistic in critical and interpretive contexts.

We are never obliged to introduce a fictional voice or conceptual prosthesis in order to account for the expressive properties of artworks: there would simply be a clause too many. There is no point in insisting on these distinctions—or their normal union in song and speech—except for the familiar confusions they engender in philosophers.

Indeed, the second sense is normally more fundamental than the first, because the first (the mental) is almost always (except for newborn infants) a structure internal to the space of the second (the cultural)—a distinction usually overlooked or reductively suppressed

by the partisans of intentionalism. The expression of psychological intention paradigmatically shares the culturally expressive features of intentional (or, better: Intentional) meaning or significative structure (in the second sense supplied) and is therefore inseparable from it.

Artworks are sui generis in the same sense in which human selves are selves: they *are* what only human selves *can* utter. Detached from their original (or originating) occasions, they sometimes mislead our theories, as when we say that artworks are no more than marks or inert matter—canvases covered with paint hung in a museum, ink-marks on a piece of paper—without regard to the encultured motivation that creates them in the first place[22] and that, in creating them, publicly transforms sound into song and paint into picture.

That something of this sort is true is clear enough from speech itself. For in hearing what another says, we often hear what we understand, without being at all clear in a comparably fine-grained way about the actual sounds the other speaker utters. This would make no sense *if* poetry were (say) mere sound to which we impute (from other sources) meanings or Intentional structures. Notice, by the way, that the "new" intentionalists *must mean* to treat the physical "configuration" of artworks (Levinson's slippery term) *intentionally* (that is, according to Levinson, mentalistically); but then the actual process of understanding speech belies the thesis.

I resist the temptation to air here the full difference between physical and cultural nature. I trust it will be enough for my purpose to take note of the fact that the piecemeal reductionist "recovers" an artist's psychological or mentalistic intentions *relationally*—that is, in ways that (on the strength of his theory) are *external* to a particular physical utterance, which, in turn, is duly qualified (by those same intentions) so that *it* functions *as* a "physical-object-viewed-as-an-artwork." The idea is that the Intentional features of the original uttering (the artist's craft effort) are *not themselves first* recovered from an analysis of the artwork uttered! (Or indeed from the artist's public

craft.) But how is that possible if inner mental states are in need of outward criteria or manifestations?

It's entirely possible that the "piecemeal" strategy is an overreaction to something close to Hanslick's worry. I doubt it; but if it is, it's hardly more than one extravagance answering another. The decisive consideration is that Intentional properties are intrinsic to artworks, speech, actions, histories, and similar things, and are completely absent (except by courtesy) from physical things.

For the moment, however, the most strategic consideration to keep in mind is this: the piecemeal reductionist wishes to eliminate Intentional (and intentional) attributes from our philosophical and critical characterization of actual or public artworks, so that *they* (paintings and music, say) may remain "mere physical things." That is, we are expected to deny that artworks actually possess such attributes objectively and intrinsically; hence, they must be (and are) restored relationally (if possible at all)—that is, externally!

The boldest of the piecemeal cohort affirm that this holds true of painting and music, but they are pretty well obliged to make an exception for literature. Normally they don't deny that our understanding of artworks requires a rich range of Intentional distinctions. So they assign them to the psychological life of artists and audiences, including (somehow, mentalistically) the intentionally informed craft abilities of artists and the critical abilities of those who genuinely appreciate the arts. (The saving idea, I suppose, is that the mentalistic *can* "always" be independently reduced in physicalist terms.)

A successful attack on intentionalism, therefore, would seriously undermine the conceptual resources of reductionism as well. The reductionist's strategy, we may say, is bent on subsuming as much of the public world as materialism can support, in order to obviate worries like Hanslick's; at the same time, it keeps in reserve whatever Intentional attributes may be needed for description, interpretation, and appreciation, without compromising the materialist nature of actual

artworks (where artworks are taken to be real). There's the point of the metaphysical difference between Danto and Levinson. Hence, it infects the mental life of artists and audiences at the cost of diminishing the independent reality of the world of human culture. A nice trick but an unlikely one: it requires a version of methodological dualism that can do no more than masquerade as a form of materialism, however inadequate it must be.[23]

INTERLUDE

A GLANCE AT REDUCTIONISM

IN THE PHILOSOPHY OF MIND

I must venture a little beyond the boundaries of the piecemeal strategy I've been tracing. It remains my primary concern, of course, and the full story's hardly finished. But surely, its fluencies, its characteristic confidence, even its daring at times, a certain noticeable absence of hesitation in advancing its profoundly contested options betoken a reliance on congenial speculations in some wider conceptual ecology. I find the external affinities particularly well developed in the strong forms of reductionism favored among the analytic philosophies of mind produced in the last four decades of the twentieth century. The lag time is entirely plausible, and aesthetics and the philosophy of mind obviously come together in the analysis of Intentional (and intentional) phenomena. The pioneer inquiries of the piecemeal theorists follow, by a decade or two, the reductionist paradigms fashioned by W. V. Quine and Wilfrid Sellars, both of whose conceptual strategies have (as already remarked) been influenced (but hardly discouraged) by the fate of the Vienna Circle.

The piecemeal reductionists sensed the nerve of their incipient movement in a distinctly informal and unmarked way: it has never had any of the flair or zeal of the thirties or the sixties, but it knows its calling and its best strategies. The movement reached a sort of critical mass only a few decades ago. It arrived, I would say, when extreme reductionisms, even eliminativisms (which were impossible to apply directly to the analysis of painting, music, and literature) became commonplace options in English-language philosophy. It is in fact hard to imagine how the piecemeal movement (in the philosophy of art) could ever have prospered otherwise, though discussions of reductionism proper rarely speak of the contribution of the "new" aestheticians. It's an extraordinary fact that the most daring proposals of the aestheticians seem so unproblematic now.

You begin to see how a brief aside into the reductionisms of a larger philosophical sort might actually help us mount a fair appraisal of the distinctive work of the piecemeal analysts. In fact, the detour should yield a more rounded sense, dialectically, of the conceptual milieu in which the piecemeal crowd has managed to market its now-familiar mix of daring and partisan confidence without laboring over its philosophical genealogy. Its usual style is entirely matter-of-fact—deadpan, I'd say; it draws almost no attention to its improbable economies. Where then does its assurance come from? It must have condensed from the "reflected glories" of a once-grander philosophy of mind. It has few distinctive arguments of its own. We must consider the importance of Walton's and Danto's having straddled topics (in a perfectly natural way) that belong to aesthetics, the theory of mind and action, the analysis of perception, and the deeper puzzles of the ontological difference between nature and culture.

By the time the generation following Danto's best work had begun to produce its own output (for instance, among such more recent figures as Levinson, Carroll, Currie, Stecker, and even younger adherents), the larger idiom had already confirmed its bona fides in

English-language philosophy. Now, of course, confidence is falling off again (among philosophers of *mind*) and may yet place both movements in a decidedly exposed position. There's a skeptical mistrust gathering among the best analytic philosophers of mind: they are no longer securely persuaded that "consciousness"—hence, also, "persons" and their encultured and enlanguaged capacities, or, indeed, Intentional phenomena in general (whether mentalistic or not)—*can* be perspicuously fitted to the constraints of a robust reductionism.

The essential mind/body question (not, of course, the reductive literature) has changed rather little since the end of the eighteenth century and the start of the nineteenth, and cannot be said to have been convincingly resolved even now, at the start of the new millennium.[1] Thus the failure of the piecemeal reductionists to address the essential topics of the more robust reductionisms that form the strenuous center of the philosophy of mind—Daniel Dennett's effort, for example—puts the entire labor of the "new" aestheticians at considerable risk: because (as I intend to show) recent philosophers of mind have not done particularly well in their efforts to resolve the deeper worries on which the fortunes of the piecemeal company finally depend.

I ask you to bear in mind that the piecemeal theories have been shown to risk incoherence and solipsism as a result of their lax strategies. They might have been spared the onus of such charges if, by proxy, the reductive accounts of mind had provided a convincing picture of (say) persons or language or culture itself. But there are no successes to record. Reductionism in the philosophy of mind fails hands down, I claim, and as a result the piecemeal company occupies a continually weakening position.

There is in fact a telltale symptom shared by the piecemeal company and the most extreme reductionists of the moment (eliminativists as well): namely, that the "defense" of their most problematic claims proceeds largely by obiter dictum rather than by engaged

debate—just those claims, in fact, that we would like to be assured are (or are not) finally viable. The practice of avoiding a frontal debate in the philosophy of mind became an effective etiquette in Quine's and Sellars's writings in the sixties[2] and yields a warning of sorts that runs from the work of the early Carnap through Quine and Sellars to Davidson and from there to figures like Dennett and Paul Churchland, who manfully try to restore a more argumentative practice. (Both Dennett and Churchland were profoundly influenced by Sellars.) From Davidson on, the laxer practice extends to Rorty and the new aestheticians (who may seem—mistakenly—to have little in common with the others).[3] I should mention as well the dwindling but hardly final extension of the unity of science movement that has perfected its reductive account of the mental most notably in the recent work of Jaegwon Kim, which is at one and the same time immensely more rigorous and more nearly convincing in its formulation than any of its piecemeal aficionados could ever have expected and yet as far from success as were the first stirrings of the unity movement some eighty-plus years ago.[4] As far as I can see, none of the "parent" reductionisms has gained an inch of philosophical turf, though their analytic skills remain daunting; indeed, on balance, they are rarely evasive in the way the piecemealers' tunneling usually is.

It wouldn't make sense, however, to take up the larger story in any depth here. But I'll risk—I must risk—a small aside, a single specimen, so to say, that I hope will strengthen my sketch of the import of the connecting themes shared by the philosophy of art and the philosophy of mind. That should help in weighing reductionism and piecemeal reductionism side by side; so that, as I hope to show, the slack practice of the second cannot be succored by the failed exertions of the first. Hands down, the best specimen texts for my purpose must be Daniel Dennett's: without a doubt, Dennett is the best-known, the most unyielding (and amusing) reductionist-eliminativist of our day. He explores in some depth a good many of the key themes

favored by a full-service reductionism, which, as it happens, the piecemeal company counts on being suitably endorsed (though they themselves never risk the labor needed).

Dennett pursues these matters so boldly and straightforwardly that when he fails to confirm (as he surely does) the viability and validity of his own solutions, there's reason to believe his efforts speak to the prospects of just about any robust reductive account of mind—a fortiori, just about any prospect of the piecemeal theories already encountered. No doubt Dennett is often too extreme. But he exposes the essential questions in a way very few others can match. I find him an ideal stalking-horse.

Even casual comparisons prove intriguing. For instance, Dennett, apparently sharing a small literature with Walton, actually develops a conception of fiction bolder than Walton's, which he applies to the analysis of persons and imaginative representation.[5] Also, in more or less the same time frame, Dennett and Danto explore the possibility of a reductive account of Wittgenstein's example (already partially aired) of the difference between a man's raising his arm and his arm's rising; both, I would say, consider a distinctly eliminativist option. Danto, as we have seen, presses the analogy between the analysis of an action and the analysis of an artwork. He seems to be saying that whatever may be the ontological fate of an "action" with respect to a "bodily movement" can be reasonably matched by the fate of an "artwork" with respect to a "mere real thing." But the verdict is murky, unsatisfactory, and trails off in a way that suggests no more than that we are faced with a choice among figurative idioms, the enabling conditions for which are nowhere aired. Elsewhere, in the "Artworld" paper, Danto had already confined the use of "is," in speaking of artworks, to the rhetorical work of the " 'is' of artistic identification": he explicitly notes that this use of "is" is entirely different from that of the more familiar "is" of numerical identity.[6] Dennett is much more explicitly an eliminativist.

Let me mention, here, some of Dennett's rather daring proposals in behalf of his sort of reductionism—his theory of consciousness and of what a self "is." Frankly, I think you will be startled by the textual linkage to Walton's account of fictionality and make-believe. I don't hold that Dennett and Walton subscribe to the same theories, of course, but Dennett does adopt a variant of Walton's theory of make-believe; perhaps it captures the nerve of the general theory after all, which Dennett applies directly and more sweepingly than Walton would to the analysis of the human self (a fortiori, to the analysis of human consciousness).

In effect, Dennett offers as a perfectly serious scientific/philosophical conjecture the hypothesis that *the brain autonomously produces a representation of the linked fictions—self and conscious mind*—that "we," who *are* the fictional artifacts *of* that representation, reflexively regard as real! Dennett goes all the way here: reductionists can do no better. Breathtaking, I admit, but also utterly arbitrary, wildly irresponsible, fatally circular, altogether indemonstrable. Perhaps even a brilliant as well as a desperate joke: transforming the utter failure of a bona fide inquiry into the smoke-and-mirrors discovery of the wildest conceivable solution, the perfect triumph of the emperor's-clothes era. You remember: I've been arguing that what's "piecemeal" about the piecemeal theories is that they suppose (without argument) that the mental life of creative artists and appreciative audiences *can* in principle be reductively managed. If not, the entire piecemeal company must be cheating! Dennett has shown us what the piecemeal theories require *if* we're ever to "save" the full range and detail of the entire human world of cultural and mental life—consistently with eliminativism or (by a larger charity) reductionism.

The trouble is, Dennett's theory is preposterous. It's as much the wave of a privileged hand as we've found in the best of the piecemeal company: as, for instance, in Danto's ingenious materialist "rhetoric" applied to actions and artworks. It can't possibly succeed; it begs the

essential questions. But it's definitely a grand guess at what would be needed—or a stopgap measure to gain some time—if the piecemeal theorists could find their way back to a full-service reductionism.

Now then, consider this passage from Dennett's *Consciousness Explained*, which offers a small sketch of his "final" theory:

> The philosopher Kendall Walton and the psychologist Nicholas Humphrey have shown from different perspectives the importance of make-believe in providing practice for human beings who are novice self-spinners [that is, *are* the unified fictions of "their" own brain's *fictional* representation of a conscious self].
>
> Thus do we build up a defining story about ourselves, organized around a sort of basic blip of self-representation. The blip isn't a self, of course. It's a representation of a self (and the blip on the radar screen for Ellis Island isn't an island—it's a representation of an island). What makes the blip the me-blip and another blip just a he- or she- or it-blip is not what it looks like, but what it is used for. It gathers and organizes the information on the topic of me in the same way other structures in my brain keep track of information on Boston, or Reagan, or ice cream.
>
> And where is the thing your self-representation is about? It is wherever you are. And what is this thing? Nothing more than, and nothing less than, your center of narrative gravity.[7]

Stunning, don't you agree? But of course it won't do at all. Because to make the proposal actually work, empirically or otherwise, you have to be able to show (tag this item (1) for the moment) just how the brain does work, which Dennett describes in such a way that whatever is rightly taken to be the work of the brain must be cast in extensional terms (and made to include the projected representa-

tion of the powers of a conscious self). You must be able to account *in* extensionalist terms for the Intentional complexities of the projected model: in terms, say, of information processed neurophysiologically or in some such way. Otherwise, as we shall see, the entire undertaking cannot but collapse.

Dennett would have us believe that the brain invents a fully formed Intentional representation (a *fiction*) that the fictional artifacts of *that* same representational schema—in effect, "ourselves" (the "conscious" reflex of that neuronal process)—then directly "report" as perceived or experienced, or as open thereupon to whatever culturally familiar descriptive, explanatory, or appreciative assertions we care to affirm. Furthermore, in satisfying (1), we also "act" in a way (2) to validate (in evidentiary terms) the disjunction between *reality and fiction*. Nevertheless, Dennett repeatedly fails to vindicate (1), and he has never attempted to validate (2). It's not even clear that (2) is a coherent possibility on Dennett's account of (1). I think it is an incoherent provision: it invokes a vestigial intentionalism.

Let me add here, out of the blue, that I don't believe Walton supports anything like Dennett's theory of mind or consciousness. I don't think Danto does either, but Danto's analogy between the analysis of action and the analysis of artworks and his account of perception and history are sufficiently at odds with one another that it's not in the least clear that he *can* consistently reject Dennett's treatment of mind as a fiction.

Dennett fails us here: first of all, he nowhere accounts for the fluency and seeming perspicuousness of the "fictive" or "representational" vocabulary; second, he nowhere shows us how, *in principle*, the Intentional idiom could possibly be derived from any brain-level extensionalist schema, unless he already has the evidence that a suitable paraphrastic program could indeed be provided. Here Dennett's failure strikes at the deepest conditions on which both the reductive philosophy of mind and the piecemeal analysis of the art world depend.

These are much more than promissory notes, but they must be made to answer for their promised counterarguments against the detractors of the piecemeal strategy. Actually, I raise several distinct objections to Dennett's attempt to surmount the first barrier—identified as item (1) above. (I draw these from Dennett's texts.) No one, to my knowledge, has ever made the slightest progress in meeting the challenge of item (2).[8] In any case, a demonstration of the inadequacy of Dennett's maneuvers (which has still to be undertaken) would indicate much more than the weakness of his own proposals; it would illustrate just how difficult it is to produce a full-fledged reductionism of the mind or, indeed, a defense of the piecemeal liberties we've been considering. Also, in my opinion, it would show the way to the simplest and most reasonable solution! Let's have a look.

In *Consciousness Explained*—surely the most ramified version of his reductive thesis—Dennett attempts to account for the functional unity of the self and the self's seeming to be the unitary seat of consciousness and rationality. Dennett's perfectly aware, of course, that if he assigns the "self" or its functions, characterized in the usual Intentional (or intentional) way, to the brain, he will be accused of being another champion of the "Cartesian theatre," which, on his analysis, is the *Ur*-version of every dualist view he opposes. He also realizes that he can gain no conceptual advantage if he merely spreads the "unified" functions of the self or mind over any number of discrete subfunctional functions (of the unified "mind") housed in the discrete neural events of the same brain: the "molar" unity of the self (or consciousness) would still have to be matched with a picture of how perception and experience and thought contribute to our being able to pursue such (molar) functions as that of testing the realist standing of our beliefs. (You cannot fail to see the pertinent analogy to the work of the piecemeal theorists.)

Ultimately, Dennett opts for a rather uneasy solution. He wishes to salvage the "personal," or intentionalist, *idiom* of mind and self, though he construes the self as no more than a grand fiction of some

sort. He ascribes the subfunctions of the functioning "parts" of the conscious self to the pertinent "subpersonal" neural events of the brain—by the deliberate use of (what he calls) "multiple drafts" (or passing interpretations) of our continually revised accounts of the would-be narratized unity of the mind's operations—since consciousness and Intentionality cannot rightly be located at any purely physical level of activity. Dennett therefore rejects the identity of mind and body—just as Danto does: for Intentional descriptions cannot literally apply at the level of neural processes.

But then Dennett is also obliged to avoid specifying, *at the neural or subpersonal level*, the Intentional (fictional) unity of the mind itself. It cannot be permitted to play an actual role of any kind: it's nothing but a fiction! Hence, at the neural level of analysis and through all merely neuronal hierarchies (however relationally defined their various roles in the Intentional narrative of the mind may happen to be), there is literally nothing to discover *but a riot of neuronal discharges* that we may treat figuratively as "vying" for the effective direction of other neuronal processes in the brain. Dennett dubs this the workings of the "Joycean machine"—a sort of would-be analogue of James Joyce's stream of consciousness, but now without consciousness itself. (Literally: a stream of neural discharges.) The neural machine, you see, is altogether physical and is thus deprived of any consciousness at all. Consciousness is eliminated, not reduced. This is probably the weakest part of Dennett's model, since it makes a complete mystery of the seeming effectiveness and unity of the Intentionalist alternative.

But you cannot admit consciousness *here* if you refuse to admit mind/body identity; and mind/body identity fails if Intentionality cannot be effectively reduced. Also let it be said that we need to be wary of confirming "consciousness" in its abstract form. (That was David Chalmers's fatal weakness, if you recall.[9]) We need only "recover" the functional effectiveness of reportable perception and thought and the like—that is, what we ordinarily acknowledge (how-

ever insufficiently analyzed) in, for instance, viewing a Vermeer interior or listening to a Bach fugue.

Dennett likens the mind to the possibilities of some form of computational software instantiated in the brain: he means, for instance, that the discrete submolar functions of our brain's software convey piecemeal instructions (perhaps by PDP, "parallel distributed processing") linking information from (say) perceptual sources to speech outputs; but at the level of the "Joycean machine," there's nothing but a random play of discharges (a figurative free-for-all for higher hegemonic "success") among neuronal "competitors" that cannot in principle be programmed to yield the higher functions of an executive self. The idea is ruled out at the very start.

There are at least two difficulties here. For one, the "language" of the "content" of the homuncular events (the play of the "Joycean machine," without consciousness) must be able to account (reductively) for whatever finally appears at the conscious and Intentional level; this problem is never solved. The other difficulty involves the contest among the "demons" (Dennett's term) of the Joycean scatter, which must nevertheless be able to come together often enough (and for good reasons) to account for the seeming fluency and unity of our "folk-theoretic" descriptions; Dennett never addresses this question directly.

Here, now, is a piece of supporting text drawn from Dennett's own account:

> There is competition among many concurrent contentful events in the brain, and a select subset of such events "win." That is, they manage to spawn continuing effects of various sorts. Some, uniting with language-demons, contribute to subsequent sayings, both sayings-aloud to others and silent (and out-loud) sayings to oneself. . . . Consciousness is supposedly something mighty special. What is so special about having advanced to the next round in such a cycle of self-stimulation? . . .

I have avoided claiming that any particular sort of victory in this competitive whirl amounts to elevation in consciousness. Indeed, I have insisted that there is no motivated way to draw a line dividing the events that are definitely "in" consciousness from the events that stay forever "outside" or "beneath" consciousness.[10]

Certainly this shows that the model has, on its face, absolutely no determinate bearing on the actual reduction of the Intentional features of mental and cultural life—including, of course, the activities of creating and understanding the arts. In effect, Dennett promises to deliver a full reduction of (what I call) Intentionality—on the way to his eliminativism—but does not actually do so. Furthermore, the piecemeal theorist means to benefit from the promise of some such effort, but nothing is ever provided that we could actually draw on. Once the limitation of Dennett's program is made clear, it's but a step to demonstrating why, in particular, his strategies of analysis, which are meant to lead us (through a successful reduction of the Intentional idiom) to a thoroughly extensional language, fail utterly: for the very idea of discovering the *right* extensional vocabulary demands the *realist* standing of the Intentional *idiom* itself (as opposed to what it putatively represents). Dennett refuses any such maneuver and thus subverts his own eliminativism. But he fails to save the reductionism as well.

I can now put Dennett's proposal in a single line: he holds—he's always held, from the publication of *Content and Consciousness* in 1969 to the appearance of *Consciousness Explained* in 1991 (and well beyond)—that the mind/body problem can be solved only and adequately by way of a "centralist" (neuronal) reduction of the Intentional language of mind rather than by a "peripheralist" (behavioral) reduction; or by way of a bottom-up (physicalist) composition of the "subpersonal" processes of the brain by which we can "explain" the

top-down (Intentional, functionally holist) phenomena of the mind, without supposing identity; or, still more simply, by replacing our intentionally freighted "person-level" idiom with a thoroughly extensionalist idiom suited to a "genuine science."

The novelty of Dennett's solution lies with his dismissing mind, consciousness, and self as fictions. In this regard, he invites comparison with Walton, as I have already hinted. Nevertheless, Dennett's view bears a closer resemblance to the language and intent of Danto's "Artworld" paper. In any case, there are insuperable paradoxes and difficulties lurking here that Dennett insouciantly ignores, which, once perceived, might dampen the ardor of our piecemeal theorists as much as they must worry the champions of reductionism proper. Effectively, Dennett adds nothing in the way of resolving the stalemate Wilfrid Sellars originally sketched in "Language of Theories" (which Dennett follows).

You must consider that, for Dennett as for Sellars, the physicalist idiom suited to the natural sciences is, like the language of Intentionally qualified selves, *itself* constructed in accord with the cognitive abilities of inquiring selves: the realist presumptions of the first are inseparable from the imputed realist competences ascribed the second. We cannot admit the entirely fictional standing of the second without jeopardizing the realist standing of the first. The knockdown clue is already in our sights: just recall, please, that in his own flights of eliminativist fancy Sellars never fails to pit the "scientific *image*" against the "manifest *image*": that is, he never fails to concede that his speculation never escapes the conceptual space of the manifest image he means to replace! In a word, Sellars brings us to the edge of Dennett's conjecture about the insuperable chaos of neuronal firings, but he cannily stops at the brain's edge: no one could possibly enter the promised land.

Quite like Sellars, Dennett expects to favor a realist reading of the reductive and eliminative idiom over the Intentional by projecting

(by some unexplained approximative strategy) invariant and exceptionless fundamental laws of nature from the data of the deceptive regularities of a "person-level" science. But anything of the sort would be impossible, as we now understand matters. Because apart from the inseparability of the two idioms (implicitly conceded in Dennett's characterization of the illegible scatter of the "Joycean machine"), any putative laws of nature fitted exceptionlessly to "all possible worlds" must be tethered to no more than sample specimens that tell us *how the world appears to "us"*: they cannot possibly be more than distorted idealizations drawn from the observed regularities said to range over aggregated specimens.[11]

Beyond that, Dennett's entire strategy requires that the (top-down) analysis of our Intentional idiom yield armies of more and more "stupid" homunculi (simpler and simpler subfunctions of a holist, Intentionally qualified function, each finally confined to a single on-off operation), which, rightly assembled, fulfill all the subfunctional functions that together constitute the molar functioning of a unified self. In that case, the entire Intentional idiom could be replaced (bottom-up) by our extensional idiom confined to the neuronal level.

Splendid idea: except for the niggling fact that the top-down and bottom-up idioms are logically at loggerheads with one another, although they are also inseparable. You must remember that the functional/subfunctional idiom is thoroughly relational: subfunctional details cannot stand alone—they have their meaning only in terms of the molar functions they "are a part of." The bottom-up idiom, by contrast, is thoroughly compositional or additive—which is to say, extensional. *No* articulation of the details of the first sort of analysis could ever justify, as such, its replacement by the details of the other, though "replacements" might be countenanced by overall considerations *if* they admitted the realist standing of what the Intentional idiom describes! Dennett nowhere explores this possibility, although he's aware of it. The piecemeal theorists cannot possibly do better.

Here now are some excerpts from *Content and Consciousness* that catch up my summary in a telling way. I think they're decisive, although they do run on a bit:

> The problem of mind is not to be divorced from the problem of a person. Looking at the "phenomena of mind" can only be looking at what a *person* does, feels, thinks, experiences; minds cannot be examined as separable entities, without leading inevitably to Cartesian spirits, and an examination of *bodies* and their workings will never bring us to the subject matter of mind at all. The first step in finding solutions to the problems of mind is to set aside ontological predilections and consider instead the relation between the mode of discourse in which we speak of persons and . . . the mode of discourse in which we speak of bodies and other physical objects. The story we tell when we tell the ordinary story of a person's mental activities cannot be mapped with precision on to the extensional story of events in the person's body, nor has the ordinary story any real precision of its own. It has no precision, for when we say a person knows or believes this or that, for example, we ascribe to him no determinable, circumscribed, invariant, generalizable states, capacities, or dispositions. The personal story, moreover, has a relatively vulnerable impermanent place in our conceptual scheme, and could in principle be rendered "obsolete" if some day we ceased to *treat* anything (any mobile body or system or device) as an Intentional system—by reasoning with it, communicating with it, etc.[12]

Dennett, I would say, is obliged here to treat selves or persons as both real and fictional and, similarly, to treat the language of science as dependent on personal reportage and as separable from it. *No one*, I venture to say, has the least inkling of how this difficulty may be resolved.

If conceded, the barrier forbids the easy continuation of the piecemeal strategies: they have no moorings to claim. But then it also stalemates Dennett. For his "determinable, circumscribed, invariant, generalizable states, capacities, or dispositions" may be no more than a pipe dream (on the strength of his own argument) and in any case cannot but be projected (by one idealization or another) *from* the phenomenologically reflexive contingent data with which he himself admits we must begin. Call into question the necessity of invariant laws of nature (against Dennett as well as Sellars) and the entire speculation stands exposed for what it is.

For the sake of rounding out this aside—which has already strayed too far from our primary concern—let me add a last reference to Dennett's admirable effort to test all the possible lines of solution he's found, and then add a bit of a hint of a saving possibility that accords very neatly with the counterstrategy I've been pursuing. The last maneuver—unfortunately, too confident as well as too careless on its logical side—draws on Dennett's trust in the large resources of AI (artificial intelligence). It will be all but sufficient, I assure you, merely to cite what Dennett says, because his argument depends on an obviously fatal but understandable equivocation: AI has large pockets but they're not without holes worn through with use. It will be clear at once that the AI argument is meant to solve the seeming difficulties I've just formulated regarding the relationship between person-level and subperson-level idioms. The problem is entirely general. Here is a well-known version of Dennett's AI maneuver:

> The constraints of mechanism do not loom large for the AI researcher, for he is confident that any design he can state *clearly* can be mechanized. The operative constraint for him, then, is something like clarity, and in practice clarity is ensured for anything expressible in a programming language of some level. Anything thus expressible is clear; what about the converse?

Is anything clear thus expressible? The AI programmer believes it, but it is not something subject to proof; it is, or boils down to, some version of [Alonzo] Church's Thesis (e.g., anything computable is Turing-machine computable). But now we can see that the supposition that there might be a non-question-begging non-mechanistic psychology gets you nothing, unless accompanied by the supposition that Church's Thesis is false. For a non-question-begging psychology will be a psychology that makes no ultimate appeals to unexplained intelligence, and that condition can be reformulated as the condition that whatever functional parts a psychology breaks its subjects into, the smallest, or most fundamental, or least sophisticated parts must not be supposed to perform tasks or follow procedures requiring intelligence. That condition in turn is surely strong enough to ensure that any procedure admissible as an "ultimate" procedure in a psychological theory falls well within the intuitive boundaries of the "computable" or "effective" as these terms are presumed to be used in Church's Thesis.[13]

I've taken the liberty of citing the full passage, because Dennett goes wrong in a way that might be easily missed in a briefer excerpt *and* because it's the linchpin of all reductive and piecemeal strategies.

Dennett means of course that the strategies I've already cited from *Content and Consciousness* and *Consciousness Explained* must surely meet Church's constraints. But he's mistaken. The *clarity* of both of the accounts mentioned *is not of the right kind!*[14] Certainly, neither advances an algorithmic formula that is "effective" as it now stands— though, I freely admit, it looks forward to yielding such an algorithm in the future. (Dennett has never produced even the homuncular "reduction" of the Intentional idiom.) The problems I've already cited disallow Dennett's claim at the get-go. The telltale clue lies in

Dennett's own confidence that *anything* "clear in conception" (or clear in the way he himself favors) *is* bound to be clear enough to satisfy Church's Thesis. But that's a non sequitur. Without it, however, we have no reason to suppose that the Intentional idiom *is* expendable, *is* the "vehicle" of the architecture of a fiction. (Besides: if it were really true, then Dennett would have provided his own nemesis—I mean Descartes—with an invulnerable stalemate against his own position.)

I've given the reductive option as full an inning as I can afford. I think it's true that the fates of the philosophy of mind and of the philosophy of art are inseparable. The reason should be clear by now: the analysis of both art and mind must fall within the hybrid complexities of the analysis of the cultural world itself. The verdict compels us to admit that the theory of science is itself a subspecialty within the space of the theory of culture. If then we admit further that the very idea of objective knowledge is a construction developed within the history of human thought and experience, we see at once the unlikelihood (the "impossibility," we may as well say) of ever exiting from the constituting powers of encultured life. To read matters this way is, first of all, to join the labors of the philosophy of art and the philosophy of mind with the single most important pivot of "modern" modern philosophy: namely, the implied contest between the Kantian and Hegelian accounts of the construction of knowledge itself; and, second, to grasp the sense in which the natural sciences are, finally, human sciences. In this sense, the work of the philosophy of art sets what appear to be insuperable conditions on the admirable work of the philosophy of science. There's a reversal for you.[15]

But if my arguments against Dennett apply (without essential adjustment) to just about any reductive account of the mind, then the piecemeal theorists had better look to their own assumptions. They are, as I've suggested, open to a serious charge of incoherence and

solipsism. The best work in the philosophy of mind might have spared them the need for a separate brief. But that's no longer possible.

Within the span of canonical analytic philosophies of mind, this would be the proper place to stop: that is, to admit that the reductionist project has not yet succeeded. But it's essential to my own argument to acknowledge that reductionism (a fortiori, its piecemeal progeny) has taken a wrong turn. This is not the place to launch a full account of a completely neglected alternative option that stares you in the face. But I think we can afford a moment more to provide a proper sense of how the counterargument might go.

Apart from the eliminativist alternative that theorists like Sellars and Dennett seem incapable of capturing, apart from the failure of reductionism and the supposedly irenic concession to the "hard problem of consciousness" that we find in the efforts of theorists like Kim and Chalmers, apart from the scandal of dualism running from Descartes to Kim and the piecemeal theorists, we must remind ourselves of the extraordinary failure of the best eighteenth-century efforts to sketch an account of what it is to be a person or self that in effect anticipates by more than two hundred years the argumentative collapse I've just been tracking in Dennett's very up-to-date reflections. Hume, you remember, quite correctly confessed his inability to discern any empiric "impression" or "idea" of the self; and Kant, introducing us to the conceptual marvels of his transcendental system, pauses as if nonplused (at §16 of the first *Critique*) to mention that—oh yes—there must be a self (an "*ich denke*") to accompany the specification of the necessary features of the closed system of categories by which the sciences achieve their familiar impressive gains.

The trouble is, Kant can grant this ego no determinate powers (though it must have some) if he is to avoid the paralogisms that such a concession might invite; and he cannot say what justifies the admission of the ego in the first place. All sanguine efforts to recover

the self—from, say, Thomas Reid and Hegel to what we may call the hermeneutic tradition—offer very little in the way of a philosophical rationale beyond reaffirming the difficulty (or impossibility) of pursuing any inquiry without conceding a suitably ramified account of the self. I suggest that, beginning with Darwin's *Origin of Species* (1859) and threading our way to the present time, entirely new possibilities have surfaced compellingly: they make no sense without the Darwinian discovery, but, although they require an evolutionary narrative, they are not primarily Darwinian even there.

I invoke two initial orienting insights here: the first, Marjorie Grene's splendid phrasing (which she shares with Helmuth Plessner) that the human being is a "natural artifact"—the creature that spans the career of *Homo sapiens* and its second-natured, hybrid, artifactual transformation (as I would put the matter, though she might not in quite the same way) by internalizing the technologies of language and the practical skills an evolving society continually amasses;[16] the second, the honest concession, acknowledged by the neo-Darwinian Richard Dawkins, that the processes of cultural transmission and evolution cannot be captured by the Darwinian model (which goes contrary to the spirit of Dennett's Darwinism).[17]

Once you have this much in place, then if you admit that one of the defining distinctions of *Homo sapiens* (very probably of Neanderthal man as well, who nevertheless, rather mysteriously, became extinct) is the capacity to invent and master a true language, and if you admit that the *evolution* of primate communication, leading up to but not quite capturing true speech and language, must have required a very long interval matching the appearance of prehuman, hominid, possibly even very early human species not yet capable of more than an incipient crossing into language proper (and whatever cultural powers that makes possible), then, on a favorable reading of the continuum of primate and human intelligence and communication, what we call the self may well be an emergent, functional artifact of

the ability of the infant members of the species to acquire, through their primate abilities, a mastery of the evolving language of their own societies of apt selves. If you allow this much, then the self must evolve artifactually, more-or-less by analogy with the well-known maxim "ontogeny recapitulates phylogeny"—except that the developmental model (fitted to the individual members of *Homo sapiens*) and the evolutionary model (fitted to the full society of mature selves) cannot be Darwinian, although it presupposes Darwinian evolution.[18]

For present purposes, I'm interested in little more than setting this late hypothesis before you as the thoroughly reasonable and viable option that it is. How could it have been overlooked for most of the hundred and fifty years that have passed since the publication of *The Origin of Species?* It outflanks at a stroke all the hopeless contortions and embarrassments of the empiricist, transcendentalist, eliminativist, reductionist, dualist, and similar theories of the self that have cluttered our inquiries. Its principal advantage rests in the immense flexibility and variability of the historicized powers of human utterance, matching whatever we are led to posit as the cultural artifacts of the various evolving and intercommunicating local societies that we encounter. It strengthens the primacy of the public standing of our encultured world and it vouchsafes the general legibility of language, history, the arts, the mind, traditions, technologies, and the like in terms of the matched duality of agents' utterances and what, accordingly, is uttered.

In short, it leaves the piecemeal reductionists completely outflanked, with absolutely no gains to trumpet over the resources of the new option. It also makes clear that the stalemates achieved by Sellars's and Dennett's extreme proposals are hardly more than the result of failing to consider the thoroughly artifactual emergence of the self—which, of course, could never be reconciled with the scientism Sellars and Dennett favor. There can be little doubt that to

admit the new possibility would change in a deep way our picture of the natural and human sciences and the link between the arts and sciences in general. But these are matters for another occasion.

The conclusion to be drawn is breathtakingly simple, for all the labor that was needed: there is no prior reason to permit the piecemeal theorists to draw on the supposed coherence of their own dualisms (or the failed labors of their philosophical uncles) in order to unite the materialist account of artworks and the mentalistic account of whatever Intentional properties are imputed to artworks. They've lost their moorings. They have an essential premise still to earn— which they cannot possibly gain.

CHAPTER 3

BEARDSLEY AND THE INTENTIONALISTS

Words cannot be mere sounds to which we attach meanings by external means. For if they were, the very fluency of speech would suddenly become problematic, caught up in an infinite regress: perhaps then—construed as an action (or "utterance")—assigned (paradoxically) to mere physical movements.[1] If we yield there, we then would have to ask ourselves: Well, assigned by whom? There's a greater regress there that we must surely avoid: we could never overtake the paradox of our own identity as selves! The cultural world cannot be the mere effect of any interpretive or self-referential or rhetorical flourish applied externally to the things of the physical world or, worse, projected as a fictive description by the brain itself "reflecting" on its own mode of functioning.[2] But if we must retreat from the "piecemeal" view of conversation and the literary arts, how could we hold the line effectively among the other arts by bifurcating our account of the Intentional complexities of poetry and painting?

To hear speech directly or a singing voice, or to see a painting or an actual deed, already implicates what we acknowledge in admitting that we are selves. Just as in Rousseau's joke, we cannot enter into a contract to speak a language for the first time! We need a proper sense of how paintings and music and literature persist apart from the informed uptake of an interested audience; otherwise, it would make no sense to speak of an objective account—an analysis or interpretation or appreciation—of the artwork before us. An unread novel remains an unread novel, not a set of physical marks and not an intermittent object brought to "existence" only when read.

Art exists, I say, in and only in our encultured world. But that much is already true of selves as well. To treat the Intentional structures of artworks as externally imposed ("externalist") attributes applied to mere physical things is, effectively, to erase ourselves! No one can escape the verdict. When, therefore, Arthur Danto says (echoing his "Artworld" paper): "that there should exist indiscernible artworks—indiscernible at least with respect to anything the eye can determine—has been evident from the array of red squares [Danto's well-known thought-experiment] with which we began this discussion [that is, his own, on transfiguration],"[3] he piles paradox on top of paradox. For one thing, he means that whatever is said to be perceptually distinctive of particular artworks (paintings) cannot be discerned at all in any merely visual way: we cannot see a Vermeer interior or Warhol's Brillo Box in the way in which (apparently) we can see a camel or a snow shovel or (?) a chromosome. Here, *The Transfiguration of the Commonplace* supports a doctrine weaker than that of the "Artworld" paper, although the two doctrines are finally inseparable. Furthermore, Danto never actually explains why we should *ever* say that artworks exist (paintings, for example) if, qua art, they cannot be initially thus discerned, or if their perceptual properties cannot be admitted except dependently, only after we agree (more-or-less on the "Artworld" paper's grounds) to permit

certain phenomenally perceivable properties of given physical objects to count as the perceivable (Intentional) properties of the paintings in question. Notoriously, Danto treats human actions similarly. He draws us in the direction of a straightforward materialism, but (as far as I know) he never actually commits us to any corresponding form of realism. In fact, in the "Artworld" paper he avoids any realist talk of artworks. This seems to be true of *Transfiguration* as well, although the realist reading is noticeably strengthened in his later work—and then, disconcertingly, read back into *Transfiguration*.

I have by these small reflections obliquely approached, I suppose, the splendid pioneer efforts and flawed propensities of one of the most important originators of twentieth-century philosophy of art, Monroe Beardsley, who single-handedly regularized almost the entire conceptual sweep of analytic aesthetics.[4] What, however, is so distinctive and troubling about Beardsley's achievement is that although he was obviously very well informed about the arts and criticism in the arts, he believed he had no need to formulate a metaphysics or epistemology of art of any kind. He never pursued the difference between physical nature and human culture (though he was aware of it), and he never ventured any systematic distinction between artworks and physical things that might be compared with Danto's master theme. He supposed he could always rely on the rigors of ordinary discourse applied without exception to the mixed things of our familiar world. So he cannot be said to have actually favored reductionism in the same way the recent intentionalists have. He's a much milder figure philosophically, temperamentally inclined toward a scientism more in favor of a formal account of truth than of a reductionist treatment of the public world. Nevertheless, he unwittingly gives aid and comfort to the new intentionalists since, in their reversing Beardsley's anti-intentionalism in interpretive contexts, the piecemeal theorists manage to separate the metaphysics of intentions from the metaphysics of artworks. As I

say, the piecemealers are dualists, but Beardsley is certainly not a dualist.

By opposing intentionalism (in his own day), Beardsley somehow motivated the very different doctrines of those who brought intentionalism back into vogue. Beardsley himself never denied the interpretable world. He found the arts in plain view, perceptible in an unproblematic way in a plain man's world, needing nothing of special invention to be analyzed or understood in advance. He wore his philosophical naiveté as a badge of honor—and with notable skill. But he ignored the complications that would force a change of direction in aesthetics. His empiricism made no explicit provision for the sui generis features of the cultural world—for the gathering need to correct the inherent inadequacy of his own proclivities when confronted by the unsecured economies of the piecemeal company. He never denied the intentional itself, although he did deny that a mentalistic account could rightly claim a criterial role in admitting artists' intentions in the description and interpretation of literature and the other arts. His intuitions were sensible enough, but his reasons were too slim.

The conceptual cracks are now in plain view: in Goodman's semiotics managed extensionally, in Danto's rhetorical warnings, in Wollheim's rejection of art-history, in the turn toward reductionism. Beardsley saw none of this clearly—saw none of this as regressive—and he had no natural immunity against such extremes. By failing to address the need for a more strenuous account of the difference between the physical and the cultural, he left the field untended and without sufficient resources to escape beyond Hume.

The subsequent union of intentionalism and piecemeal reductionism ineluctably revived (in the late twentieth century) the essential misstep of the classic retreat (of the early twentieth century) back to the paradoxes of a stubborn dualism (the Cartesian stalemate) that was unable or at least unwilling (for instance among the positivists) to risk going much beyond the conceptual resources of

the seventeenth and early eighteenth centuries! We are still in the grip of such a time warp, more than two hundred years too late.

Still, Beardsley did champion the idea that there must necessarily be a single right interpretation of a poem or other artwork—advanced apparently on logical and semantic grounds alone, without the least worry as to whether such a claim might itself prove arbitrary or question-begging or indemonstrable or simply false, or, for that matter, tantamount to a metaphysical claim Beardsley would never willingly have espoused.[5] His claim remains important and influential nevertheless, precisely because it is completely unsupported by any analysis of the logic of interpretation or of the structures of the cultural world, or indeed by any sustained comparison between physical and cultural phenomena. Beardsley's predisposition in favor of empiricism and scientism simply offers no resistance against the new forms of intentionalism and reductionism that were poised—without the need for much exertion—to coopt his own economies. The new intentionalists simply made a virtue of what Beardsley isolated as the cardinal sin of literary criticism: he insisted on preserving the public world of cultural things; they risked his gain in the service of a more fashionable, if softer, scientism.

When, for instance, he considers (what I call) the Intentional features of literature, Beardsley never invokes reductionism in a way that would match the full empiricist treatment of what to count as the objective properties of paintings; although it's also true that when he considers the visual properties of paintings, his largest generalizations tend to ignore the complexities of Intentional features or fail to see any threatening paradox ranging over expression and representation.

In any case, Beardsley is a very different kind of theorist from the "intentionalists" and "piecemeal" strategists of today (Noël Carroll and Jerrold Levinson, for instance, Arthur Danto and Richard Wollheim): for they are, loosely, reductive intentionalists manqués, whereas Beardsley opposes Romantic intentionalism without op-

posing the reality of the cultural or Intentional world. The new intentionalists are characteristically inclined to favor the "single right interpretation" thesis by devices that are already reductive as far as artworks are concerned; whereas Beardsley believes that intentionalism in interpretive contexts actually threatens to subvert the objectivist option of a uniquely valid interpretation. They count on confining intentions and imputable intentional structures to the mental life and informed behavior of artists and audiences—apart from the admitted physical objects that are to be counted as art; whereas Beardsley simply turns away from metaphysics, turns instead to champion (on purely formal grounds) a strict bivalence in interpretive matters governing the arts. They venture a metaphysics; Beardsley wrongly believes he can confine his own inquiry to the methodology of criticism. Both are inclined to disjoin perception and intention, which (I would say) may well be the single most strategic clue to the essential misstep of "piecemeal" aesthetics: accordingly, both tend to construe visual perception phenomenally and bare intention mentalistically. But that itself becomes a problematic disjunction, in fact a delusion, once we admit the "constructivist" lesson Kant and Hegel share.

Beardsley offers no account at all of how we might determine the unique "meanings" of words and literary pieces—or, indeed, of where meanings are to be found. He offers nothing but sunny confidence about discerning expressive and representational structures. (The "reductionists" do no better, of course.)

The entire industry is a house of cards—viewed from either perspective—and would remain ramshackle even if some intentionalists were to allow (as some do, admitting ambiguity and equivocation) the occasional threat of an irreducible plurality of valid interpretations. Nothing of importance seems to have been risked here. We need a firm theory of cultural fluencies if we mean to secure any sort of objectivity; and we need much more than that if we hope to restrict objective readings to no more than a single right interpreta-

tion. Reductionism cannot help us—for of course the same problem arises among the physical sciences and for the same reasons.[6] Objectivity cannot be more robust than a reasonably responsible constructivism attentive to consensual tolerance and as careful about remembering our evidentiary practices and critique of same as a historicized and diverse form of life makes possible. Even this rather vague flourish signifies that Beardsley is already much too sanguine about the rigor of his own theory of interpretation. No one, I would say, has been able to mount a compelling argument to show that matters can be treated otherwise than constructively. The general conditions of knowledge and understanding are surely common ground for the entire run of human inquiry.

Beardsley *was* profoundly mistaken about the defense of bivalence: it cannot rightly ignore the (metaphysical) differences between physical nature and human culture. On his own usage, although not according to his conviction, logical and semantic analyses do indeed prove to be versions of what we usually call metaphysics—metaphysics "by other means," perhaps. The semantics of truth, Beardsley thought, must be uniform in the physical sciences, practical conversation, and the interpretation of artworks; without a doubt (he supposed), it must yield to the realist lesson drawn from the sciences themselves. But Beardsley never said why, and the claim is seriously mistaken, *if* we deem it demonstrable at all. At the very least, it's a doubtful thesis that on the one hand insists on a strong bivalence ranging over the objective interpretation of artworks and on the other avoids any independent account of the nature of artworks and physical objects. Simply put: semantics is not, and cannot be, an autonomous discipline. In that sense, a good many recent philosophers of art (intentionalists, reductionists) cannot rightly claim to have solved Beardsley's problem, even where they oppose his anti-intentionalism.

The fact is, Beardsley's strong insistence on bivalence in interpretive matters is never pertinently attentive to the perceptual or

semantic peculiarities of the data on which it would have to be tested. For their part, the "piecemeal" theorists simply match their version of reductionism and their prior perceptions of particular artworks. They are terribly vague about how to test their own pronouncements in accord with the theories they claim to favor.

Surprisingly little has changed, therefore, since Beardsley's inquiries of about thirty-five or forty years ago, as far as fundamental issues are concerned. We must still reckon with a general neglect of the culturally and historically variable structures of artworks and the cognate structures of our critical understanding of them. There is still a strong sentiment (hardly analyzed) in favor of the general adequacy of a model of conversational discourse applied to the interpretation of literature as well as of construing sensory perception as favoring empiricist or phenomenalist strategies of analysis applied to the nonliterary arts. There is still a strong conviction that objective interpretation must yield in the direction of a bivalent logic favored in the sciences, without much or anything in the way of an account of the nature and properties of artworks that might sustain such a commitment.

My sense is that pertinent policies are genuinely difficult to explain. Nevertheless, the principal differences between Beardsley and the piecemeal reductionists lie elsewhere. They believe they can strengthen their account by favoring intentionalism in the description and interpretation of artworks; whereas Beardsley believes that intentionalism is subject to all sorts of vagaries that can only subvert the reliability of interpretive practices confined to bivalent choices. You must bear in mind that the Romantic theorists (Hirsch, for instance) are also committed to the single-right-interpretation thesis.[7] It's for these reasons that Beardsley serves so well as a stalking-horse in scanning the entire run of Anglo-American philosophies of art.

Beardsley also yields an unintended corrective to certain obliquely influential reductive and dualistic tendencies: for instance, Hanslick's undeveloped worries about "musical expressiveness"[8] and H. P.

Grice's much too easy reliance on private intentions[9] in the disciplined retrieval of linguistic meaning. We see why such strategies fail, once we admit the fluent marvel of actually hearing and understanding speech: we miss, for instance, the enabling presence of a public culture, and we find that we are the victims of impossible theories. Grice goes solipsistic and Hanslick goes dualistic. Beardsley does neither, but he gives mixed and fragmentary signals, which he never unites robustly enough to bridge the differences between physical nature and human culture.

Beardsley has no difficulty in admitting a wide run of Intentional properties in discussing his inexhaustible supply of specimens. But when he theorizes, it is almost always insufficient for the purpose. He has no distinctive or developed theory of art at all; he falls back to seemingly uncontested aesthetic properties. He admits literary meanings and author's intentions, but he treats all such concessions insouciantly, almost without philosophical reflection, even where he opposes intentionalism. More disappointingly still, he never balks at invoking the entire descriptive and interpretive vocabulary of the arts, although his incipient theories of the visual and the auditory are as empiricist as he can manage. He seems bent on enriching a phenomenal vocabulary without ever addressing the deeper question of the relationship between whatever is merely phenomenal (or phenomenalist) and the phenomenologically "realist" properties he seems to admit—that is, Intentionally freighted properties of the kind the piecemeal theorists avoid.[10] None of this was lost on the hard-edge speculations of such theorists as Wollheim and Danto.

Beardsley's "propensity" apparently precludes the need for any explicit metaphysics or epistemology; all the constraints that are needed (Beardsley believes) are already accessible in the conversational habits we all invoke. But is that more than self-deception? Where do we actually *find* the right rules of meaning and truth for interpreting poetry, or the conditions of adequation between referent and attribute? Beardsley is drawn to conceptual economies

largely in accord with the unity of science program, which, however, he never explicitly defends. A similar disinclination appears among the "piecemeal" champions of their own fall-back position; but there is no bedrock that they share, and they never demonstrate the advantage of their versions of a would-be common strategy.

All this collects rather loosely a small multitude of theorists that runs from Beardsley down to the most recent self-styled Rortyans, Deweyans, Wittgensteinians, Davidsonians, Griceans, and similar-minded aestheticians of nearly every stripe, who are prepared to affirm the easy disjunction between (say) semantics and metaphysics or between semantics and epistemology, to prioritize the first over the second, and then to shun (without apparent disadvantage) all dealings with the metaphysics they actually invoke.

The larger analytic source of this false economy was already in vogue, a generation before, in the influential semantic theories offered by Donald Davidson and Michael Dummett, in whose hands metaphysics always masquerades as the empirical analysis of language;[11] although even these initiatives, which are hardly reductionist, oppose the self-deceptions of the positivists and dwell on Quine's subversive simplifications of Carnap's strategies and the import of Wittgenstein's annoyance with Bertrand Russell's Fregean sympathies.

Metaphysics, you realize, is not a "facultative" competence of any kind—nothing that could justifiably have been the proper object of Aristotle's *nous* or the privileged discoveries Kant assigns to transcendental reason. "Metaphysics" is no more than a conceptual convenience, a reckoning of how to bring order to whatever kinds of things we claim to discern in the real world without false privilege. It cannot be independent of semantics, nor semantics of it. It's hardly an autonomous discipline any more than is logic or epistemology or methodology. Its detractors—both Dummett and Davidson, for instance—miss the point completely. Dummett prioritizes semantics

over metaphysics, and Davidson detaches the semantics of truth from any and every epistemology. The "semantics" of the intentionalists is a piece of the same deficient practice.

It's more than reasonable to refuse to treat artworks or selves as mere material things (without embracing dualism), since "cultural" or "Intentional" attributes cannot, as we now understand matters, be directly ascribed to mere physical things. But no such commitment can rest on merely semantic grounds. The systematic importance of this single distinction, which must color our account of any of the forms of understanding, perceiving, and interpreting artworks, is rightly flagged as marking a "metaphysical difference" within a holist conception of the world and our ability to know it. So that it is more than a merely factual error to insist that we should avoid all metaphysics like the plague, as Richard Rorty and certain literal-minded readers of Wittgenstein's *Investigations* have so influentially urged.[12] But the seeming primacy of semantics and the dismissal of metaphysics conspire to support a doubtful source of entirely new rigor; on my view, however, semantics is itself a "metaphysics by other means," a relatively modest constructivist discipline that collects our most reasonable prejudices about what is real and what we know and understand of what is real.

I have thus brought together in a desultory way three argumentative themes that form the general strategy of opposing what I've been calling "piecemeal reductionism," the most salient recent program of analysis applied to the fine arts. In doing so, I've marked ("at the first tier") an important weakness of reductionism in the large, as well as of the diminished options of the piecemeal variants: namely, the confusion of metaphysics and/or epistemology and would-be logical and semantic inquiries, where, as it turns out, inquiries of the second sort are little more than cryptic versions of the first. As I say, I associate this entire maneuver with the executive influence of figures like Dummett (following Frege) and Davidson (following

Quine), which effectively obscures the inadequacies of a very wide swath of analytic aesthetics. In a curious way, it also explains something of the slippage between the union of analytic epistemology and aesthetics on the one hand and Rorty's postmodernism on the other. Both obviously fail if you heed the elementary lesson that neither logic nor semantics is an autonomous discipline; each loses its modal force as soon as you admit the historicity or cultural formation of our rational and cognitive powers. Contrary to Dummett's explicit claim, there is no known way to pursue the logical or semantic analysis of natural language or scientific theory prior to and neutrally with respect to metaphysical and epistemological commitments.[13] How otherwise could we demonstrate the claim (Davidson's as well as Frege's) that natural language is—or is ideally—thoroughly extensional? You see how doubts about Beardsley's strict bivalence follow directly from such considerations.

There's the first tier's verdict, which I'm bound to say stalemates a large part of the best work of recent aesthetics—as in Beardsley and, closer to our own day, Nelson Goodman and Arthur Danto at least.[14] The second tier concerns the attempt to explain the general logic of interpretation without specific reference to the confirmed nature of the different cultural things we choose to interpret. I associate this strangely defective option with Beardsley once again—loosely, I should say, since Beardsley was negligent about the ramifications of his own theory more than he was mistaken in what he chose to defend. I find a similar defect in the more diversely motivated work of theorists like Paul Thom, Michael Krausz, Richard Shusterman, Robert Stecker, David Novitz, Stephen Davies, and a good many others, who could not possibly support their own logical and semantic claims without venturing to say precisely what they suppose interpretation answers to (metaphysically) in the real world![15] You see the inevitable reductio at the second tier, and how it dovetails with the reductio of the first. It can not be true that the analysis of an art-

work's nature is irrelevant in determining the conditions of objective interpretation.

The third tier concerns the very idea of fixing the objective meaning or Intentional structure of literary and nonliterary artworks. As earlier remarked, the leading analytic conjecture favors an intentionalist model of meaning based on the supposed paradigm of ordinary conversation. I associate this most recent strain of analytic intentionalism with the work of Noël Carroll and Jerrold Levinson particularly.[16] They are dialectically engaged with one another's options in a space of argument (in fixing meaning) larger than mere intentionalism can support. Both implicate metaphysical puzzles (which they nowhere directly analyze) and metaphysical solutions (which they nowhere explicitly defend). I must add that they are also remiss in invoking intentionalism in their accounts of linguistic meaning, as are Grice and Searle, on whom they obviously rely. They seem unaware that a mentalistic account of discursive meaning risks an insurmountable incoherence.

It's child's play to protest that, apart from the paradoxes of a strict intentionalism, a conversational model of meaning, however altered or amplified, simply lacks resources enough to address the extraordinary problems that arise in literature that depend on the methodological differences between invoking an actual speaker's intentions in the thick but transient context of a shared conversation and an artwork's Intentional structure (even where it invokes an imagined conversation). For example, in W. H. Auden's excellent poem "Musée des Beaux Arts," reference is made to Breughel's painting of Icarus falling from the sky. But determining the literal sense of the relevant line does not enter at all into the "meaning of the poem" even though it plainly engages the "meaning of the words": the remark is "meant" to be (hardly in any mentalistic sense) no more than a passing bit of acceptably pointless small talk between two men who are chatting (for other reasons) as they stroll together through an art

museum's halls. The irony of any allusive aptness in the supposed reference is hostage to the plain fact that normally a poem has no actual conversational context.

You see here how the "meaning" of the "words" and the "meaning" of the "poem" are two very different matters. Theorists favoring the conversational model (Noël Carroll, for example[17]) will have great difficulty admitting this. At best, the speech-act model is a blunderbuss strategy for capturing the sense of standard bits of discourse in notably unexceptional contexts of conversation and the like. It has absolutely no assured criterial competence when applied to literature. Certainly, it nowhere affords an analysis of the metaphysics of the intentional or Intentional structure of discursive meaning, though it's probably true that Searle, as opposed to J. L. Austin, did suppose he was gaining ground on the very nature of intentionality and, possibly, subjectivity.

For related reasons, though in a more intricate way, you may read all the perfectly straightforward sentences of Kafka's *Trial* and *Castle* as carefully as you please and still remain completely baffled as to the "meaning" of the story. I don't deny that we must understand "the written word" if we are to understand literature. But what does that now mean? The hermeneutics of literature hangs in the balance. So too must the hermeneutics of painting and music: because, although music is not a language, if sounds and marks can be semiotically transformed into uttered speech, so too can brush strokes and instrumental sounds be transformed even if they cannot be analyzed in accord with the same models of interpretation.

Here, at the third tier of my objection, it pays to press the argument in a more detailed way. It's here, closest to actual artworks, that certain neglected considerations prove decisive when applied to the entire run of what we count as the description, analysis, interpretation, understanding, appreciation, and critique of Intentional structures among artworks and other cultural referents.

For the moment, let us keep the following in mind: first, that what we find at this third stratum of inquiry is directly dependent on the first tier's finding; and, second, that there are endlessly many literary forms in which either there is no discernible authorial intent or whatever may be claimed along those lines depends, evidentiarily, on what, in nonauthorial terms, may be objectively attributed to the work itself (the artwork)—which, more often than not, trivially entails (if we wish) the author's intention.

I take these nested findings to form a proper template against the main thrust of current analytic aesthetics; so that marking them as I have counts (lightly) as a reasonable challenge to piecemeal reductionism—I would have said "counts as a reductio," if all the pertinent evidence were already in hand and if the evidence were already informed by the expectation that meaning and Intentional structure must be as problematic among the nonliterary arts as among the literary ones.

The irony remains: in countering the extreme views of the reductionists, we seem to draw closer to Beardsley; for Beardsley's "innocence" never abandons the cultural world. Beardsley endorses the objectivity of our discourse about the cultural world—endorsing the accessibility of linguistic meaning. Nevertheless, Beardsley treats the discrimination of linguistic and literary meaning and of Intentional structures in music and painting very nearly as extensions of sensory perception itself. There is, in effect, no "metaphysical" account in Beardsley of the difference between the perception of physical nature and the discernment of the meaning of a poem, although of course sensory perception and understanding language are never confused.

In acknowledging Beardsley's opposition to intentionalism and his support of an objectivist view of poetic meaning, we must ask ourselves exactly where, if not within critical practice, Beardsley could possibly have marked the ground for his sanguine view of the

objectivity of interpretation. For their part, the intentionalists mean to weaken any objective or objectivist view that rests on the realist standing of the cultural world. They count instead on the completely interior, mentalistic intentions of human selves.[18] The intentionalists are not advocates of the objective standing of interior intentions: it's more nearly right to suppose that, regarding our interior life, very little can trump avowal! It was in fact Beardsley's purpose to expose the paradox of appealing in some criterial sense to private mental states in the interpretation of public literature. That's the point of the "Intentional Fallacy" piece: when we rely on the diaries and letters of authors, we are in the public domain; and there, no privilege accrues to the author, even where we speak of the author's intentions.

You have to ask yourself whether it makes more sense to confine effective "intentions" within some sort of interior psychologistic world somehow separated from the physical world that it can at times command, or admit an emergent sui generis cultural world that transforms the functional effectiveness of certain already evolved "intentional" or "mental" powers, themselves inseparably incarnate in biological materiae. The first seems preposterous and (in any case) relies on processes reductionism cannot possibly explain; the second is at least coherent, partially understood, not particularly difficult to imagine, though it is still quite poorly mapped empirically. I see no contest here.

To go this far, however, suggests a further reflection that may afford some closure for our puzzles. Consider for instance these rather unguarded, awkward remarks by Jerrold Levinson, speaking primarily of paintings:

Particular physical artworks, such as paintings, typically have subtle aesthetic properties that natural physical objects (e.g., rocks or trees) and nonartwork artifacts (e.g., chairs or pencils) do not, and that is due to both their generally more specific essential patterning and their complicated intentional-historical

governing, which brings them into an appreciatively relevant relation to the history of art and art-making. But an intentioned-and-specifically-configured physical object is still, in the important sense, a physical object; it is composed of matter, is at one place at one time, and is subject to a familiar range of causal interactions with other physical things. . . . [Al]though the identity of such an object is, as has been admitted, culturally given and determined, there is little reason to think of the object itself as occupying an ontological plane different from that which rocks and chairs inhabit. The case, however, is quite otherwise with multiply instantiable works, such as poems, preludes, or prints, which really do require another category of existent—that of a type—because such things cannot plausibly be identified with any physical objects, however complicated or qualified.[19]

I'm very glad Levinson is so straightforward here. Let me meet him in the same spirit: I begin with some preliminaries, which may encourage you to reconsider the issue with more care than it usually receives. For one thing, there's nothing about a multiply instantiable print, as far as physical properties are concerned, that would lead us to suppose that prints are not as physical as unique paintings are—if paintings are simply physical objects. (Levinson may not have read his Goodman carefully enough.) Notice that the "property" of being multiply instantiable, which, Levinson admits, *is not a physical property (if it is a property) and (accordingly) cannot be explained solely in physical terms*—even if we admit a set of artworks as possessing similar physical properties collected as Intentionally the same, that is, as "tokens-of-a-type." Levinson's mistake (here) is a completely extraneous error: *nothing* regarding the metaphysics of artworks follows in any necessary way from the convention of treating prints as "multiply instantiable." The convention is no more than a counting mechanism, not unlike that of counting a composer's works in ways that do not rely

on performances of the works independently counted; although, of course, new technologies and new practices may invite perspicuous changes in our counting conventions. Prints are indeed taken to be multiple "tokens-of-a-type" in spite of perceivable differences among a run of prints and are counted as such in virtue of their Intentional structures. They are not types tout court. There *are* no types—in any sense in which types may be thought, as with Levinson and Wollheim and Currie, to exist; and if they were admitted at all, they could never possess or manifest visual or auditory properties of any kind. Does that mean that Levinson is conceding that artworks, seeming physical objects (etchings and lithographs, after all), possess essential or defining properties that preclude their being physical objects? If so, then he's lost the argument even as he claims to have explained the matter away.

Or does he believe (as I do) that to predicate a property of a "thing," we must have good reason to believe the property and the thing in question can be "adequated" to one another ontically? For, if the concession holds for prints as well as for musical and literary artworks, then the admission of a good reason for counting prints as multiply instantiable may itself impose on us the further difficulty that such a "property" ("being multiply instantiable") may be impossible to "adequate" to a visual artwork if that artwork is taken to be a mere physical thing. Being "multiply instantiable" is a complex consideration that joins our acknowledging the Intentional structure of artworks (which already defeats any merely physicalist account of artworks as such) and the choice of one or another additional convention for regularizing our counting artworks or words or things of other kinds in some manageable way for other purposes. Levinson has obviously been misled by his own scruple.

I urge (and have urged at some length in the past—at least thirty years ago) that we should refuse to admit that there are "types" (that types exist though they be abstract entities); and that, in admitting that multiple prints of a Dürer etching (say) are indeed instances of

the same etching, we need not construe the (indissoluble) expression "token-of-a-type" to mean that types exist. We introduce the notion solely for purposes of counting what an artist may have produced. But that has nothing to do with first admitting the Intentional properties of artworks (beyond posing the need for an individuating convention). It has more to do with market and legal considerations—and alternative counting options.[20]

·It's extraordinary that Levinson has no difficulty admitting types as existent but not paintings, if paintings possess (may I say) indissolubly hybrid properties that have intrinsic Intentional import. But what does he think of Schubert's *Lieder*? Is the spoken word merely physical? Are human beings—that is, human persons, selves, gifted creatures that speak and paint and sing—no more than physical? Would persons suddenly become abstract types if we admitted that persons could be cloned? Nonsense, I say. What could possibly be the point of insisting on such a doctrine, if reductionism doesn't work at all in the art world; or if piecemeal reductionism is incoherent?

To save the ascribability of the properties we ordinarily attribute to artworks, the new intentionalists, you realize—Levinson well among the leaders of the pack—are forced to retreat to a form of solipsism if they are not to be at risk of admitting some incarnate public manifestations of actions and artworks and speech that actually possess Intentional (but thoroughly nonmentalistic) features. For if they really do possess such features, the reductionist game will be lost: paintings will then not be mere physical objects and they will not be able to be characterized as possessing nothing but physical properties. The adequation problem will nag on.

These are well-known difficulties, but they cannot be swept aside merely because they are well known. There's also more to be said that bears in a pointed way on the exchange between "actual" and "hypothetical" intentionalists—which you may find more compelling. Carroll, for instance, holds quite doggedly to "actual intentionalism," though his discussion of the arts and of our analysis and

interpretation of the arts tends to be extremely informal and entirely open in ascribing (or seeming to ascribe) Intentional properties to artworks at the same time he suggests the possibility of discounting such ascriptions as metaphorical, or as not universally applicable, or as contentious in other ways—with respect (say) to equivocations on the term "express."

In an introductory text, for instance, Carroll offers a sketch of a deductive argument that leads to a number of familiar dilemmas. His "premise 2" is particularly instructive. Carroll poses there the adequation question (without naming it as such); he says, "If artworks (and parts of artworks) possess expressive properties literally, they must be the kind of things that can bear mental properties."[21] (Premise 1 raises the question of whether such ascriptions are to be taken literally or metaphorically.) But what's important is that Carroll treats the issue of expressive properties almost entirely in "mental" (or inner mentalistic) terms. That is, he converts "expressive" properties into humanly "expressed" properties, construes the local properties of music, say, as metaphorical transforms of a living person's uttered "expression" of inner psychological states. (Here, he follows Goodman in effect.) Carroll hardly touches on the issue of whether "expressive properties" can be at once public and nonmental properties wherever they are taken to be the properties of actual artworks. It's also worth noting that Carroll yields quite generously at times in the direction of Levinson's notion of hypothetical intentionalism.

Levinson is certain that the two forms of intentionalism are very different, but he does not say exactly what the difference is. Carroll's approach is much more informal, but then he tends not to worry metaphysical issues in the pointed way that Levinson does. In any case, apart from gossip, I would say that "actual" intentionalists tend to take a decidedly mentalistic view of interpretive meaning—that is, of bringing an interpretation into accord with an artist's intentions. (Hence, perhaps, the attraction of the conversational model.) In that sense, the admission of "hypothetical" intentionalism can only mean

that the Intentional properties of artworks may rightly and objectively be attributed to them (without reference to any person's expressing himself in the mentalistic way)—hence, in a way that raises the adequation question.

Here then is the knockdown consideration. On the one hand Levinson maintains, as we have seen, a very strong physicalist account of paintings; but he also takes the actual intentionalist view of interpretation to be inadequate precisely because of its narrow mentalistic view of artists' intentions. He sees a need for a greater flexibility in interpretive contexts; he admits we must be able to conjecture about what to regard as an ampler view of an artist's intention if it is no longer confined to inner mental states but is responsive, say, to the art-historical tradition in which the artist works.

This cannot be anything but a spare and provisional yielding (akin to that of the Romantic hermeneuts) regarding a public tradition and a critical practice based on the inspection of actual artworks. I see no way in which these concessions (whether on Levinson's or Carroll's part) could make coherent sense without attributing Intentional properties directly to artworks.[22] If so, then Levinson has surely placed himself in a dilemma he cannot escape. To hold to hypothetical intentionalism, he must give up his physicalist view of paintings and other kinds of artworks (that is, his piecemeal reductionism); and if he insists on the latter (as he sometimes does), he cannot but fall back to the solipsistic and impoverishing threat of actual intentionalism. Carroll cannot escape either: he's taken what appears to be a very strong mentalistic stand. But I admit he's vaguer and more equivocal than Levinson—a matter of good sense no doubt, but a policy that is also not entirely responsive.

In fact, on one occasion in which he (that is, Levinson) reviews these issues—well before his most recent discussions, in a setting in which he admits to being drawn to a "Wittgensteinian" solution (offered by Colin Lyas)—Levinson waffles on the matter in just the way he should, although as a consequence he seems unable to bring him-

self to a resolute solution. For on his own terms, there is no solution to be had. Lyas, he notes, offers "an account of literary intentions, according to which they, like intentions in other spheres, are embodied in and through the concrete acts and situations they govern and are inseparable from them." He goes on to say:

> But I think there is a real question whether this account will do for all sorts of artistic intentions. . . . It is just not clear that all artistic intentions are displayed in or through a work itself, or even the act of producing it.[23]

I take this to be an unintended reductio—out of Levinson's own mouth. He worries the question of universal adequacy; but surely he's conceded that there must be a very sizable run of artworks in which "intentions" are "displayed in or through a work itself." This alone ensures the collapse of both intentionalism and piecemeal reductionism. For the rest, it is at least likely that Wittgenstein's well-known dictum (to the effect that inner mental states are in need of outward criteria) will confirm our escape from any reliance on the intentionalist's private or dualistic world. Unlike Wittgenstein, Levinson fails to distinguish between evidence for and "criteria" of inner mental states. I see no recovery in the offing.

CHAPTER 4

INTENTIONALISM'S PROSPECTS

Here now are two absolutely essential ground-level constraints on the metaphysics of cultural things that bear decisively on our discerning the objective meanings of literary and nonliterary artworks alike, constraints which the theorists mentioned in the prior chapter rather incautiously neglect. The first holds that the "cultural," ranging predicatively over a wide run of attributes that are not literally applicable to mere physical things and that involve meanings and Intentional structures, is, paradigmatically, *collective* in nature, that is, drawn entirely from the geistlich sources that account for the original emergence of culturally apt selves and their characteristic forms of utterance.[1] The other affirms that all such attributes are intrinsically *determinable* with regard to meaning and Intentional structure— *not* indeterminate and *not* determinate in the way physical attributes are said to be. Nevertheless, they remain open (as such) to objective interpretation. They also help to explain why we cannot "exit" from language or our encultured condition; why we cannot be the selves

we are if we are incapable of fluent communication with other similarly encultured members of our enabling society; and why questions of meaning and interpretation take a holist form (the point of the "hermeneutic circle").

These two constraints inform the entire space between the problems that confront our interpretive theories and the enabling regularities of concrete societal practices. For example, the property of instantiating a genre in the arts entails an aggregate's sharing—an aggregate of artworks—Intentional structures in a collective rather than a merely distributed way: genre properties are projected and idealized from craft practices; they are not normally separable from their aggregated exemplars in the way physical predicates tend to be. Genre distinctions are not antecedently defined abstract predicates instantiated contingently among randomly tested particulars; they are collectively manifested exemplars of an age or Geist or something of the sort. This explains why we rely on aptly customized characterizations of would-be instances (mots justes) in validating their inclusion under given genres—hence, normally, in interpretive contexts. We construe genres as capturing the open-ended, evolving spirit (Geist) of an age or practice or artform—as in speaking of the tragic, the Romantic, the cubist;[2] genres are constructed attributions intended to identify the evolving saliencies of actual historical formations (as in the arts) grasped horizontally rather than by formal definition.

In any event, if my initial constraints are conceded, they effectively identify two features of the Intentional that oblige us to admit fundamental differences between physical and cultural descriptions that cannot fail to color the logic of interpreting and understanding artworks. (They've been wantonly ignored by the "reductionists.")

They help to explain, for instance, why the recently revived analytic debates about interpretive intentionalism are almost always vacuous and irrelevant—why intentionalism was found to be indefensible more than thirty years ago and was already known to be

profoundly flawed (in its exclusively mentalistic form) by its own defenders (Schleiermacher, for instance) more than two hundred years ago. Geistlich or collective attributions cannot normally be avowed or invented by merely individual conjecture. My two constraints also explain why the logic of objective inquiry in the arts cannot be confined in the manner canonically proposed for the physical sciences (whether validly applied there or not): for instance, why the exceptionless use of a bivalent logic or the cognate use of excluded middle cannot possibly be adequate to its task—say, as formulated by theorists like Beardsley and Wollheim and Nicholas Wolterstorff;[3] or, more contentiously, why relativism and objectivity cannot easily be shown (or shown at all) to be incompatible in principle in interpretive contexts. (Here it is worth mentioning that to admit constraints on the scope of bivalence and excluded middle is not, as such, to violate the supposed principle of noncontradiction: the charge is often, however mistakenly, directed against relativistic concessions—for instance, regarding the interpretation of artworks—which, on one argument or another, may be needed to accommodate art's very nature or the historicized nature of Intentional properties. This is, indeed, part of what I mean in speaking of the "determinability" rather than the "determinacy" of Intentional attributes.)

I trust you see how very naturally—but dangerously—reductionism threatens our grasp of the sui generis complexities of the cultural world and all that it includes. It could easily promote (though it need not) a seriously diminished expectation regarding whatever part of reality exceeds the conceptual resources of what we now treat as the merely inanimate and biological order of things. In this sense, reductionism places the burden of proof on our demonstrating the sheer intelligibility of what (contestably) I claim to be irreducible to the materialist or dualist vocabularies the piecemeal company is prepared to endorse. (Think, here, of discounting Freudian psychoanalysis as a kind of psycho-babble in a pharmaceutical heaven-on-earth.)

The arguments I've been collecting may then be read as challenging the reductionist's presumption at every turn. Consider, for example, that a serious regard for the global diversity of cultural life may be inadvertently diminished by insisting on the principled adequacy of any idiom tethered primarily to the technology of information or neurophysiology or genetics or something of the sort. There's no need for blackmail complaints here, but in a world like ours there's no room for complacency either.

I trust it is becoming clear that I've been favoring a version of the Hegelian "correction" of Kantian constructivism. What this means is that once we abandon cognitive privilege and any would-be modal necessities in the actual world, once we concede that knowledge cannot be shown to form a determinately closed system in anything like the way Kant specifies in his first *Critique* (and second preface), once we regard our conceptual framework as a contingent formation within an evolving cultural history, we cannot claim in principle to have secured an "absolute" standpoint of any kind as pertinently constant for all responsible discourse. (That is, a standpoint tethered to what is actual but also reasonably in accord with what would belong to the infinite, intelligible totality of all that is actual.[4]) But if we lack an absolute standpoint, can we avoid adopting one or another form of relativism? I think not.[5]

Hegel identifies the geistlich structure of cultural description and interpretation, but he does not go on to articulate the constructive, pluralized, relativistic, and incommensurabilist possibilities of the historicized Geist of any age. Yet such possibilities are already implicated in the most daring reading of Hegel's strategy. The idea appears, for instance, in a peculiarly static way in Foucault's epistemes, though Foucault loses the very process of history in cataloguing history's amplitude! I think we must return to Hegel in order to advance beyond his own preferences of what he takes to be exemplary.

I must add a further cautionary word here against what is sometimes called Idealism or transcendentalism or right-wing Hegelian-

ism. The proper warning against too literal-minded a reading of Hegel's appeal to the Geist of an age follows what I've already said about genres: "Geist" is no more than an oversized, encompassing predicate of the collective and Intentional (open-ended and historicized) sort, certainly not the admission of any separable, autonomous—intelligent, actual, benignly monstrous—entity whose own thoughts our thoughts ineluctably instantiate. Geist—the nominalized form of the distinctive difference between the Hellenic and the Hellenistic (say), or between the Christian and the Islamic—are totalized constructions provisionally fitted to a dense array of relatively well-sorted instantiations, drawn from diverse sectors of societal life, in a way that captures the Intentional uniformity of their having been produced or created by the congruent conceptual habits and motivations of the members of some originating society. Thus (we say): we think and act as "modernists" or "postmodernists" because we are the suitably formed denizens of such an age. Stylistic and horizoned differences emerging over historical time gradually appear to be so distinctive and so coherently conjoined that we begin to discern holistic constellations of Intentional unity that we find we cannot afford to ignore. All such structures are, however, ultimately stable only for an interval, distinctly transitory: we anticipate that they will have to be revised, enlarged, deformed, altered, replaced as often as we require along whatever lines we believe will not betray their predictive and verstehende use.

To return to the main theme then: I have now mentioned four coordinate "metaphysical" constraints that bear decisively on the general contrast between physical and cultural things—a fortiori, on getting clear about the nature of artworks: one, that cultural attributes are *collective* in structure in what are variously invoked (by well-known discussants) as the geistlich and sittlich (Hegel), the lebensformlich (Wittgenstein), the gemeinschaftlich (Tönnies); a second, that such attributes are *determinable*, not determinate in the way physical properties are said to be; a third, that the cultural is *emergent* in a

sui generis way, indissolubly embodied or incarnate in the physical and biological world (that is, hybrid), not dualistic; and a fourth, that the *Intentional* features of cultural attributes are not normally ascribed in externalist or abstract ways, but are rather thought to be intrinsic or *internally* discerned in appropriate denotata (as by un mot juste)— hence, also, *irreducibly*.

Even this slim cluster of ontic distinctions shows incontrovertibly that, if reasonably confirmed, cultural things must be very different from physical things and that the description, interpretation, and explanation of artworks and other cultural things cannot possibly be reduced in terms confined to the description of the physical world.

Regarding the last two constraints, we must bear in mind that a functioning self, an agent capable of entering into a conversation or composing a poem, must already have acquired a geistlich "second nature"—that is, a share of the capabilities unique to well-formed selves (which occur nowhere else in nature) by way of internalizing, in infancy, the collective competences of one or another society's language and customs. Hence any self will be a determinate individual (determinate in number, as we say, as determinate as any physical object could be) but *not* for that reason alone determinate "in nature," predicatively.[6] Once, however, a person masters the distinctive capabilities of his home culture, his own life's activity, joined communicatively and actively to that of similarly informed others, will inevitably alter the enculturing milieu of future generations as well as the evolving capabilities *of his own future activity*. To become (to evolve into) a self (a *yo* or *ich* or *ego*) is to have acquired a second, an Intentional, artifactual nature: an aptitude for speaking and understanding a language and whatever additional Intentional processes and formations the first makes possible. We become selves in a second-natured way—transformed, metaphysically different, emergently hybrid—by internalizing, idiolectically, a collectively formed competence.

But to accomplish all this is to be subject to the flux of history, which cannot be more than interpretively determinable—whether applied to the narratives of societal life or to the Intentional structures of artworks. The fixities of intentionalism, therefore, falsify the most plausible picture of the metaphysics of cultural things. Think of Picasso's visiting Braque's studio, or Matisse's, during the heyday of his powers—partly, at least, as a discreet and gifted intellectual pirate. To admit the historicity of culture is to admit the continual change of human "nature" and the uttered world of the arts. You may glimpse here the lineaments of a plausible contrast between the characteristic methodological rigor of the natural and human sciences. Relations between the two sorts of science are even more problematic than the distinctions mentioned suggest. But I can allow myself no more than a hint here of a larger and more decisive quarrel that our opposition to the piecemeal program inevitably broaches.

The human self is a hybrid artifact: by origin, a biologically adept variant of a species-wide animal nature (*Homo sapiens*, a primate intelligence notably apt, in infancy, for acquiring self-transformative cultural powers) that severely limits the possibilities of communicative and interactive success and failure of every possible kind; and, by cultural formation and transformation, an idiolectic variant of a collective second nature or ethos, enlarged by bilingual and bicultural affinities for other human cultures (or histories or subcultures), so that individual selves are continually altered by their own and others' utterances and interventions.

Picasso's merely observing Braque at work undoubtedly shaped his own fresh intuitions, so that he left Braque's studio, even without thinking, to express a painter's instant inventions that were probably not yet formed when he entered Braque's studio—possibly not formed when he left For, both Braque's and Picasso's cubist idiolects were already first cousins within the avant-garde energies of

the then-contemporaneous forms of French painting. Their individuality was already a kind of bilingual sharing of the same collective forces that made it possible for each to learn so quickly from the other, without either's having to betray his own signature—at the same time they continually changed the evolving near-future-presents of then-contemporaneous painting. In a very real sense, they shared a common collective nature (though idiolectically), which made it possible for each to understand the other's creative work so quickly.

You see this even more clearly in the exchange between Picasso and Matisse, since their differences seem so much more striking than those between Picasso and Braque; hence also you see how ingeniously they borrow from one another. And we, attentive members of an engaged and delighted audience, discover that we can actually follow their every improvisation (*in their work*) as if we were listening to a traditional song. This literally means that a human self, a potential artist, is in principle open in a global way—through the processes of a concatenated bilingualism and biculturalism—to all the cultural resources of the world. If reductionism is ever to succeed, it must keep up with the pace of cultural innovation. But it can't.

Insistence on the "obvious" adequacy of *any* merely parochial "idiom"—the behaviorism Quine and Skinner once made so authoritative, the paraphrastic conversational modeling of poetry and Grice's implicatures—seriously risks curtailing the simplest spontaneous capacity of any one culture to understand the divergent innovations of any other. So the quarrel about reductionism has a political side we dare not ignore. Every deep understanding of a natural language requires a deep immersion in the history and customs of its people. Even Noam Chomsky now admits the mistaken assumptions of his "universal grammar." It's true he's plunged even deeper into his fantasy of an innatist mechanism. But the telltale truth is that he's effectively abandoned the decisive importance—at the level of theo-

retical description and explanation—of the empirical mastery of actual cultural materials.

The idea of a global understanding (of poetry or politics) is hardly a species of universalism. It's more a matter of collecting useful, no more than provisional methodological generalizations. One could even say, paralleling what E. O. Wilson says of the nearly endless invention of new "species" of ants, that societies of second-natured selves similarly invent new "species" of the hybrid artifacts that we are; and if that is true, then universalism is probably a delusion. (Also, of course, here, species of artifactual creatures are not "natural-kind" kinds at all.)

I should also mention in passing that I regard these reflections as providing an essential clue to the right analysis of the relationship between empirical data and the semiotized or mathematized theoretical entities and causal processes introduced at the explanatory level in the most advanced physical sciences: dawningly noted, for example, by figures like Ernst Cassirer and Pierre Duhem and Thomas Kuhn but not satisfactorily (in my opinion) by theorists like Chomsky or Bas van Fraassen (working in seemingly opposed ways) or (by extension) among aestheticians like Danto, Walton, and Wollheim. The constructivism, or *constructivist realism*, of the theoretical entities of physics *and* of the artworks and linguistic phenomena (and indeed the selves or subjects) of the world of human culture is neither fictional nor "idealist" (in the preposterous sense in which it is sometimes alleged that we ourselves effectively create the "physical world" or "natural world" our science describes and explains "verifically," say, along Kantian lines).

We do indeed construct our best *picture* of the real world according to our own lights, and we do of course produce, or "utter" (in a uniquely human way), the things of the cultural world (artworks, technologies, languages, hybrid selves). But the very idea (Kant's) that the natural world *is* the work of "transcendental Idealism" is al-

ready illicit if it entails a form of noumenalism (regarding what is "given" externally), or is no more than a misleading façon de parler.

Here we touch on the sole distinction between the epistemological and the metaphysical that a post-Kantian/post-Hegelian understanding of science could possibly sustain. The contribution of constructivism in the sciences rightly centers on the inherent limitation of any finite intelligence to come to the end of a potentially infinite and endlessly revised inquiry (informed by the evolving experience of human history). (This is Charles Peirce's profound Idealist or pragmatist—hardly "idealist"—discovery.) Epistemologically, we construct our best picture of what, objectively, we take the natural world to be like. But *that* is no license for treating the cultural world as a merely fictional or rhetorical or "interested" (that is, prejudiced) redescription of the bare physical world.

For my present purpose, I draw attention only to the unrestricted possibilities of interpretation vis-à-vis artworks, without denying the operative constraints of actual interpretive practices that function under and through historical change. So it is not a surprise that the "meaning" of an artwork, its Intentional structure, can also change and evolve. How could the reductionists possibly manage that? There's nothing in the physical world to match it, though the evolution of inanimate and animate nature remains a challenge to the supposed necessity of exceptionless laws of nature.

More to the point, if the very formation of the human self as a "second-natured" hybrid, generated from biological and cultural sources, acquires its distinctly cultural aptitudes by instantiating, ideolectically, the determinable resources of one or another historical ethos, then it becomes quite impossible to make sense of the "methodological dualism" favored by the new intentionalists (or, indeed, to confirm nomological universals in the cultural world). They could never make sense of "inner" intentions if they did not admit public practices and public genres: they defeat themselves, believing that some sort of mentalism can capture the distinctions of collective

life. But when mentalism fails, they cannot provide a raison d'être for their own labors. This argument counts against Danto and Levinson—and for the same reason. Also, of course, if reductionism fails, then the unity of science program fails—or takes an utterly different form (for instance, on the assumption that every science is a "human science").

In any event, if what I've said about intentionalism holds, then the intentionalist controversy leads directly to a reductio. All of this, I'm certain, had dawned long ago among the post-Kantian hermeneuts, whether Romantic or historicist (Schleiermacher, for instance, Gadamer, Betti, Hirsch), as well as among the English-language analysts (Wimsatt and Beardsley, for instance, the New Critics who reject intentionalism) and, per contra, the recent champions of analytic intentionalism, who have almost nothing in common with the hermeneuts.[7]

Here then, to confirm the point, is a carefully crafted definition of "authorial intent," adjusted in the direction of what has been called (by Jerrold Levinson, its chief advocate) "hypothetical intentionalism"—which, I'm afraid, risks conceptual vacuity:

> Actual utterer's intention is not what is determinative of the meaning of a literary offering or other linguistic discourse, but [is] rather such [an] intention optimally *hypothesized*, given all the resources available to us in the work's internal structure and the relevant surrounding context of creation, to a *legitimately* invoked specificity. . . . What is the scope of specific author-based contextual factors in the genesis of a literary work that are legitimately appealed to in constructing our best hypothesis of constructed meaning? The answer to this, I suggest, lies somewhere between narrowing such scope, on the one hand, to nothing more than the language and century of composition [*sic*], and widening it, on the other, so far as to encompass the expressed intentions of the author to mean

such-and-such as recorded in external sources, e.g., private diaries, taped interviews.[8]

To favor any line of argument that denies the inherently collective nature of understanding and interpreting literary texts makes a muddle of language and culture and inevitably leads to an intolerable solipsism.[9] Levinson has no conception of the inherently collective and historicized nature of a natural language: if he did, he would realize that his own formulation (just cited) was a pale imitation of a public world that all but obviates his contribution. You must bear in mind—the point is regularly slighted—that *external* evidence about an author's *interior* intentions (letters, diaries) is already *internalist* in the evidentiary (culturally pertinent) sense: both because its own Intentional import depends on textual considerations embedded in a supporting public culture and because its evidentiary relevance depends on establishing a suitable congruence between the text to be analyzed and what the "external" evidence is alleged to establish *about it*. There is never a point at which "external" evidence is "determinative" of textual meaning in a psychologistic or mentalistic way; for that would require a privileged vantage not subject in the normal way to culturally "internal" sources—solipsistic sources perhaps or, as with W. V. Quine,[10] independent behavioral criteria somehow cleverly constructed to supersede our relying on any already accessible cultural history.

It's the well-meaning eclipse of historical sensibility and of cultural immersion that needs to be corrected—in addition to our confronting the doubtful adequacy of applying a conversational model of understanding in the analysis of literature. Once you see this, you mark the confusion of "hypothetical intentionalism." The operative assumption of the conversational model is, of course, the "determinative" saliency of (external) psychological intentions—which accords very nicely with Levinson's strategy[11] but risks its seeming adequacy by ignoring the threat of conceptual incoherence. For how

can we account for the bare intelligibility of inner intentions and feelings if not (as Wittgenstein observes) in terms of the legible public space of cultural life? And where can the "meanings" of literary texts be found, except (if you allow the idiom at all) by consulting actual linguistic (and linguistically informed) practices?

You cannot fail to see that when Levinson invokes "hypothetical intentionalism," he speaks of what would otherwise be "actual" intentions (according to Carroll's formulation), now "optimally hypothesized" (as he says), once "given" pertinent information about the cultural context of those putatively independent intentions. Hence he does *not*—indeed he cannot—fail to give pride of place to mentalistic intentions even in validating his "hypothesized" adjustments. He remains therefore a natural ally of the piecemeal company. He is in effect the counterpart analyst opponent of the Romantic hermeneut (Hirsch, for instance), who, by roughly comparable (but utterly opposed) means, enlarges the critical role of the "psychological" to include genres beyond anything that might be viewed as purely "mentalistic." The hermeneuts, of course, do not mean to be dualists of any kind and certainly do not mean to privilege private or inaccessible intentions. I don't believe Levinson ever quite escapes mentalism.

Levinson is also vaguer than Hirsch about the range and order of such resources. He's a problematic "externalist" about mentalistic data; whereas the post-Hegelian Romantics and their successors (whether "Kantian" or "Hegelian," whether Hirsch or Gadamer) oppose any principled disjunction between the psychological and the cultural. Faute de mieux, the Romantics are "internalists" in the culturally pertinent sense—which, preserving coherence and consistency, *all* who support a realist sense of the cultural world must be. Levinson nowhere explains why he does not apply Intentionally freighted descriptions to artworks directly; for, of course, if he did, his own intentionalist improvement would instantly dwindle to zero!

You would have to go to the extreme lengths someone like Michael Riffaterre favors, if you wished to find a literary theorist

(admittedly, Riffaterre is more structuralist in the Francophone manner than hermeneutic) who would be willing to isolate the entire literary world from what (in the encompassing culture) he supposed was technically irrelevant to literary criticism. Even there, however, Riffaterre's maneuver cuts across the entire logical disjunction the new intentionalism insists on and introduces in its place a strict "internalism" of an utterly different sort—one that would never prioritize an author's private intentions over cultural resources.[12] (It's true, of course, that Riffaterre avoids the essential hermeneutic question of horizonally altered sensibilities. The classic forms of structuralism cannot admit historicity; witness the animus between Lévi-Strauss and Sartre.)

I think there is no way to make the new intentionalism convincing or coherent. For relevance considerations drive it to feature the executive function of externalist criteria (that is, the externalism of psychologistically private grounds); but the "optimizing" adjustments it favors (the internalism of admitting a pertinent public culture) oblige it to concede that a raw mentalism must yield to reasonable criterial idealizations by way of evidence drawn from the cultural world itself. The first resource may not be accessible at all; and in any case the second obviates the need to invoke it. Beardsley's anti-intentionalism never opposed the idea of psychological intention; it favored instead an exaggerated sense of methodological rigor, which it never validated. (Beardsley had little patience with heterodoxy.)

In effect the intentionalist quarrel deflects us from a more fundamental issue. For "internalism" in the culturally pertinent sense means no more than that interpretation must rely on what Hegel, for one, claims falls within the scope of the "geistlich."[13] Such a concession would disallow any disjunction between the psychological and the cultural (another favorite theme of Wittgenstein's). It would make no sense. So the quarrel between the intentionalists and the anti-intentionalists cannot fail to be a subsidiary question *within the space of the geistlich world itself*, relative to the articulation of objective

criticism; otherwise, it would have to be an oblique defense of the larger program I've labeled piecemeal reductionism. That *is*, in fact, the new intentionalism's ulterior purpose.

You must see how, in its deliberately careful way, "hypothetical intentionalism" avoids the essential complexities of the cultural world: how it equivocates, for instance, on the meaning of an author's intention (which it clearly submerges in the analysis of public documents and the like); how it ignores the metaphysics of artworks (which it nevertheless consults); how it pretends to approximate to some ideally adequate criteria of meaning (which it presumes to supply but never legitimates); and how it leaves the entire question of interpretive objectivity completely at sea.

Ineluctably, maneuvers of these sorts remind us of the deeper worries they wish to outflank. Put very simply: they find the flux of history intolerable, unless it can be suitably subsumed under neutral or invariant or universal or rationally idealized uniformities: Frege's ideal logic, for instance, Russell's *Principia*, the necessary propositions of Wittgenstein's *Tractatus*, Chomsky's universal grammars, Searle's speech-act rules, Grice's implicatures, Sellars's postulated nomological universals fitted to the physical sciences—Kant's transcendental a priori for that matter, possibly even Parmenides's dictum, if only the piecemeal theorists could reach that far.

The historicist replies: Yes, of course, but all such would-be invariants are no more than the endlessly replaceable posits of historicized reason itself. There's the deeper lesson of that most important phase of modern Western philosophy, the one that spans the grand work of Kant and Hegel and comes to rest in the fresh inventions of figures like Ernst Cassirer and C. I. Lewis.[14] For (faute de mieux) if you admit the flux, then every invariance or universality or necessity is a "practical" construction; and if it is, then it cannot escape Intentional complications; and if that is so, then the entire reductionist undertaking will prove pointless—will be unable to provide a pertinent (a reductive) paraphrase of critical discourse.

Reductionists regarding artworks never address this sort of challenge. Politically, universality now means global inclusion, not universal invariances of any kind. It means concatenated or serial or bicultural interpretation—the triumph of the Rosetta Stone, so to say, rather than the assurance of any Platonized or innatist module of grammar or concept. Alternatively put, the arts are part of practical life, not plausibly decipherable by way of any application of an invariant neurophysiology or syntax.

I daresay the question is as far as we can go. But it never goes deep enough to confirm the supposed "error" of adhering to the flux of history. More than that, flux and invariance have entirely different pedigrees: invariance is a rational dream that can never be securely captured in thought or experience, except by way of unearned privilege; flux, by contrast, is the plausible precondition of practical improvisation, a condition we may wish to escape but can never confirm escaping. Faute de mieux once again, the theory of art and culture naturally falls within the historical flux. Intentionalism is a stopgap measure on the way to universalism, and universalism is never very far from the imperialisms of one or another conceptual ideology. (Think, once again, of the fate of behaviorism.)

Among our theories of language, you will find the universalizing impulse more than blunted, already by the 1940s and 50s, by J. L. Austin's having done battle in a quiet way with the hegemonic application of Gottlob Frege's immensely influential analysis of what he (Austin) called "constatives": that is, asserted propositions viewed as the bearers of objective truth-values. Austin demonstrated (somewhat thinly) that there were indeed all sorts of other familiar uses of language (not even literary), especially "performatives" (and, later, "perlocutionary acts" and looser kinds of affirmations). Austin was indeed able to demonstrate—against the conviction of the positivists (A. J. Ayer among the English cohort, but also in effect John Searle, who is hardly a positivist and who passes for an Austinian, although

he favors necessary and sufficient conditions for bona fide speech acts)[15]—that his own account included varieties of discourse that were clearly meaningful without being constatives at all, without being reducible to constatives, and without being wedded to bivalent truth-values.[16]

Frege, Russell, and the Wittgenstein of the *Tractatus*—who dominate an important part of early twentieth-century Eurocentric philosophy—were all ensorcelled by the quest for a single, ideal, universally adequate language (a rationally constructed language) through which all natural languages—themselves demonstrably imperfect with respect to the unique function of providing suitable bearers of truth-values—could in principle be perspicuously replaced in whatever logical, syntactic, grammatical, and related respects might be required by the new canon's ideal objectives: presumably, then, a language suited as well to poetry and the interpretation of poetry, *if* either could be shown to be genuinely meaningful.

In my opinion, the "new" intentionalists—among philosophers of art: Noël Carroll and Jerrold Levinson—are attracted (however informally and inexplicitly) to something close to the Fregean notion of an ideal language. Carroll is much laxer than Levinson and views himself as a moderate voice between extremes; and so he is. Except that, since he also endorses some of the more tendentious doctrines (intentionalism in the strongest mentalistic terms), the would-be moderation seems less plausible than it would otherwise be. Some believe that intentionalism hardly needs a demonstration: the conversational model, they think, is a fair approximation to an ideal language—one that hardly needs to be shown to fit the close analysis of poetry and the novel.[17] But that borders on the irresponsible. Literature is too much of a motley. (Think here of Paul Celan.)

The sheer wit of Austin's unmarked exposé was barely noticed in the rush to sanitize the deliberate informality and scatter of his reminder of the inexhaustibility and general adequacy of natural

language. He was demonstrating, without explicit mention, how Frege's suspicions about the "imprecision" of everyday language simply led to the distorting glories of formal semantics when *their* would-be rules were offered in place of the "rules" of the other. It's hardly an accident that Frege and Chomsky and Jerry Fodor and Dennett and Churchland and Sellars all subscribe (in different ways) to utterly impossible models of science applied in some invariantist way to the human world; or that intentionalists like Levinson and Carroll and the piecemeal reductionists should have supposed they were following the call of science in favoring the chimeras of reductionism and scientism or the seemingly more plausible, more accessible approximations of lesser figures like Grice and Searle.

It's not unhelpful, therefore, to recall that Alfred Tarski had already candidly admitted, in a postscript to his famous paper on the concept of truth in formalized languages, that the extensionalist program he had such high hopes for had almost no sustained application among natural languages. By its unguarded honesty, Tarski's comment completely undermines Donald Davidson's supposed application of (Tarski's) "Convention T" to ordinary language.[18] Nevertheless, Davidson's attraction among analytic theorists of language and literature may very possibly have stiffened the reductionist resolve of the new intentionalism at the same time Tarski's remarks may have (finally) dissuaded Davidson from continuing with his own program of promoting extensionally idealized languages. One might even say that Davidson finally shifted his allegiance from Frege to Rorty. In any case, he and a number of his more adventurous followers were wrongly attracted for a time to the idea that his own account of natural language was somehow congenial to a Gadamerian-like hermeneutics. But the truth is, there is next to nothing in Davidson's oeuvre that could possibly sustain such a vision—which would have been, in any case, incompatible with his Tarskian avowals. In the end, for instance in "A Nice Derangement of Epitaphs," Davidson effectively abandons his own best-known theories.

Austin might have found related distortions closer to home, in the speech-act theories that mistakenly assumed his name (Searle's, for instance) but that, truth to tell, delivered him once again into Frege's hands; and of course he would have found other false universalisms among the most recent analyses of how to read and interpret literary language. The attraction of a conversational model as the most fundamental part of an analysis of the whole of natural language is a very plausible derivative theory, drawn from speech-act theories of one sort or another, of how to provide a disciplined account of the entire sprawl of language loosely sympathetic to Frege's impossible dream. Even so, it remains still to be shown that it is genuinely worth applying to literature at the level of literature's well-known linguistic liberties. Speech-act theories of language tend to favor constatives, which may well distort the analysis of literary imagination (a fortiori, critical rigor) at the very start of any reasonably open inquiry.

I find these problems implicated in Beardsley's adherence to a strict bivalence in the matter of validating interpretations of literary texts. It appears also in the work of Donald Davidson, both in his analysis of metaphor and in his unsuccessful effort to apply Tarski's scrupulous extensionalism to the unruly sprawl of natural language.[19] It appears, of course, in Searle's attempt to bring Austin's innovations back into accord with Frege's general model and, in particular, in Searle's own effort to develop a "Fregean" account of fictional language.[20] I regard these developments as part of a perfectly understandable but demonstrably unsuccessful—arguably, misguided—application (to the arts) of the general scientism that swept through Western philosophy during much of the twentieth century.[21] It has a distinctly universalistic confidence that it has never actually earned; it is also distinctly suspicious of analyses that, in pausing to distinguish carefully between physical and cultural phenomena, challenge the so-called unity of science program and the choice of physics as the paradigm of science itself. This is part of the deeper contest that

the new century must resolve. Nevertheless, it's also little more than the backdrop for our present concerns regarding intentionalism and piecemeal reductionism.

Add now two small remarks of John Searle's, who professes to follow Austin faithfully (although he remains more of a Fregean than Austin ever was), and you have the key to the premature tendency of analytic semantics to ride roughshod over cultural and historical sensibilities in the direction of some sort of globalized uniformity that treats local diversities of language as largely apparent, superficial, utterly misleading if read literally. Thus Searle claims: "Different human languages, to the extent they are intertranslatable, can be regarded as different conventional realizations of the same underlying rules"[22]— which is thoroughly Fregean, of course, but completely unsupported, a statement that simply ignores Austin's fine-grained sketch, that might even count as the (failed) semantic mate of Chomsky's would-be universal grammar (which Chomsky has now abandoned in its originally arresting form).[23] There are no compelling all-purpose translation rules for natural languages. The insistence that there must be such rules does no more than impoverish and deform the entire run of cultural interaction and understanding.

Searle also claims that fictional discourse is straightforwardly parasitic on normal illocutionary acts—in effect, on constatives:

> Reference to fictional (and also legendary, mythological, etc.) entities are not counter-examples [to his own well-known Fregean doctrine: to the effect that reference must be made to what exists—Searle's "axiom of existence"]. To make this clear we need to distinguish normal real world talk from parasitic forms of discourse, such as fiction, play acting, etc.[24]

On Searle's view, fictional uses of language are essentially uses of "fictional discourse," that is, ordinary constative acts adjusted to the executive needs of "exists in fiction." Extraordinary, except for the

nagging worry that recent literary intentionalists seem to have followed Searle, or others of his persuasion, by somewhat altered routes. But that amounts to a theorizing disaster, an impoverishing gloss on the probable resources of the arts and cultures of the world. The bare logic of "exists in fiction" has almost nothing to do with the enormous (well-nigh incalculably diverse) resources of literary language. Even the novel has *imaginative* dimensions that are not really *fictional*, although they are not constative in the realist sense either. That we depend (as we must) on what we take to be the real world hardly signifies that "fictional discourse" (more accurately and less tendentiously: "literary discourse") *is* "parasitic" on a single real-world model of constative acts (or, for that matter—thinking of recent theories of literature—parasitic on an "actual intentionalist" theory of conversation). You cannot fail to see the common conviction shared by Searle and Walton: the imaginative work of the novel and pictorial representation are insouciantly made to count (by both of these influential figures) as fiction and make-believe.

You must bear in mind that "fiction" and "imagination" have rather little in common: the first concerns an extremely limited constraint on the use of "true" in constative settings and certain novelistic analogues; the second concerns a distinct mental capacity that is not in principle restricted to the constraint the first imposes. These notions cannot be treated as if they were different species of a common genus—they do, however, provide the key to Walton's unfortunate habit of confounding them. Simply put: the imaginative is hardly limited to the imaginary. Walton misses the point.

Nearly every theory of the novel—misleadingly termed "fiction," though that usage is too deeply entrenched to be effectively replaced—tends to speak of literary imagination in binary terms: that is, speaks of our *imagining* (or visualizing) something as construing the "object" of our effort *as* fictive or real, disjunctively. But to think only in this way risks losing altogether an absolutely marvelous capacity (essential to literature), namely, the elementary ability to live

(a little) in imagination *free of ontic commitment* (pictorial or poetic), *so as not to be confined* to the disjunctive option advanced by Searle[25] and others. Its distinction is hardly more than that of being absorbed in "what is imagined," without implicating any commitment to a specifically fictive "world" or to the actual world—and, of course, its distinction never signifies our being deprived of either of those possibilities. (Imagine that!)

Generically, to imagine "a world" is not to play at "make-believe" (in Kendall Walton's sense[26]): it's more primitive, simpler, more free-wheeling and diverse, more fundamental, somewhat "closer" to what is implicated in our perceptual powers. It may indeed be the *Ur*-sense of literary imagination (it's certainly not the "imaginary"), which (by just that contrast) completely obviates the supposed paradox of the "moral function" of "fiction." Thus, to mark an Intentional *resemblance* between the imagined world of a novel and the actual world presents no paradox at all to moral reflection—and would not, even if, *subsequently, or in addition*, we conflated the imaginary and the imaginative in Searle's way (according to his so-called axiom of existence). What we would *first* imagine would *then* (and only then) be deemed to be fictive or to discount our supposing that this or that novel (somehow) affirmed or implied or presented a truth about actual persons or events or the human condition itself. Otherwise, imagination (imagined possibilities, *not* fictive or imaginary ones) entails no paradox as such. Make-believe, in Walton's sense, is inseparable from, and limited in function to, what *is* fictive; it has no bearing on what we merely "imagine" as (or when) opposed to what we merely perceive or believe true. (You see how unnecessary and avoidable the usual restrictions of the speech-act and propositional models of the fictive are when brought to bear on what, in a more neutral sense, we simply "imagine.")

In fact, once you grasp the point (which is modest enough), you realize that even affirming the fictionality of what we are able to imagine is usually extraneous to what we thus imagine! It has to do

rather with a convention for, for instance, avoiding certain legal entanglements. But why would even that be needed if what we call "fiction" were not easily assimilated to the open possibilities of the experienced world? Those philosophers of literature who construe "fiction" propositionally (as by assigning truth-values: David Lewis, for instance, following Searle) risk failing to notice the natural affinity, per imagination, among representations of the actual, the imaginative, and the specifically fictional. They risk ignoring the important fact that the *literary*—in any sense that might be central to what is intended in speaking of our aesthetic sensibilities—is *not* primarily linguistic at all, though it obviously depends on our understanding bits of language. There's a radical lesson here that sweeps away the preposterous worries of Hanslick regarding music and the hothouse concerns of the propositionalists facing the supposed paradoxes of the moral relevance of fiction.

It would be perfectly reasonable to suggest, for instance, that the power of modern cinema (hence, the power of *its* moral "function") rests with the grand liberties afforded by filmic imagination, which is no more, of course, than an analogue of novelistic or theatrical (or, more loosely, musical) imagination. The play of imagination is suppler and freer than propositional commitments. It cannot be captured by anything like the speech-act model: it's closer to nonpropositional seeing than to assertion.[27] But that already undermines the supposed aptness of applying the conversational model to the reading of literature.

We are too easily misled—as by the discursive analysis of the sentences of a novel—into thinking that we must hew to something close to Searle's "axiom of existence" or Walton's "make-believe." But if you favor instead the analysis of an imagined world made accessible by a novel or a film, you cannot fail to see that the "ontic" question may not arise at all! When, for instance, I view (drawing on a rather limited habit of movie-going) the gripping recent film, *The Constant Gardener* (based on John Le Carré's novel), the question of

choosing between a fictive world and the real world hardly need arise; for which reason also the "moral function" of literature and film is as unavoidable as it is plain. Almost anything presenting or representing an imaginable human world is, for that reason alone, completely suffused with moral significance—in much the same sense in which it is said to be "aesthetically" absorbing (whatever that may now mean). Only a penchant for an exclusively *linguistic* analysis of the novel could lead us to suppose that the moral function of literature is largely restricted to moral claims or moral truths or to overcoming the paradox of discovering moral truths in fiction! Utter nonsense, I say. Think only of this: that literature *trains* us—even if that is not its purpose—to construe the possibilities of human life in an orderly and responsible way. To admit only that is to grasp the fatuousness of our verbal scruples about fiction. The appreciation of *War and Peace*, for instance, normally does not require a close disjunction between what is historically accurate and what is added fictionally or merely imaginatively. But that's not to deny that the same disjunction is critical to an appreciation of Hochhuth's plays and Capote's *In Cold Blood*.

Construed in the free-wheeling spirit I recommend, imagination completely avoids the awkward visual and auditory puzzles produced by the intentionalists and piecemeal reductionists—for instance, regarding the public status of pictorial representation: the bane of theories like Danto's, Wollheim's, and Walton's. The entire line of reasoning that makes depiction perceptually and ontically problematic may be no more than a conceptual extravagance. (I think it is.) Imagination, in the relatively "neutral" sense I favor, is no more than a paradigmatic instantiation of what we mean when we speak of intentionality.[28] There's nothing unusual, for instance, in Vermeer's *imagining* a Dutch interior and visually depicting (painting) what he's imagined; his pictorial representations are all quite actual, whether their "intentional objects" are fictive or actual or merely imagined: Vermeer's representations are after all actually able to be *seen*. All

this, you realize, strengthens the sense in which the representation of what we (merely) imagine or visualize belongs primarily to the public world of some encompassing culture. Intentionalism and reductionism are bound to appear implausible and extravagant in this regard.

There is no single model, actual or ideal, that settles the determinate norms of discursive, narrative, conversational, fictional, dramatized, imaginative, or other potentially literary or nonliterary uses of language; and there are no reliable surface features of *sentences* that we can invoke to ensure the objective rendering of the "meaning" of any literary text or utterance. To put the point in the sparest possible way: the conversational model, which paradigmatically depends on an actual, sustained, face-to-face encounter between at least two speakers, can always be tricked in a thousand ways; so that departures from any would-be literary paradigm, which to untrained eyes and ears may seem entirely unproblematic, may completely baffle our efforts to understand particular texts along the lines of a conversational or speech-act model or of any less familiar model.[29]

Every reading or interpretation of a text is premised (however automatically) on a logically prior conjecture regarding the right way to treat the "voice" (or voices) of a given text. Normally that cannot be decided at the start of reading or by inspecting the separate *sentences* of a text, since reading literature poses the holist question (the continually invented possibilities of the "hermeneutic circle"), which implicates a search for what I'm calling the imagined voice(s) of a particular text. Searle ignores such scruples; Carroll overrides familiar doubts. Behind such worries the vast diversities of creative literature "stretch far away."

You begin to see the power of these reflections if, for example, you ask yourself how we could ever know, watching (say) Robbe-Grillet's *Last Year at Marienbad* from the start of the film, just what the narrative thread of meaning is that might reveal its objective order by its montaged sequences; or for that matter, how—if we yielded even a little in

Bakhtin's direction regarding the cannibalizing or "carnavalesque" power of the novel, or the "heteroglossia" (the stratified, interpenetrating "voices" that can be eked out) in what seems to be a single piece of discourse—we could ever suppose that "the novel" was reliably and straightforwardly dependent on (and legible in terms of) the logic of some (linear) conversational paradigm or rule of fiction. On Bakhtin's view, even the unitary structure of language is an idealization drawn *from* heteroglossal complexities.[30] At the very least, a novel is an *imaginative structure made accessible linguistically but not confined to language*!

Returning to the themes of piecemeal reductionism, I may now mention that the likeliest theoretical analogue, in the analysis of painting, of Searle's thesis regarding the logic of fiction can be found in Kendall Walton's theory of "make-believe," which Walton applies first to Seurat's *Grande Jatte* and then, ingeniously, to a very wide swath of all the arts.[31] Both accounts are reductionistic in the piecemeal way, though by different routes. Both favor a more-or-less exclusionary paradigm: strict speech-act rules (for Searle), the "mandated" rules of make-believe (for Walton); and both fail to pursue the *prior* question of just how it is that particular artworks are constituted and reliably grasped in the first place. That counts as an extraordinary—even fatal—omission. How could Walton possibly know—in advance of an informed comparison—that there *was* a "game of make-believe" that could reliably help us understand *Grande Jatte* or (say) one of Anselm Kiefer's seemingly elegaic panels, or, for that matter, van Gogh's *Starry Night*? How would Searle know that Velásquez must have drawn on a secret variant of natural perspective in organizing *Las Meninas*—one which remains lost to us now?

Make-believe is not the equivalent of a phenomenologically informed perception of pictorial representation: it can only presuppose it, where it is relevant at all. It is certainly not the equivalent of mere visual imagination. Think again of seeing one of Vermeer's lovely Dutch interiors: it requires a distinct way of seeing, a trained

eye, not a pretense of seeing anything one doesn't actually see—not a make-believe in any way at all.

There is indeed an ingredient of visual imagination in visual perception, not only in pictures but in the real world. When I see someone entering a room, for example, and only part of his body is as yet visible, *I see him* (as one says) as he enters the room, although I don't yet see the occluded part of his body. *There* you have a case of visual imagination *in* visual perception (in perceiving what is real); it is certainly not—couldn't possibly be—a fictive pretense at seeing! It is not so much a question of being accurate or precise about what one sees as it is of being reasonable about what we mean by "seeing." It's in this sense that I would say the primary use of the term "seeing" must be phenomenological (the sense of attending to our Erscheinungen, which are already culturally formed and informed), not at all merely ocular, phenomenalist, sense-datum, neurophysiologically triggered, or anything of the kind.[32]

In fact, to "subtract" from the "phenomenological" (thus conceived) whatever is imaginatively added to what we actually "see" is *not* to approach anything authentically "phenomenal" or empiricist in any supposedly passively "given" way—*from* which, thereupon, the phenomenologically florid "givens" of reportable perception can be effectively distinguished and then *added* or reconstituted. There are no such original givens, unless in accord with one or another privileged explanatory theory. The best we can say is that phenomenalist minima can be reasonably abstracted from the phenomenological if they can be specified at all; that neither is privileged; that both are profoundly informal posits; that we cannot do without some relatively rich phenomenological account that allows theory and culturally informed experience and the like to "penetrate" reportable perception; that the empiricist extreme (something approaching sense data, say) is not in any strict sense reportable at all; and that there is no one valid way to report what precisely we see.

When I see a Vermeer interior, I normally see it three-dimensionally, although I realize that it's painted on a two-dimensional surface, which I can also see two-dimensionally. But I don't agree at all that I am necessarily pretending about anything when I see *that*. The supposed precision of an ocularly restricted or empiricist account of "seeing" is bought at the price of its not being (its never being) independent of what we normally are able to report as seen; and what we normally report as "given" in visual perception (not privileged in any sense at all) is bought at the price of reportorial informality and a lack of clear boundaries between seeing and visual imagination. That too requires an enabling theory.

By "phenomenological," then, I mean something very ordinary, certainly not anything as high-blown as Husserl's conception (which seems to me to have taken a wrong turn). The "piecemeal" theorists whom I've been featuring—Beardsley (very loosely), Wollheim, Danto, Walton, Currie, Carroll, Levinson, at least—seem all of them to have endorsed (on paradoxical and self-defeating grounds, or on no grounds at all) some sort of empiricist constraints (often loosely defined and loosely applied) regarding what we "actually" see and what we don't, even when we are not quite aware of what we see. For the moment, let me simply say that the best approximation to what I mean by the "phenomenological" conforms with Hegel's notion of "the world's-appearings-to-us" (our Erscheinungen) in his *Phenomenology*; although (quite frankly) I think we can do better than Hegel at elaborating his own conception. (What I've just ventured *is* very close to Hegel's notion, shorn of Hegel's systematic extravagances.)

We *do see* the stately world of *Grand Jatte*, that is, its represented world, the painting's world visually represented; although we must of course learn to see it aright. But we do learn *to see* it in the same perceptual sense (seeing and hearing different parts of the world) that serves us when we say we actually *hear* and understand speech directly. We hardly "make-believe" we are continually hearing speech, and we plainly hear what a strict empiricist account would never

admit can be heard. (Consider, per impossibile, that *we* merely imagine that *we* exist!)

But if you admit that hearing speech does not depend on our first "making-believe" that in hearing certain *sounds*, we are hearing speech, then (I say) it's just wrong to claim that we *see Grand Jatte's* world only by first "practicing" the game of make-believe on *something else*—the *paint*, perhaps, on a *painted physical surface*! Imagine trying to explain speech as if it *were* no more than sound that we somehow construe (representationally, let us suppose: hence fictively, in something close to Walton's sense) *as* speech—say, by invoking a speaker's inner and prior intentions. Something similar is supposed to be involved in seeing pictorial images. The odd fact is that Walton risks losing altogether the perception of paintings as paintings in his effort to explain how we grasp the power of paintings to represent or depict anything at all. I view this as a mistake akin to Danto's mistakes regarding the very existence of a painting (in his early accounts in *Transfiguration* and the "Artworld" paper).

Correspondingly, fiction is not a full-blooded form of discourse, in the sense Searle favors in his account of speech acts (partly borrowed from Austin): fictional discourse, or the fictional operator, merely brackets Searle's "axiom of existence" within the scope of a more ramified use of language; it affects no more than a certain "dependent" speech act that cannot possibly stand alone. There are no advantages here for any all-purpose mode of literary interpretation. In fact, it makes as much sense to think that we can always *waive* (without invoking ontic import at all) the "axiom of existence" (imagining the world of a novel) as it does to assert that we explicitly *reject* the would-be valid application of the axiom (on the grounds that we intend to "refer" to the events of a purely fictive world). Why not?

Walton's argument makes no sense if not first grounded in an analysis of the way visual images are actually *first* perceived and interpreted: "make-believe" must be practiced *on* a visual (or literary)

content identified *before* it is ever called into play. It cannot generate its own initial data, the very data on which it normally practices its distinctive "magic"!

Why, we may ask, would anyone actually propose the make-believe condition if he didn't believe we *never* actually see Vermeer's represented interiors? He must believe we don't *see* in the phenomenological way: perhaps, then, we see only sense data or what an analysis of the images on the retina suggest we really "see," or something of the sort. Still, in his game of make-believe involving treating tree stumps as bears, Walton obviously admits that we *do see* the tree stumps and may (by chance) see bears. But how does he explain *that* without thereby making provision for outflanking the make-believe he insists on in viewing Seurat's *Grand Jatte*? I don't think that question can be as easily answered as it may seem. There's a regress there we must avoid. Could we, for instance, be playing make-believe with sense data, in "seeing" trees? Preposterous analogy.

If you take sensory perception to be essentially reportorial—not always reported or accurately reported but reportable in the usual first-person sense—then, (i) there is no known way to draw a fixed demarcation line between what is seen and what is visually imagined in what is seen; (ii) there is no way to specify what we see, without admitting that what we see normally includes an ingredient of visual imagination as well as culturally informed visual discrimination; and (iii) there is no plausible way of acknowledging the critically formed perceptual powers of human agents without admitting the phenomenological amplitude of simply seeing pictorial representations in the same sense in which we hear speech and see things move. But then, *seeing* in the phenomenological sense is at least conformable, perceptually, with conditions (i)–(iii): for we also see Intentionally qualified structures—the altar of a church, the Cross, the representation of Judas's betrayal (in Giotto's fresco). Thomas Kuhn, I note, was puzzled by the phenomenology of Galileo's seeing pendulums where Aristotle did not.[33]

For *related* reasons, when I turn the volume down on the television, or when I see a movie on a long flight and don't have the headset on, I literally don't see *what I would see if I heard* the dialogue! How would one explain that? I suggest it shows (iv) that seeing normally implicates the resources of memory, theory, imagination, *and* the informational input of all of our active senses functioning together—*penetrating* one or another mode of perception. No doubt there are reasonable demurrers, but I don't see how they can be firm enough in the right way to disallow our actually seeing a Vermeer interior.

There's the bold advantage of Hegel's inestimable intuition about what is phenomenologically "given": we begin with what we take to be the contingent appearings-of-the-world-to-us—not, therefore, in *any* assured way in which the world "objectively" appears. We begin presuppositionlessly (but not neutrally, not in any way free of our own enculturation) with what appears reportable, certainly *not* with what appearances are thought to "represent" externally, not with any privileged theory regarding the independent world—certainly not with Kantian Vorstellungen.

We begin with no more than what we are unwilling or unable (in transient contexts of reporting) to deny we experience—which, conformably, we find we continually rework and reinterpret as our sense of how the world-disclosed-in-experience changeably persuades us to believe this or that regarding how the world actually "is." This means, for one thing, that in favoring phenomenology over correspondence, we cannot but abandon any hope of final ("relationally" realist) accuracy in what we report we "see"; and for another, we must abandon the idea that what is "given" is essentially representational in any correspondentist way. We construct our sense of what (in the realist way) we take the world to be like.

What is thus given is indeed construed representationally, but only on the evolving grounds of how we interpret what we believe was and is phenomenologically given—in the "internalist" sense that belongs to our encultured ability to posit what we take to be the real

world, even where, as in pictorial representation, a perceivable or perceptually imaginable "world" is given representationally. It's on such grounds that we first construct (if we can at all) what *we* judge to be an objective picture of the world—but not by checking correspondences. Earlier phases of our Erscheinungen are then taken to "represent" what, dawningly, we begin to regard as the (perceivable) actual world: regarded merely as "given," however, it is not representational but (more carefully construed) presentational. We are constructivists in our realist beliefs, but we do not literally construct the world. Vermeer uttered or constructed a visually imaginable world: he did so *by constructing an actual pictorial representation*! (There's no literal-minded idealism there.)

In seeing a Vermeer interior, therefore, I see a representation, not because perception is itself inherently representational (as the empiricists usually believe: Locke, say, rather than Hume) but because the *Vermeer is representational*. There's the conceptual advantage of treating imagination as distinct from fictive or realist presumptions. Nearly every recent analytic theory of sensory perception is disposed to adopt a representational thesis a priori—which is to say, it either loses the "given" altogether or transforms it into a prior indubitability. But if Hegel is right in his correction of the Cartesian and Kantian conceptions of sensory experience, then a representational theory *of* ordinary perception surely must be a mistake: something akin to an empiricist maneuver meant to replace phenomenology's "given" with some antecedent (completely unsecured) certainty about the objectively discernible world (given in a mentalistic sense). Epistemological representationism tends toward noumenalism or solipsism; corrected, it proves pointless—which is not to say that there are no representations of things.

There is no way to capture all of this except by the flux of evolving experience. Hegel's phenomenology grasps the immensely important intuition that the "given" must remain first-order; but, if so, then it is given in a way that can never be bounded by phenomenalist

constraints. (These findings should prove invaluable in analyzing the perception of paintings.)

Searle's verdict is a flat-out obiter dictum that ignores the recorded subtleties Austin had already collected within the discursive and conversational modes of speech. Searle's entire line of reasoning cannot be more than a house of cards; it is also (if I may say so) a kind of colonizing danger to the very prospects of mutual understanding throughout the world. It leads us to believe that the diversity of cultural history never really disturbs the universal adequacy of the speech-act model in the analysis of conversation *and* the literary uses of language. Walton is drawn to something analogous in the perception of the entire range of artworks. Beardsley is drawn to the exceptionless constancy of bivalence and excluded middle in objective interpretation. All of these maneuvers are unearned: some are willful oversimplifications; all are characteristic manifestations of scientism or piecemeal reductionism. They disclose no sense of history or the historicity of thought (and perception), whether in aesthetic matters or (dare I say?) political affairs.

Here now, to bring this part of our inquiry to a reasonable close, is a short passage from Walton's *Mimesis as Make-Believe*, which I offer in the way of supporting my charge against the piecemeal theorists. Walton's book is too huge to do justice to it in this small span, but I think the lines I've selected fix the issue clearly and fairly for all the arts:

> Pictures are props in games that are *visual* in several significant respects. The viewer of Meindert Hobbema's *Water Mill with the Great Red Roof* plays a game in which it is fictional that he sees a redroofed mill. As a participant in the game, he imagines that this is so. . . . Moreover, his actual act of looking at the painting is what makes it fictional that he looks at a mill. And this act is such that fictionally it itself is his looking at a mill; he imagines of his looking that its object is a mill. . . . On observing

Hobbema's canvas, one imagines one's observation to be of a mill.[34]

I'm afraid Walton's remarks are hopelessly contorted: mistaken, arbitrary, misleading, equivocal, excessive, incapable of being literally accurate as a rule, utterly idiosyncratic if meant as a figurative resumé of what we actually see, and, most important, entirely negligent about what we actually do see when we see a painting and about how we actually see a pictorial representation in a painting. (Pictorial representation cannot possibly be given by any single concrete formula, just as there is no one way to read "literature.") Does Walton mean that on seeing the painted canvas, make-believe "converts" what we see (in seeing the canvas) into a fictive seeing of an actual mill; or does he mean that, in seeing the represented mill, we cannot escape playing a game of make-believe with *that*? If it's the first, then *seeing* a pictorial representation is itself an artifact of make-believe—which is nowhere convincingly argued; and if it's the second, then Walton clearly loses by winning—since make-believe would then be no more than an *additional*, completely extraneous use of pictorial perception itself. Read in the right way, tertium non datur; although there are indeed plenty of wild tertia to go around.

When I see a photograph of my father,[35] in one sense I never suppose I see my father (he's no longer alive); but in another sense I do see my father because it is he who is photographically pictured. I believe that when I see Hobbema's painting, I myself *never* imagine that I'm seeing an actual mill, as opposed to seeing a depiction or representation of a mill, though I could easily make the small effort to do so and I readily admit that I do see "the mill" in the painting. I would also have no difficulty in considering whether Hobbema was depicting an actual mill; but I don't believe images in paintings and photographic images *are* normally regarded in the same way in this respect. Also, if I admitted that I saw a representation of a mill and denied that I played a game of make-believe with *it*, wouldn't that consign

Walton's theory to the back-benches, in the same sense in which Goodman's suggestion that Rembrandt's *Night Watch* might serve as a doorstop deserves to be ignored? (You see the comic possibilities.)

I am certainly never obliged to imagine that anything that is fictional is real when I merely see a pictorial representation as a representation. There's no fictional ingredient there at all, or at least there needn't be. I don't believe I am violating any "rules" of depiction or representation if I don't imagine that I see an actual mill when I see Hobbema's representation of a mill; and, surely, my looking at Hobbema's painting never necessarily entails my imagining (fictionally) seeing an actual mill. There *is* no sense of "make-believe" that is essentially entailed *in* seeing an actual pictorial representation: make-believe is an activity *added* to the act of simply seeing the painting as the pictorial representation it is; otherwise, it's just a freestanding game. There is nothing, as far as I can see, that is specifically fictional in seeing Hobbema's representation of a mill or Seurat's representation of a strolling couple on the Grande Jatte. It would be a contradiction to claim there must be a fiction there. In fact, if you read what Walton actually says in the passage cited, you see that you cannot be quite sure whether he means to play make-believe with the representation we first see or holds instead that we "see" the representation only if we play make-believe with the painted surface of the canvas.

But that is hardly to deny that, as *in* seeing *Grande Jatte's* world, our seeing the representation of a mill or Seurat's representation phenomenologically (*not* in the phenomenalist way) entails more than a small bit of visual imagination that penetrates and informs what we actually see—so that we rightly say that *that is* what we see. It's only that what we mean by "imagination" here need have nothing to do with make-believe; as I say, the same sort of imagination is in play in seeing someone's beginning to enter a room by coming through a doorway: it has nothing to do with fiction. (I wouldn't object to your saying that hearing speech involves an aptitude for auditory imagina-

tion, *if* you didn't take the concession to entail that we never actually hear speech! There's an instructive parallel, here, between the "grammar" of imagination and the "logic" of constructivism.) Walton offers a great many splendid examples to ponder. But I'm afraid he's made a fundamental mistake as well—a mistake I dare assign to the "piecemeal reductionist"'s dustbin.

CHAPTER 5

A FAILED STRATEGY

Let me climb down from these heady abstractions to the level terrain of my initial image (the magic violinist). I'd like to offer in the way of a very small example a contemporary piece of philosophical instruction about how to determine the meaning of a poem, an instruction that quite unintentionally affords a minor illustration of all that I oppose in opposing piecemeal reductionism. It's a textbook exercise, possibly a little more interesting for being fashionably "in" (in the piecemeal way) than for its perceptive power. But I don't wish to propose a better reading of the poem—William Blake's haunting little verse, "The Sick Rose," as it happens, one of the "Songs of Experience"—although I can't disregard altogether how we might proceed more convincingly.

The poem itself is a slight one, probably selected as an easy piece of figurative or fictive language for a quick lesson—possibly then a "parasitic" bit of discourse (as Searle might say). I'm interested rather in the second-order implications of our instructor's advice

about how to read poetry effectively—his methodological guidance, so to say—which happens to betray the fatuousness of treating the uses of literary language as if they might be generated somehow by various "conversational" devices derived from or judged to be straightforwardly analogous to those deemed to be worth recommending in the analysis of Blake's lines. The proposed analysis proceeds in fact by reading Blake as if we were following the ordinary sentences of a perfectly ordinary conversation that takes place in a perfectly ordinary real-world context. You begin to see how the "conversational model" favors intentionalism and does so in the search for a universally reliable "method" for analyzing linguistic and/or literary meaning among the usual modes of organizing and using language. Hence, focusing our intuition more narrowly now, we might be thought to be able to determine by an all-purpose method "the meaning" of different kinds of literary "utterance."

Of course, *we don't know* whether the "conversational structure" abstracted from "The Sick Rose"—abstracted from its seeming grammatical surface—actually confirms the conversational structure *of the poem itself*, or whether it's (somehow) the record or representation of one side of an actual or fictional conversation or an uttered sequence of constatives. *We never know!* We never learn that, or whether, the meaning of Blake's lines rightly yields or ought to yield to a conversational strategy of analysis. To be candid, I'd say Blake's lines never provide sufficient evidence to justify such a judgment. But surely this sort of lacuna does not confront us in a genuine conversation; if it did, we would wonder whether what we took to be a conversation was one: there's an existential commitment in a conversation that orients us correctly, whereas whatever analogous commitment we suppose informs a poem or a piece of literature we must *first* discern, if the text is at all problematic. (Think, for instance, of trying to fathom Mallarmé's "Un coup de dés.")

The advice tendered by our reader—Robert Stecker—puts itself at serious risk because, as we may argue, the interpretation of Blake's

(or any) poem entails taking a stab at a reasonably good *pre-interpretive interpretive guess* at the holistic structure or unity of meaning of all the potential part/whole substructures of the text before us. This is no more than a standard heuristic caution, certainly not a privileged methodology, motivated though it may be by a measure of experienced reading and directed for that reason against any simple or single linear model of how to analyze the meaning of any randomly selected text—literary or not. I see no reason to suppose that the uses of language are sufficiently homogeneous to vouchsafe any such success.

The same sort of warning applies to conversation itself, although matters are usually simpler there. The meaning of an ordinary conversation—more precisely, our being able to grasp a conversation—usually proceeds linearly, or somewhat linearly, because for one thing we normally witness the temporal unfolding of a conversation and we may then even participate in it; for another, we (or others) may interrupt a conversational exchange to ask for specific clarification then and there. That is, when a conversation is not strictly linear, we can often bring it closer to linear or sequential fluency by some acceptable intervention; alternatively, a conversation usually makes provision for, and incorporates into its own seemingly linear text, feedback mechanisms that affect the meaning and the meaning of the ordering of the sentences of a piece of actual discourse. Even in conversation, a string of linearly generated sentences cannot be counted on to match the dynamic complexity of the utterances in which those sentences are embedded and collect their meaning. They may not even conform to the canonical regularities assigned in speech-act theory and may not favor the systematizing uniformities of any such theory. In general, we cannot always, even in conversational contexts, derive the "form" of the dynamic process of a discourse from the seeming surface grammar of the discrete sentences we mark as its running text; and we certainly cannot derive a proper grasp of the "world" it implicates or discloses that qualifies both our

understanding of its uttered sentences and the constructed would-be utterances within whose terms the sentences generated are deemed to be rightly or reasonably grasped.

Here the entire model begins to falter along lines that are clearly analogous to what we have already observed with respect to the difference between a phenomenal and a phenomenological account of perception. Furthermore, what's possible in a live conversation is normally impossible in published poetry; so that the conversational model, applied (beyond conversation) to the unclassified scatter of printed literature, threatens to distort and impoverish our reading of texts that are not even remotely similar to standard conversations.

More than that, we begin to suspect that reference to "the text" (of a poem) may itself be a hopelessly contested and equivocal notion: we cannot, for instance, be at all sure that in analyzing the "text" of a poem, we *are* analyzing *a purely linguistic structure* of any sort *or* a structure that might include, or even feature, an "imagined world" made accessible by (but hardly restricted to) a "right" or accurately construed reading of the verbal sequence of what is also called "the text." Any idea of a right "method" for reading or understanding a poem may be mortally challenged by this sort of complication. How many such alternatives might there be? I think we never *know*! "Conversation" itself seems to be a profoundly contested notion, and here serious mistakes begin to mount in the direction of systematically distorting and impoverishing communication.

Ironically, Stecker's general advice tends to converge with Beardsley's empiricist confidence and assurances regarding the transparency of meanings; although, of course, Stecker favors relying on authorial intent in the literary setting, just where Beardsley unconditionally opposes any such strategy. (He's closer to Carroll and Levinson, of course.) Also, both treat intentional factors psychologistically: Stecker, by way of a borrowed adherence to a larger strategy known to be affiliated with reductivist leanings; Beardsley, out of a stronger adherence to the public requirements of an objective reading that

nevertheless prefers "conversational" transparency to interpretive labors applied to authors' would-be intentional states. But the near-reduction of the poetic, the fictional, and the dramatized to some straightforwardly discursive prototype is clearly championed by each, in very different ways, in the vain hope that the analysis of conversational or constative discourse affords the best prospect of approaching some underlying universal syntax of actual verbal exchange, or poetry, or indeed, the whole of natural-language use—in the manner, for instance, that Searle favors (but not Austin), or Frege and Bertrand Russell (but less so Strawson), or finally Beardsley (but not the classic hermeneuts). Stecker's strategy threatens to render entirely invisible or indecipherable an alarmingly large part of the literature of any culture he might put his mind to—confident that there's nothing to be found that his method will not straightforwardly disclose. (You may in fact be tempted to think that the logic and grammar of understanding any language and any corpus of poetry can always be straightforwardly modeled on standard conversational English!)

Here is Blake's poem in its entirety:

> O Rose thou art sick,
> The invisible worm,
> That flies in the night
> In the howling storm:
>
> Has found out thy bed
> Of crimson joy:
> And his dark secret love
> Does thy life destroy.[1]

In favoring a broadly conversational model of understanding linguistic meaning, Stecker supports a version of "actual intentionalism" (Noël Carroll's initial paradigm), the nerve of which he renders thus: "that the correct interpretation of an art-work identifies the

intention of the artist expressed in the work."[2] There's an extraordinarily revealing, entirely unintended (and unperceived) grammatical equivocation here that puts the issue before us in a perversely clear light. (Think of adding, or not adding, a comma after "artist.") For if Stecker's remark is read as signifying that what the artist intends to express *in his work* (that is, intends psychologically or "externally") *is* nothing more than what the *work actually expresses* (in some essentially nonpsychologistic or "internalist" sense), then Stecker allows no executive role at all for the interpretive contribution of the author's actual (interior) intention. That would mean that Stecker provides a reading of actual intentionalism that, oddly enough, agrees with the verdict already advanced in the name of Beardsley's anti-intentionalism. But if it is read as signifying that the "correct interpretation" should be confined to that part of the artist's psychological intention *that is actually expressed*, independently, *in* the work, then "actual intentionalism" would play no more than a subtractive role (if it played any role at all) in delimiting what otherwise *is* (or may be said to be) *expressed in* the work itself.

In either case, authorial intent would have no independent role to play in determining what a given artwork "means" or expresses, or even "intends" in what is expressed, on grounds of putatively prior ("external") evidence regarding the artist's *expressed* intentions. (Anything else is likely to veer off in a solipsistic direction.) It's also entirely possible to read Stecker's line as signifying that interpretation should be directed to the artist's intention, construed mentalistically; that the literary text may be reasonably assumed to "express" that intention; and that we should therefore read the text itself as providing evidence, however problematically, of that same intention.

Contrary to its own apparent intent then, Stecker's proposal may effectively concede that the meaning of a poem cannot be restricted to the poet's intentions (construed mentalistically), and that poems have legible (Intentional) structures that can be discerned by consulting the actual text in accord with the public history of read-

ing poetry. That would surely yield (or approach) a reductio of all versions of "actual intentionalism." Hence despite appearances, Stecker's doctrine might actually converge with what Beardsley proposes in his well-known paper, "The Intentional Fallacy" (written with W. K. Wimsatt).[3] And what if an author's poetic intention is, on every possible count, as baffling as his poetic text—and for the same reason? Here the subtleties of intentionalism may be entirely beside the point, as far as reading poetry is concerned. (Keep that in mind, please.)

The truth is: to distinguish carefully between *intention* (construed psychologistically) and a text's apparent *Intentional* structure need have little or nothing to do with favoring or opposing any particular version of piecemeal reductionism; although it's true enough that both "actual" and "hypothetical" intentionalism (Carroll's and Levinson's theses, respectively) have often been endorsed (in recent discussions) in order, precisely, to strengthen reductionism's hand, as by encouraging us to treat *all* intentional (psychologistic) attributions as essentially *external* to whatever, by a successful reduction (or elimination) of apparent Intentional structures, may come to be treated as a "mere-physical-object-qua-artwork": a transparent maneuver that succeeds by a kind of simulation—which is to say, that fails. (Here simulation is very close to make-believe.)

The intentional (or better: the Intentional) structure *of* an artwork is, in any case, not the same as its creator's (mentalistic) intention: in an obvious sense then, in the order of interpretation, if we admit mentalism, an artwork will be "externally" related to its *own* creator's intention. It cannot be similarly related in the process of original *utterance*—for trivial reasons, it cannot be external to itself. There must therefore be an equivocation on the notion of an "artist's intention": on the causal view, the intention must be externally related to the artwork produced (in, say, the Humean sense of causality); and, on the utterance view, the artist's intention must qualify, inseparably, the very action that is the creation of the artwork itself. The first option

ultimately yields an anomalous form of (mental) causality, and the second obviates the relevance of mere, private, or dualistic "mental causes" altogether. There is thus no usual causal role for intentionalism to fill. To be sure, *agency* is itself a distinct form of causality, not reducible to anything like the Humean model; and whatever belongs to agency (its intentional and physical parts and features) cannot then count as the operative causes of the actions or utterances that agency is rightly said to generate or utter. On Danto's view of the matter, a creative intention could never be causally external to any *artwork*, although if mentalism were admitted, it would (dualistically) be causally pertinent to changes in any physical object (or "mere real thing") that (as Danto also says) "is" the artwork in question *only when* rightly viewed under a suitable figurative description. For there would then be no actual (contingent) relationship between an artwork and a physical thing: there would never be two different things poised *to* enter into any external relationship; and there would not even be a pertinent identity relation, because where identity obtained, there would literally *be* nothing that *was* an artwork.

But would anyone wish to say anything of this kind *of* the "relationship" between selves and the members of *Homo sapiens*; or, for that matter, between speech and sound? Remember: internalism and externalism serve primarily as theories of how to determine the meaning of an artwork; intentionalism without a ramified semantics or pertinent causal theory or metaphysics of culture fitted to the reading of texts or the perception of public works makes no sense at all. This explains the force of admitting that we hear speech directly, without needing any intervening or externalist induction or figurative construction.

I concede that Stecker's formula is much too slack to capture E. D. Hirsch's robust alternative to the "piecemeal" theorist's "actual intentionalism"—which Beardsley had already had in mind at the time of writing *The Possibility of Criticism* (1970). Stecker finally yields in Jerrold Levinson's direction (favoring "hypothetical intentional-

ism"),[4] but he offers nothing in the way of resolving the paradox he and Levinson and Carroll somewhat share with Hirsch in the unlikely way they do.

It's entirely possible that in the last analysis Carroll (apart from Levinson) simply favors mentalistic intentions over Intentional structures in the interpretive setting; so that he may actually be less concerned with reductionism than Levinson is (or Danto or Wollheim or Walton, for that matter). I think it is very likely true that he's not nearly as interested in pursuing reductionism as are the others. Still, Carroll favors an idiom that he must know is thought to give the advantage to the piecemeal option. He yields somewhat, on intentionalism, in Levinson's direction, and he is hospitable to theories, like George Dickie's, that are easily enlisted for "piecemeal" purposes. I cannot see any clearcut commitment on Carroll's part on the most tendentious issues here—for instance, in "Identifying Art," which I'd have thought would have probed much deeper doctrinally than it actually does.[5] Carroll may be a middle-of-the-roader with no more than a passing preference for the piecemeal strategy. But if so, then it's difficult to account for his strong support of "actual intentionalism"—unless (what I find unlikely) he means no more than that artworks are best viewed as public "utterances" (in the sense I've been favoring here)—though finally explained in mentalistic terms. But that would amount to confusion on stilts.

Hirsch's account is also problematic, essentially on *internalist* grounds, because it collapses (for very different reasons) the distinction between authorial intent and the intentional (Intentional) structure of a text.[6] Genre-governed attributions are certainly internalist in nature, but (on analytic accounts that favor reductionism) authorial intent is definitely not construed in the internalist way, since that would entail the objective standing of the cultural world—and therefore obviate the adequacy of any form of mentalism. A related compromise seems to arise in the much-discussed paper by Noël Carroll, "Art, Intention, and Conversation," which Stecker

somewhat follows and which, in its own turn, lightly follows Hirsch's conflating of the two senses of "intention." But, of course, that means that there is no prospect that *any* model of "conversational meaning" or "utterance meaning" (Stecker's terms), read simply in the sense of intent construed mentalistically, could possibly serve as the paradigm for an intentionalist interpretation of the literary uses of language.[7]

In effect, Hirsch's grand effort (which I very much admire but cannot endorse) really attempts the impossible: that is, it seeks to capture the open-ended process of historical creation by changeless universal forms that effectively collapse the difference between the mentalistic and the nonmentalistic versions of intentionalism. There's the nerve of Hirsch's failed theory of genres—a kind of Aristotelian essentialism manqué, a regressive attack on Gadamer's historicized hermeneutics (whatever Gadamer's own limitations may be), pressed into service after no less than two hundred years of post-Hegelian reflection. It was clever of Beardsley, therefore, to sense so presciently the strategic fact that a choice between his own anti-intentionalism and Hirsch's intentionalism would never need to introduce a single word about their common longing for a neutral universalism that (thus far at least) would obviate historicity though not true history. For, of course, both strongly favor an internalist approach to reading literature.

Intentionalism alone is hardly reductionistic—as Hirsch's work confirms. The piecemeal reductionists have other fish to fry: they are perfectly willing to allow a full-blown psychology of inner states assignable to human selves (which, you realize, is not to favor *internalist* interpretation); they wish only to oppose an Intentional realism of artworks—hence, to resist ascribing to actual artworks any Intentional attributes. They are in this sense externalists: in effect, they hold that Intentional attributes are posited on intentional or mentalistic grounds. For, wherever intentional attributions fail to rely primarily on public evidence, they remain a conceptual scandal or an

insoluble mystery—as they threaten to be in Levinson and Carroll (for different reasons), and also earlier in Danto.

In any case the "new" intentionalism can never be more than a fragment of a viable theory of interpretation, and what might justify conceding any part of its would-be contribution lies entirely outside the scope of its most insistent claim. Nevertheless I'm interested in such claims, because they play an important part in larger philosophical contests that help us to understand the novelty of the cultural world and the complexities of the human condition. But it says rather little in the way of instructing us in the right reading of literature. For *to* admit the public standing of Intentional structures is effectively to obviate the criterial role intentionalism assigns intentions mentalistically construed: for either such intentions are utterly private or they themselves implicate public criteria. Wittgenstein effectively disposed of any distinctive contribution on the part of either option. The argument holds for both analytic intentionalism and for romantic hermeneutics.

All this signifies a penchant for reducing the cultural to the psychological. Alternatively put, wherever *intentional* attributes (which may well include a mentalistic analogue of the Intentional) are rightly taken to justify our attributing *psychological* properties to artworks (an obvious paradox), they thereby signify that such properties can only be relationally or "externally" imputed to the objects in question. This double maneuver leads therefore to the judgment that paintings (say) are either mere physical objects (Wollheim) or rhetorical "transfigurations" of mere physical objects (Danto). But of course neither strategy is genuinely independent of the perceptual resources it pretends to escape—and indeed neither is entirely coherent. Accordingly, if you change loyalties: if you reject dualism and attribute Intentional properties to artworks directly (for instance, expressiveness and other "intentional" properties), all of the fearful paradoxes the piecemeal theorists bring to the philosophical table

dissolve at once. What's left to save? Still, they leave to one side the matter, say, of how to approach the meaning of a poem.

Of course, once the findings mentioned find their rightful place, familiar quarrels about the nature and Intentional structure of artworks become noticeably more tractable. You see this instantly on scanning Stecker's opening remarks about Blake's little poem. For instance, you can hardly miss the essential point of the double contrast we've been puzzling over: that is, between nature and culture and between conversational utterance and the uttering of artworks. By and large, these are the principal foci of analysis regarding the pros and cons of piecemeal reductionism. Both have important "metaphysical" implications.

Consider then the following rather surprisingly assured remark of Stecker:

> First note that there are aspects of the meaning of the poem that it would be natural to say we know prior to interpretation. We know that the poem is ostensibly about a rose that becomes infested with a worm that destroys it. We know the rose is red (crimson), the worm invisible and flies at night in a storm. We know there is more to the poem than this. We know that we will appreciate the poem only if we can come to some understanding of what this more might be. We also may have some specific puzzles about some lines or phrases in the poem. For example, why is the worm invisible? Is it literally invisible or . . . ? Clearly these are interpretive issues.[8]

Good enough—well, perhaps. But Stecker conflates too hastily the meanings we might assign the apparent words and sentences of the text *in contexts other than the context of the poem* and the meaning of the words gained by interpreting the structure of the poem or of the words read *in the context of the poem* (or text). Stecker's made the whole

thing out to be a string of constatives or a structure recoverable from such a string. Here I think of a perfectly ordinary bit of work in the service of reading a poem—an approach to an unfamiliar string of words (not at all the same thing as a string of unfamiliar words) set out in a telltale form that signals that we are probably in the presence of a poem—forewarning us, that is, against a "linear" policy of reading texts in just the blunderbuss way Stecker recommends. He speaks confidently of knowing "aspects of the meaning *of the poem* prior to interpretation," but he could have arrived at his finding by simply consulting an ordinary dictionary or perhaps nothing more than his presumed verbal fluency. He claims to understand parts or aspects *of the poem* by drawing on seemingly independent but familiar uses of the words of the poem that may be completely alien to the poem itself. How does he know that the words have the same sense, or play suitably congruent roles, in the structured texts he suggests he's comparing? How does he know Blake's intentions?

Certainly, there's no way of reading Stecker's assurances but as bypassing intentionalism altogether at the "start" of reading; or as relying (again, at the start of reading) on the adequacy of recovering the Intentional structure of the actual public text. How much more would it take to extend the concession to the entire labor of understanding and interpreting Blake's poem? (Consider only that to appeal to an author's diaries or letters will raise the original question of literary relevance and of the objective recovery of meanings and private intentions again.)

I must also emphasize that when we speak of understanding "the meaning of the words" of a given text, we normally do not isolate "the meaning" as a formulably determinate precipitate; rather, we signify that we have embedded "the meaning" (the would-be meaning) in critical remarks regarding how to read the text perspicuously, by which we take ourselves to have made "the meaning" accessible to those we have instructed. Meanings, like facts, are not separable "en-

tities" of any kind: we trade in words and sentences and speak of their meanings, but we can never isolate meanings independently.

The point of the warning is perfectly straightforward: Stecker must be committed to a more "particulate" conception of verbal meaning than he could possibly defend; he speaks of "aspects of the meaning of the poem that it would be natural to say we know prior to interpretation." But that's precisely what we can never say: we explicate a text only by way of improvising interpretive near-equivalences of meaning between the paraphrastic instruments we introduce and the parts of the original text we mean to match—passingly. This is in fact the nerve of the very "theory" of meaning Wittgenstein introduces at the start of *Philosophical Investigations*, in his remarkably acute treatment of St. Augustine's account (in *Confessions*) of a child's learning his first language: "A child uses [the] primitive forms of language when it learns to talk. Here the teaching of language is not explanation, but training."⁹

Allow me to insert here (rather brusquely) a small clue in favor of exploring an entirely different way of reading Blake's poem. I have no intention of offering an actual interpretation; I'm more interested in establishing the import of our sense of the familiar *discontinuity* between understanding poetry and understanding prosaic, practical, constative discourse and ordinary conversation. My sense is that "The Sick Rose" is not "meant" to be deciphered at all but is rather a contrived utterance that captures a sense of foreboding and spreading malaise that gains its effect precisely by being brief, easily remembered, disarmingly simple, almost childish, and above all impenetrable. Interpreting the images so that we can recast the sentences in some more legible way is, on this view, to defeat the "right" way to read the poem: it can be made to support all sorts of allusions. But the poem does not "intend" any of these, although our associations enhance the poem's effect. Obviously I mean, in using the terms "meant" and "intend," the "right" to speak of certain In-

tentional features of the verses rather than of mentalistic intentions we might attribute to the poet himself. I take Blake's poem to be a remarkably intuitive early form of an "impenetrable" utterance; it looks like a series of assertions, but arrests our attention in an uncanny way that remains pointedly significant but does not depend on the paraphrastic possibilities of the verbal images introduced— although the images themselves are of decisive importance. Furthermore, if one insists on "interpreting" Blake's poem, then there will be no end of plausible readings, and to pursue them risks diminishing the distinctive power of the poem itself.

I find it instructive to place Blake's poem in a possible array of "impenetrable" poems of increasing difficulty leading up to our time; these are associated with a sense of detached dread, the altered strangeness of our world, the uncanny, and possibly the presence of palpable but unspecified evil, and all seem to be linked to momentous (perhaps even recognizable) human interventions that nevertheless remain nameless. In our time, Paul Celan's poems may conceivably count as among the paradigms of such a poetry—for instance, these lines:

ENGHOLZTAG unter
netznervigem Himmelblatt. Durch
grosszellige Leerstunden klettert,
 im Regen,
der schwarzbllaue, der
Gedankenkäfer.
Tierblütige Worte
drängen sich vor seine Fühler.

NARROWOOD DAY under
 netnerved skyleaf. Through
bigcelled idlehours clambers,
 in rain,
the blackblue, the
thoughtbeetle.
Animal-bloodsoming words
crowd before its feelers.[10]

Celan produces a much more intense effect than Blake by estranging the German without making it unreadable, which is in a way an analogue of his own estrangement among a German-speaking people

who lived their ordinary lives in their Nazified world. In the same way, I suggest a way of reading Blake by a line of inquiry that does not depend on purely verbal explications.

The same lesson can be said to apply to the explication of meanings at every stage of instruction. So we *cannot* know in advance the meanings of the words of a particular text (or even of a conversation), although of course much of ordinary discourse is completely formulaic. If this weren't true, there'd be no point to dictionaries at all and language might well be impossible to master. The trouble is: Wittgenstein's excellent picture of a "primitive language" coordinates bodily responses and facial expressions and the like with bits of discourse in order to orient the child; whereas printed poems and novels confront us in a relatively contextless way. We can only draw on the skilled practices of reading.

We may never succeed in the analysis of "The Sick Rose"—in fact, I think it likely we won't. But surely the words *oblige* us to consider an imagined world within the bounds of which *their* "utterance" is thought to fall, which then conveys us well beyond the merely verbal. We find—we are likely to find, though it may be contested—that our best guesses at *the meaning of the words* must be informed by what we suppose to be our own pertinent general and local knowledge and experience *of the human condition itself*—overriding any "literal reading" of the "words." You see how natural it is to exceed any merely "verbal" policy: how reasonable it is to doubt the adequacy of any merely conversational or constative methodology; hence also how reasonable it is to challenge any merely psychologistic reading of what the poem "intends."

What Stecker means—what he can only mean—is that certain words and sentences may be read, *apart* from the poem itself, as reasonably straightforward constatives; he has no evidence at all that such readings are acceptable readings *of any lines* in the context of the poem. The conjectured meaning of key words and phrases may be flatly mistaken; the lines may have an unexpected function in the

context of the poem that affects and overrides the apparent or even usual meaning of the words in other contexts; and, even more important, "the meaning of the poem" cannot be confined to the verbal meaning of the words in Stecker's sense or in any other merely verbal sense. It requires imagining a suitable world. Stecker couldn't be more mistaken.

Normally we treat a published poem as an integral text, though that's hardly to say its "meaning" or Intentional structure is thereby fixed or legibly unified or even legible at all, or that we should approach its "meaning" in the same generally linear way we approach a simple conversation or a string of explicit constatives or a set of instructions for installing a ceiling fan. That would be a serious mistake—very possibly the impulse of an inexperienced reader.

Blake's lines are short enough to allow us to keep the entire piece in plain view. Even so, Stecker's instruction literally *rules out* the relevance of what I've called a pre-interpretive conjecture about the likely hermeneutic structure of the entire piece—which is itself a kind of interpretive trial-and-error strategy. The operative conjecture takes the form of a thought-experiment, a series of possible false starts advanced heuristically in the spirit of the hermeneutic circle, centered on plausible but uninformed readings of seemingly structured substructural parts of the structured meaning of the entire poem viewed as an Intentionally adequate unity. Such an effort, which cannot be linear in principal (or cannot be known to be, a priori), involves at least two essential kinds of consideration that Stecker's paradigm completely precludes—without argument and without any compensating or recuperative strategy: one, that the very meaning of particular words within an encompassing poem cannot be rightly guessed from some other possible use in an entirely different context—a context (say) invented entirely from dictionary entries or something of the sort; the other, that actual hermeneutic possibilities are themselves a function (under diverse or conflicting strategies) of a historically evolving culture.

This way of proceeding completely baffles all forms of extensionalism as well as the use of the linearized structures of any standard semantic or grammatical sort. I remind you here of Chomsky's remarkable reductio of B. F. Skinner's behaviorist model of linguistic meaning. There is no merely linear grammar, Chomsky demonstrates, although it is also true that Chomsky has now abandoned his own famous model of an extensional and universal grammar.[11] The hermeneutic approach to literature shows convincingly that the semantics and syntax of poems cannot be separated along the lines of anything like Chomsky's best-known conviction. Would Chomsky admit such a decisive reversal now? I doubt it. I think he means to find an extensional structure deeper in the innatist way than his former grammars could ever have supported.

Returning to Blake: we see how improbable it is to suppose that the analysis of the meaning of the poem's verbal text can be managed in a purely verbal way; conjectures about the poem's imagined "world" (which must inform the meaning of the words) cannot possibly be confined in any merely verbal way. I don't deny here that we may advance conjectures about a poet's creative intentions in terms of sketching his career or the interests of his age. But for one thing, *that* hardly vindicates intentionalism (or mentalism) in biography or history; and for another, whatever is thereby yielded must then also justify its specific use in the interpretation of the text before us— which once again falls short of validating intentionalism.

Furthermore, there's no convincing reason to think that our understanding the *meaning* of what a speaker says in a conversation is at all the same kind of thing as understanding the "meaning" of a simple specimen poem like Blake's. "Verbal meaning" is not straightforwardly "found" anywhere; and what we "discern" in understanding a complete poem seems to be very different from what we have in mind in speaking of the meaning of the separate words and sentences of either a literary text or an ordinary conversation. In any

case, it's here that you begin to see the self-impoverishing constraints of piecemeal reductionism.

In short: for one thing, the meaning of words and the verbal meaning of sentences are not pursued in any single way in different contexts of use; for another, the meaning of conversations and poems and the like is almost never merely (or, for that matter, primarily) verbal in any literal sense; and, for a third, the context of a conversation is usually as palpable as the meaning of the words in any such context, but the "context" of a poem is characteristically something that must be suitably fathomed (or guessed) in order to read the poem's words correctly. Certainly, the meaning of literary pieces is characteristically *not* confined or centrally focused on the meaning of mere words and sentences, although we cannot experience or understand what language makes accessible in literature (that is, an imagined human or humanlike world) without our having learned to read the verbal text in a way in which it can be made to yield a verbally represented imaginable world. But if even part of this is true in an informal way, Stecker will have started us off on the wrong foot altogether. (Of course, the imagined utterance of given verbal lines may well be part of the world imagined—whether in Shakespeare or in Blake.)

A cartoon rendering of the "piecemeal" purpose of the new intentionalism might go this way. Ordinary conversation affords the likeliest model of how the meaning of constative discourse *could* be construed in terms of a speaker's intentions—in a way, say, approximated by something like Grice's psychologizing meanings, by his bypassing the need to examine the actual structure of any piece of well-formed language in its own public space. Build then on that, the piecemeal advice might go, and suppose, against all odds, that the conversational model must work in the long run: that is, that *any* reasonable alternative way of understanding or analyzing a poem or novel must eventually yield to a skillfully iterated use of the intentionalist

strategy. Following that advice, then: simply dismiss all conjectures that fail to fit the practice! I don't claim the "intentionalists" are quite so benighted, but they surely stretch our credulity in just this direction.

The most plausible recent intentionalist account is offered in Noël Carroll's "Art, Intention, and Conversation." It is primarily an attack on Beardsley's "anti-intentionalism"; but neither Beardsley nor Carroll is very clear about what to understand by the "intentional." Both favor a mentalistic account. But Beardsley does not quite acknowledge the fact that E. D. Hirsch, whom he criticizes as an intentionalist, was a late Romantic hermeneut—hence, was perfectly aware, as was Schleiermacher before him, that the merely psychological had to be embedded in the intentional (really: the Intentional) structures of objective genres, which were already known to manifest their structures in ways that were simply not mentalistic at all. (Artists might not even be aware of such genres.) A knowledgeable artist might deliberately abide by such constraints, and an informed artist might then have brought his inner mental states into accord with the public practices he favors.

Carroll offers a related compromise for different reasons. Opposing Beardsley's anti-intentionalism by way of Roland Barthes's account of the literary, Carroll suggests that, against both, we may apply some form of speech-act theory that would reinstate or strengthen the explanatory power of the intentional:

> Barthes apparently maintains that when language is divorced from the goal of acting on reality ("narrated . . . intransitively"), the relevance of the author disappears, and a space is opened for the reader to explore the text in terms of all its intertextual associations. . . .
>
> I am not sure that once language is used "intransitively," the author becomes irrelevant, since identifying such a use would appear to depend on fixing the author's intention to

work in certain genres or forms, namely, those that function intransitively.[12]

Carroll does not quite see that the intentionality (the Intentionality) of genres is meant to be (and is) a publicly accessible structure that actually poses the very question of the continued pertinence of the purely mentalistic model. I'd say he's made a decisive concession here—perhaps inadvertently, in any case not perspicuously—against his own doctrine. He either doesn't see the dialectical danger or it's not his topic, which would be puzzling. Furthermore, although it's true that Beardsley shows a certain naïveté about the "irrelevance" of authors' intentions—you may substitute Beardsley for Barthes in Carroll's text—there is a perfectly reasonable "internalist" account of Intentionality (along certain lines that Carroll would now concede) that would confirm the entirely subordinate role of the externalist (or mentalistic) reading of an author's intentions, without at all dismissing the relevance of an author's or artist's public utterances. Certainly it would support Beardsley's own account of literature as "representing illocutionary acts,"[13] *if* the notion of an "illocutionary act" was made broad enough to encompass the whole of the literary uses of language. Certainly the mentalistic option ("actual intentionalism") would lose its executive role in critical practice.

It would be enormously helpful—in trying to reach a proper understanding of the full scope of the intentionalist strategy and its bearing on the fortunes of "piecemeal reductionism"—to have Carroll's plain-man's summary of the matter before us. It would be hard to find a more thorough and candid statement. Let me try your patience a little by citing the opening remarks of the "Art, Intention, and Conversation" paper in a fairly full way:

In the normal course of affairs, when confronted with an utterance, our standard cognitive goal is to figure out what the speaker intends to say. And, on one very plausible theory of

language, the meaning of an utterance is explicated in terms of the speaker's intention to reveal to an auditor that the speaker intends the auditor to respond in a certain way. That is, the meaning of a particular language token is explained by means of certain of a speaker's intentions.

Likewise, in interpreting or explaining nonverbal behavior, we typically advert to the agent's intentions. . . . Nor is this reliance on intention something that is relevant only to living people; historians spend a great deal of their professional activity attempting to establish what historical agents intended by their words and their deeds, with the aim of rendering the past intelligible. Furthermore, we generally presume that they can succeed in their attempts even with respect to authors and agents who lived long ago and about whom the documentary record is scant.[14]

I think all of this is quite doubtful criterially and nearly vacuous where it claims its critical function. But I also think it can be satisfactorily recovered in a spirit strongly opposed to Carroll's mentalistic convictions, if (1) we speak of "intention" primarily in terms of the Intentional public structures of artworks, deeds, histories, and the like (as, in effect, Carroll concedes, though hardly explicitly and hardly in terms of the mentalistic option); and (2) we admit that the textual materials themselves—by which an author's intentions (otherwise restricted in the mentalistic sense) are admitted to have their own nonmentalistic (Intentional) structure—*are* sufficiently accessible in *that* way, then any interpretive reliance on mentalistic criteria will be rendered redundant or will be completely eclipsed or will be reduced to a very small, logically dependent courtesy that would never be allowed to override our internalist resources. The very idea that there is anything like a rule that could be invoked to support the intentionalist's policy is simply not convincing in the light of the dialectics of the situation, the problem of determining literary meaning

(viewed as different from mere verbal meaning), and the sheer vitality and discipline of a counterpractice that is clearly stronger than anything the externalist can muster.

Carroll may be faulted on at least the following counts: first, it is not at all necessary to construe the "anti-intentionalist" stand in accord with Beardsley's unguarded insistence on the "irrelevance" of intentions; second, both Beardsley and Carroll fail to address the difference (and the strategic import of the difference) between intentions in the mentalistic sense and publicly accessible Intentional structures in literary pieces (which each invokes but does not quite see); third, mentalistic intentions that are publicly manifested need not be judged to be irrelevant to interpretation (since they then have Intentional standing), but where they are admitted they must already be coopted by internalist considerations that go contrary to "actual intentionalism" (think of Wittgenstein); and fourth, the issues just raised have absolutely nothing to do with presumptions of fictionality or the paradigmatic status of the conversational model of discourse, which Carroll rather unconvincingly invokes.[15]

Apart from all this, it's worth remarking that Stecker is strongly influenced by Carroll's inconclusive model just at the point at which both begin to yield in the direction of Levinson's "hypothetical intentionalism." This leads to an almost unbelievable muddle, because Levinson, who is plainly aware that the "actual intentionalist" thesis is both inadequate and impoverished, offers an adjustment in the name of what he calls "hypothetical intentionalism" that elicits a favorable compromise from both Carroll and Stecker.[16]

There are, however, at least two quite important defects in Levinson's account: for one, he seems unaware that his adjustment exceeds the spare resources of the mentalism actual intentionalism accepts, and yet he wishes us to understand that the adjustment *he* offers *is* intended to strengthen a psychologistic account of the meaning of an artwork; second, he seems unaware as well that if we were to adopt anything akin to the adjustment he offers, we would have

completely obviated the need for any reliance on mentalism at all—along the lines already sketched.

More tellingly still: Levinson seems not to realize that his adjusted intentionalism completely undermines his ulterior commitment to piecemeal reductionism.[17] For not only is it true that intentions in the mentalistic sense are in need of outward criteria (Wittgenstein's charge), but the same maneuver is needed if "actual" intentionalists are ever to escape solipsism. But notice: in escaping solipsism, in the context of the philosophy of art, the *intentional* (if allowed at all) cannot fail to be inferred directly *from* the Intentional structures and attributes of artworks now viewed as publicly perceived objects. Hence, to admit all this is to admit the objective standing of artworks *as* irreducible, Intentionally qualified things—a doctrine obviously at variance with any bona fide form of piecemeal reductionism. In a word, to strengthen hypothetical intentionalism at the expense of actual intentionalism *is* to defeat the piecemeal strategy! This counts against Levinson, Carroll, and Stecker for essentially the same reasons.

It does no good to insist that Levinson's account remains tethered to a mentalistic reading of intentions. It's true, of course, but it cannot possibly help him—or Carroll. It's true because the mentalistic claim is itself now saved from paradox by making it depend on a non-*intentionalist* (though still Intentional) account of the intrinsic properties of artworks (a fortiori, by making it depend on an inferential account of artist's "hypothetical" intentions—even if hypothetical *intentions* are themselves regarded as an improved reading of the mentalism favored by "actual" intentionalism). If you're in for a penny, I say, you may as well be in for a pound.

Stecker has bought into more than he bargained for. The meaning of the words he assures us we understand *before* we ever attempt to read or interpret Blake's poem *is not* (*is never*, except by spot luck) *the meaning of the first line of the poem proper*! There is no normal sense of the

string of words *O Rose thou art sick* that we could justifiably invoke apart from the poem—in claiming to know, in advance of grasping the "meaning" of the actual poem, *the meaning of the first line of the poem's actual text*, that is, the meaning of the words just cited read as forming the poem's correctly interpreted first line.

The "meaning" of the first line of the *text* (its poetic contribution, let us say) is the meaning (or whatever run of meanings) that may be rightly assigned to *that* line *within* the perceived or argued unity of the (uttered) *poem*; the "meanings" of the separate words and phrases and sentences that we suppose constitute the correctly interpreted lines of the text *are not yet* (in any sense at all) proper parts *of the "meaning" or intelligible structure of the text or poem*. They cannot be more than *externally* culled from our general well of linguistic experience—from, say, dictionaries or remembered bits of conversation, or other poems for that matter (or letters or diaries).

The bare *words* that we suppose compose the poem's *text* (in one sense of "text": the verbal sense) are equivocally so designated; whatever words (rightly construed, rightly assigned *their* proper meaning) *are* finally found to belong to the text must, for trivial reasons, be admitted to be proper parts of the *text* (in another sense of "text," which yields, say, the imagined world of the poem itself)—a text then that in turn *is* the *poem* when suitably so construed. Because, of course, the text (in this sense) comprises all the linguistic structures of the poem viewed as its proper parts when rightly assembled and understood; in a further sense, the text includes more than the words rightly understood: namely, it includes *that* (or *what*) in virtue of which the words *are* rightly understood (that is, a sense of the poem's "world"). The "text," then, is part *and* whole of the poem.

But the "words" we bring to mind from external sources (any sources at all), *by considering which* we hope to guess correctly the "meaning" *of* the words *of the text itself, are not*, as such, actual parts *of the poem*. They belong only to one or another of an endless number of

transient "ponies" linking the shifting strands of our collective culture, the largely inchoate grab bag of our society's entire experience, which no single reader can possibly muster or master.

Internally, text and poem are hermeneutically or structurally linked in part/whole terms; externally, whatever words and other linguistic structures we take to close to the words of the poem before us are really counters in a thought experiment or gamble we hope will yield a proper hermeneutic clue. Here I offer no more than a slimmed-down gloss on the superb lesson sketched by Roland Barthes in his well-known essay, "From Work to Text."[18] Frankly, I have no reason to trust Stecker's opening suggestion that Blake's poem *is* about a rose at all; or, for that matter, Carroll's insistence that the conversational model of discourse (and its intentionalism) holds the key to the interpretation of all literary texts. I don't think we can ever really confirm that either of these claims is (likely to be) true! I don't know whether the supposedly "fictional voice" of the poem *is* fictional. (It needn't be: it may merely be imagined in reading this, or any, poem correctly.) I'm certainly not prepared to say that the distinction between fiction and reality is always important or even relevant in reading something like Blake's poem. We are, it seems, invited to *imagine* a "voice" uttering the lines given, but *that's* not fiction—and it's not make-believe either. Imagination, as I've already observed, does not require an ontic commitment of any kind. It's a standard capacity in human thinking: it's not part of the logic of constatives.

I'll leave this issue in its unsettled state. You'll see the reason in a moment. Let me turn very lightly to a piece of more idiomatic prose that begins in a way that seems to be not altogether unlike the mood of Blake's more "literary" specimen. When I first read the opening lines of Dostoevsky's *Notes from Underground*, which, by a strange coincidence, seem to be "about" illness (as Stecker might innocently say)—possibly, notes from an actual diary—I could certainly not

have found any telltale reason in them for not reading them in a straightforwardly constative way. Try them yourself:

I am a sick man . . . I am a wicked man, an unattractive man. I think my liver hurts. However, I don't know a fig about my sickness, and am not sure what it is that hurts me. I'm not being treated and never have been, though I respect medicine and doctors. What's more, I am also superstitious in the extreme; still, at least enough to respect medicine.[19]

Here, as all of us know who've read the piece, a literal-minded conversational or constative model doesn't really fit the thrust of the "story," although the discursive dimension must surely be acknowledged. It dawns on us that the opening lines introduce a literary device, not even Dostoevsky's in his own voice, which gradually converts everything uttered (everything permitted to be overheard, so to say) into a huge symptom and a reflexive analysis of the underground man's own state of mind—and (prophetically) the mind of his readers, whom he somehow understands but cannot claim to know directly (that is, ourselves) and who, in turn, are drawn ineluctably (as he anticipates) to the glancing power of his insinuations. We are, in fact, face to face with the radical self-consciousness of the Dostoevskyan "hero"—or so we may claim as a distinct possibility—which Mikhail Bakhtin isolates and which is, in a deep sense, a literary construct that precludes (because it absorbs) every form of constative utterance.

I trust you see that (and why) my discussion of the literary text makes it quite impossible to affirm any lexical order between the "description" and the "interpretation" of a literary work. In general, the "meaning" of artworks must be construed hermeneutically along lines close to those I've laid out. But if so, then the *construction* of a work's interpreted meaning cannot be captured by any account of

description and interpretation fitted to our practice regarding physical referents (think of the Olduvai Gorge) rather than cultural or Intentional ones (Blake's poem, or Dostoevsky's novel).[20]

Let me suggest that the verbal analysis of the words and sentences of the (verbal) *text* may need to be subordinated to the holistic analysis of the *poem* or *novel* to which it belongs (the text as a whole). What we mean, then, by "meaning" at some middle-range level of analysis may not be the same as what we mean by "meaning" at the level of the unified artwork. (These distinctions are meant to be no more than heuristic.) Accordingly, "author's intention" is an inherently problematic notion, very possibly an artifact of how we finally construe the meaning of a work. "Author's intention" cannot be independent of "the meaning of the work"—unless by ensuring its irrelevance.

I am reminded of the fact (known apparently to many) that W. B. Yeats often wrote poetry that, on "independent evidence," was motivated by very idiosyncratic doctrines and mythologies that he largely invented from rather willfully mixed and scattered sources. It's claimed, in fact, that many of his poems can actually be read coherently in accord with these personal mythologies, but they are (said to be) usually poorer for it. They can also be read, it seems, by drawing on more familiar and more plausible literary sources that may, in some measure, go contrary to what Yeats probably "intended"; although, in reading them thus, the poems seem to prosper and gain in stature. I'd go that far in tendering polite concessions to the intentionalists. But it remains indisputable, for all that, that the pertinence of an author's intentions must be textually defensible. Beardsley never opposed such a possibility, probably because it still entails the executive priority of a public culture. Furthermore, once you concede the Romantic hermeneut's adjustment, which Levinson approximates in the most abstract way, it's easy enough to extend the courtesy (in the mentalistic sense) to what Levinson calls "hypothet-

ical intentionalism." But that, I think, begins to make the issue no longer interesting.

Here, for the sake of accuracy, is a short summation, by Levinson, of the notion he calls hypothetical intentionalism:

> The indissolubility of literature from categorical intentions of that kind [that is: what is "intended for a kind of reception"] does not entail that there is and can be no meaning in a literary work other than what the author in fact intended it to mean. We are in the last analysis entitled and empowered to rationally reconstruct an author as meaning, in a work, something different from what he or she did, in private and in truth, actually mean, so long as we have put ourselves in the best position for receiving the utterance of this particular historically and culturally embedded author.[21]

If you read this apart from Levinson's larger philosophical commitments, the passage makes a perfectly reasonable (if slightly tortured) statement. But I don't believe it *can* be squared with the would-be economies of Levinson's piecemeal reductionism or with the implications of distinguishing carefully between the opposed programs of actual and hypothetical intentionalism. The "intention" Levinson ascribes to the artist here is, finally, no more than formulaic: it has no critical role at all regarding the meaning of literary pieces or of other artworks. I would say that that's precisely what's partially recovered by introducing the very idea of "hypothetical" intentionalism. It signifies an altogether different approach to the interpretation of art, not a strengthened form of actual intentionalism at all. It threatens to escape mentalism—in the direction of admitting the robust world of human culture. Both Levinson and Carroll may find the correction difficult to accept. (We must, Levinson advises, "put ourselves in the best position for . . ."; but what could that

reasonably mean, if not that we should consult the Intentional structures of the text before us and the pertinent parts of the history of literature?)

To return to my specimen text: no uninformed reader could possibly know at the start of reading what Bakhtin helps us to see; and any attempt to read what appears to be a discursive record of some sort would falsify the meaning of the novel in the profoundest way. The correction would never leave the opening lines in place as a proper constative part of the "meaning" of the novel. I must add, of course, that I'm offering a suggestion here, in a relatively uncomplicated way—say, without invoking any Gadamerian "fusion of horizons" or Bahktinian "heteroglossia" or Barthesian poststructuralist structuralist codes. But any such complication would strengthen, not weaken, the need for a pre-interpretive interpretive guess. It would also confirm the good sense of treating our discerning the "meaning" of the words and sentences of an ordinary conversation as a very different sort of undertaking.

I admit the importance of bringing our accounts of nature and culture under one conceptual tent. In fact, I insist on it. But I see no evidence at all that they converge in any easy way that favors the conceptual adequacy of any of our physicalist proclivities. The two go together, of course, but exactly how is problematic enough to justify indefinitely postponing any "piecemeal" presumptions and, accordingly, any assurances regarding the logic of interpretation. We must earn the right to leap ahead—or back.

Still, if the dialectical advantage of this sort of countermove makes any sense at all, then the center of gravity in all our efforts to understand the arts must lie with our ability to discern the public structures of a historical culture. For only a public culture can account at one and the same time for the powers of human selves as agents, speakers, artists, audiences, and the like; for the very meaning of their internal intentions, thought, experience, and deeds; and for the intelligibility of what they "utter" in the way of artworks and the

objective work of the disciplines by which the significance of what they thus utter is actually fathomed.

The entire undertaking would make no sense without admitting the sui generis nature of a cultural world, as real a world as the physical world and yet inseparably embodied in it. But to admit a realist account of Intentional structures obviates at a stroke both the new intentionalisms of our day and the reductionism they are meant to serve. We are ourselves "second-natured" in a culturally informed way, matched in fact to the intelligibility of whatever, as the inventive selves we are, we "utter."

It is hard to see why, if we are apt enough to produce artworks, we should not also be apt enough to grasp directly (by perception and/ or understanding) what we thus create. Furthermore, we cannot otherwise account coherently for the culturally emergent features that appear to collect at either end of the productive and appreciative process. For what would count as a conceptual adequation between the one and the other would exceed the conceptual resources of any intentionalism that, if not itself encultured, must founder on its own solipsistic puzzles; and any materialism that failed to introduce (and legitimate) a vocabulary fitted to the emergent entities we call selves and artworks would impoverish the vocabulary by which we understand ourselves. It's a most improbable reflection that acknowledges the grand world of the arts and then restricts its descriptive and explanatory powers in such a way that it can never rightly admit (through its diminished competence) the very interests that have obviously elicited its characteristic work. Evidently, we must save the piecemeal strategists from themselves, just as we must acknowledge what, all things considered, we believe we are.

NOTES

First Words

1. See, for a reliable orientation on the "primate" intelligence of *Homo sapiens*, Michael Tomasello, *The Cultural Origins of Human Cognition* (Cambridge, Mass.: Harvard University Press, 1999). On the difference between the primate intelligence of the species and the emergent presence of what we may regard as a true self, Tomasello is, I'm afraid, not at all reliable. In fact he often straddles the two notions without any clear sense of their fundamental difference.

2. See Noam Chomsky, *New Horizons in the Study of Language and Mind* (Cambridge: Cambridge University Press, 2000); also, Richard Dawkins, *The Selfish Gene*, rev. ed. (Oxford: Oxford University Press, 1969).

3. See my *The Unraveling of Scientism: American Philosophy at the End of the Twentieth Century* (Ithaca: Cornell University Press, 2003).

4. See Marjorie Grene, "People and Other Animals," *The Understanding of Nature: Essays in the Philosophy of Biology* (Dordrecht: Reidel, 1974).

5. See, for a general overview, my *Historied Thought, Constructed World: A Conceptual Primer for the Turn of the Millennium* (Berkeley: University of California Press, 1995).

6. See Paul M. Churchland, *A Neurocomputational Perspective: The Nature of Mind and the Structure of Science* (Cambridge, Mass.: MIT Press, 1989).

7. Wilfrid Sellars, "Philosophy and the Scientific Image of Man" and "The Language of Theories," *Science, Perception, and Reality* (London: Routledge and Kegan Paul, 1963), 40, 126.

8. Jaegwon Kim, *Mind in a Physical World: An Essay on the Mind-Body Problem and Mental Causation* (Cambridge, Mass.: MIT Press, 2000), p. 9. Compare Jaegwon Kim, *Physicalism, or Something Near Enough* (Princeton: Princeton University Press, 2005), 5.

9. See William C. Wimsatt, *Re-Engineering Philosophy for Limited Beings: Piecewise to Reality* (Cambridge, Mass.: Harvard University Press, 2007), appendices A–B. Wimsatt's book is rather courageous, charming on the autobiographical side, and brings an "engineer's" caution to the rashness of "principled" solutions of the descriptive, testable, and explanatory work of the sciences.

10. David J. Chalmers, "Facing Up to the Problem of Consciousness," in Jonathan Shear, ed., *Explaining Consciousness: The "Hard Problem"* (Cambridge, Mass.: MIT Press, 1995–97), 9; see also David J. Chalmers, *The Conscious Mind* (New York: Oxford University Press, 1996).

11. Chalmers, "Facing Up to the Problem of Consciousness," 11n1, 12.

12. Chalmers, "Facing Up to the Problem of Consciousness," 10.

13. See Thomas Nagel, "What Is It Like to Be a Bat?" *Philosophical Review* 83 (1974); on functionalism, see Hilary Putnam, *Representation and Reality* (Cambridge, Mass.: MIT Press, 1988). Putnam, who had been, earlier, both a "mentalist" and a "functionalist" by turns, convincingly defeats both mentalism and functionalism. Chalmers fails to come to terms with Putnam's argument.

1. Piecemeal Reductionism: A Sense of the Issue

1. For an overview, see my *The Unraveling of Scientism: American Philosophy at the End of the Twentieth Century* (Ithaca: Cornell University Press, 2003).

2. Compare Arthur C. Danto, *The Transfiguration of the Commonplace: A Philosophy of Art* (Cambridge, Mass.: Harvard University Press, 1981), 4, and Ludwig Wittgenstein, *Philosophical Investigations*, trans. G. E. M. Anscombe (New York: Macmillan, 1953), I, §621, chiefly, but together with §§174, 296, 306, 329, 332.

3. See Arthur C. Danto, "The Artworld," *Journal of Philosophy* 61 (1964): 571–584; and *The Body/Body Problem: Selected Essays* (Berkeley: University of California Press, 1999).

4. Wittgenstein, *Philosophical Investigations*, I, §304.

5. Jerrold Levinson, "Defining Art Historically," *Music, Art, and Metaphysics: Essays in Philosophical Aesthetics* (Ithaca: Cornell University Press, 1990), 4.

6. Richard Wollheim, *Painting as an Art* (The A. W. Mellon Lectures in the Fine Arts, 1984) (Princeton: Princeton University Press, 1987), 9.

7. Wollheim, *Painting as an Art*, 44.

8. On the matter of history as a science, in the spirit of the unity of science program, see Carl C. Hempel, "The Function of General Laws in History," *Aspects of Scientific Explanation and Other Essays in the Philosophy of Science* (New York: Free Press, 1965). See also Rudolf Carnap, "Psychology in Physical Language," trans. George Schick, in A. J. Ayer, ed., *Logical Positivism* (Glencoe: Free Press, 1959). On the concept of historicity, see Joseph Margolis, *Historied Thought, Constructed World: A Conceptual Primer for the Turn of the Millennium* (Berkeley: University of California Press, 1995).

9. See Thomas S. Kuhn, *The Structure of Scientific Revolutions*, 2nd ed. enl. (Chicago: University of Chicago Press, 1970); also *The Essential Tension: Selected Studies in Scientific Tradition and Change* (Chicago: University of Chicago Press, 1977).

10. See Theodor W. Adorno, *Essays on Music*, ed. Richard Leppert, trans. Susan H. Gillespie (Berkeley: University of California Press, 2002).

11. See G. W. F. Hegel, *Lectures on the History of Philosophy*, vol. 1, trans. E. J. Haldane and Frances H. Simson (Lincoln: University of Nebraska Press, 1995).

12. Wollheim, *Painting as an Art*, 44.

13. See Richard Wollheim, *Art and Its Objects*, 2nd ed. (Cambridge: Cambridge University Press, 1980).

14. Wollheim, *Painting as an Art*, 7.

15. This is in fact the strategy of John R. Searle, *The Construction of Social Reality* (New York: Free Press, 1995), supportively cited in this and related contexts by one or another of the more recent piecemeal theorists.

16. This is the rather wild thesis offered by Daniel C. Dennett, *Consciousness Explained* (Boston: Little, Brown, 1991), ch. 13. See, in this connection, Noël Carroll, "Art, Intention, and Conversation," in Gary Iseminger, ed., *Intention and Interpretation* (Philadelphia: Temple University Press, 1992); and "Interlude," below.

17. Gregory Currie, *Arts and Minds* (Oxford: Clarendon, 2004), 77.

18. Here I recommend the notable amplitude of Charles Peirce's theory of signs, which more than adequately accommodates what is conceptually needed. On Peirce's view, signs are irreducibly triadic; *and* the "iconic" function of signs (resemblance) and their indexical (causal) functions are both (quite normally) capable of being embedded in their symbolic function (what, as I read matters, captures the cultural or Intentional function primary to artworks and language). See *Collected Papers of Charles Sanders Peirce*, ed. Charles Hartshorne and Paul Weiss (Cambridge, Mass.: Harvard University Press, 1932), 2.227–307. Currie resists invoking any similarly generous conception, which, of course, is the hallmark of reductionism.

19. Currie, *Arts and Minds*, 70.

20. Currie, *Arts and Minds*, 76.

21. In a curious way, Roger Scruton inadvertently appears as a theorist who at times approaches the piecemeal position, although he is an obvious opponent—in "Photography and Representation" for instance, in *The Aesthetic Understanding: Essays in the Philosophy of Art and Culture* (London: Methuen, 1983), 102–126. The essay is a strong and interesting one. Scruton seems bent on construing the intentional in painting (and other perceptual contexts) in interpretive terms rather than (at least in part) perceptually. My guess is that this is due to his animus against Husserl, possibly in accord with the views of thinkers like Roderick Chisholm and Elizabeth Anscombe. But Brentano's theory of the intentional is at least as inadequate as Husserl's, though for very different reasons; and Hegel's account of the phenomeno-

logical is stronger than the accounts of either—and closer to the cultural and historical world. What Scruton says may, however, be read as outflanking Currie's account of photography, though problematically.

22. Currie, *Arts and Minds*, 77.

23. See David Marr, *Vision* (New York: Freeman, 1982); and Dominic Lopes, *Understanding Pictures* (Oxford: Clarendon, 1990), 101–107. Lopes is relying here on the views of Gareth Evans, *The Varieties of Reference*, ed. John McDowell (Oxford: Oxford University Press, 1982). Compare Fred I. Dretske, *Seeing and Knowing* (Chicago: University of Chicago Press, 1969) and *Knowledge and the Flow of Information* (Oxford: Blackwell, 1981).

24. Currie, *Arts and Minds*, 65.

25. Currie, *Arts and Minds*, 66.

26. Currie, *Arts and Minds*, 65.

27. Danto, "The Artworld." For an analysis, see Joseph Margolis, *Selves and Other Texts: The Case for Cultural Realism* (University Park: Pennsylvania State University Press, 2001).

28. See Wollheim, *Art and Its Objects*. These difficulties surface in an unguarded way in Jerrold Levinson, "What a Musical Work Is," *Music, Art, and Metaphysics* (Ithaca: Cornell University Press, 1990), apparently under Wollheim's influence. See further my *Art and Philosophy* (New York: Humanities Press, 1980).

29. See G. W. F. Hegel, *Phenomenology of Spirit*, trans. A. V. Miller (Oxford: Oxford University Press, 1977).

30. See Wittgenstein, *Philosophical Investigations,* I, §§257–265.

31. Compare Searle, *The Construction of Social Reality.*

32. Another attempt to revise the order of things may be found in Margaret Gilbert, *On Social Facts* (Princeton: Princeton University Press, 1989).

2. The New Intentionalism

1. I have always thought that musical performance and the silent interpretation of a score (even humming along) were comparable activities within the scope of criticism. Here I acknowledge the reflections of a friend and colleague, Peter Kivy, who has recently extended a similar idea, providing a

close comparison between the reading of a score and the reading of a novel. I've benefited from a reading of an early précis of Kivy's idea, parts of which Kivy had indeed already aired in earlier papers.

2. The image came quite unbidden, in the process of exploring some texts relating to my discussion of Wittgenstein's contributions to the philosophy of art. I was struck very forcibly by Wittgenstein's attraction to a similar image applied in a much wider context; see Joachim Schulte, "'The Life of the Sign': Wittgenstein on Reading a Poem," in John Gibson and Wolfgang Huemer, eds., *The Literary Wittgenstein* (London: Routledge, 2004), pp. 146–164.

3. See G. W. F. Hegel, *Philosophy of Right*, trans. T. M. Knox (Oxford: Clarendon, 1942); and *Phenolenology of Spirit*, trans. A. V. Miller (Oxford: Oxford University Press, 1977).

4. For an informed conjecture about the evolution of the animate world from the inanimate, see A. G. Cairns-Smith, *Genetic Takeover and the Mineral Origins of Life* (Cambridge: Cambridge University Press, 1982). See further, regarding our current picture of the ampler context of *inanimate evolution* required by the theory of the Big Bang, Robert P. Kirschner, *The Extravagant Universe: Exploding Stars, Dark Energy, and the Accelerating Cosmos*, with a new epilogue (Princeton: Princeton University Press, 2004).

5. The point is already conceded in the most candid way by Richard Dawkins, *The Selfish Gene*, rev. ed. (Oxford: Oxford University Press, 1989); and *The Extended Phenotype: The Long Reach of the Gene*, rev. ed. (Oxford: Oxford University Press, 1989).

6. See my *Unraveling of Scientism: American Philosophy at the End of the Twentieth Century* (Ithaca: Cornell University Press, 2003).

7. See Richard Wollheim, *Art and Its Objects*, 2nd ed. (Cambridge: Cambridge University Press, 1980).

8. See, for instance, my *Historied Thought, Constructed World: A Conceptual Primer for the Turn of the Millennium* (Berkeley: University of California Press, 1995).

9. See Arthur C. Danto, "The Artworld," *Journal of Philosophy* 66 (1964): 571–584.

10. See *The Philosophy of Franz Brentano*, ed. Linda L. McAlister (Atlantic Highlands, N.J.: Humanities Press, 1976); and Roderick M. Chisholm, *Perceiving: A Philosophical Study* (Ithaca: Cornell University Press, 1954), pt. III. See also the comment on Roger Scruton in chapter 1, note 21.

11. Jerrold Levinson, "The Work of Visual Art," *The Pleasures of Aesthetics: Philosophical Essays* (Ithaca: Cornell University Press, 1996), 154.

12. See Jaegwon Kim, *Philosophy of Mind* (Boulder, Colo.: Westview Press, 1996).

13. See E. D. Hirsch Jr., *Validity in Interpretation* (New Haven: Yale University Press, 1967).

14. Noël Carroll, "Art, Intention, and Conversation," in Gary Iseminger, ed., *Intention and Interpretation* (Philadelphia: Temple University Press, 1991), 97, 117. Carroll is one of the principal defenders of "actual intentionalism," which, in the conversational context, is clearly intended to be "externally" accessible. Carroll has influenced other discussants, for instance Robert Stecker, *Artworks: Definition, Meaning, Value* (University Park: Pennsylvania State University Press, 1997), and was himself influenced by William Tolhurst, "On What a Text Is and How It Means," *British Journal of Aesthetics* 19 (1979): 3–14. But Carroll fails to explain the sense in which the interpretation of art is "on a par" with the interpretation of ordinary conversation or the reasons for thinking that artworks must give pride of place to consulting author's intentions (in a strongly mentalistic sense) over whatever may be admitted as informative about such intentions that may be discerned *in* literary pieces. See especially Carroll's argument against Barthes and Beardsley (pp. 102–112). Carroll's counterarguments tend to be local to the authors he refutes, but his conclusions are more general than the argument can sustain.

15. Peter Lamarque, "Appreciation and Literary Interpretation," in Michael Krausz, ed., *Is There a Single Right Interpretation?* (University Park: Pennsylvania State University Press, 2002), 288.

16. See H. P. Grice, "Utterer's Meaning and Intention," *Philosophical Review* 78 (1969): 147–177.

17. See Arthur C. Danto, *The Transfiguration of the Commonplace: A Philosophy of Art* (Cambridge, Mass.: Harvard University Press, 1981). But you can find other

versions of "piecemeal reductionism" in Wollheim, Nelson Goodman, Jerrold Levinson, and Kendell Walton, among others.

18. Compare John R. Searle, *Speech Acts: An Essay in the Philosophy of Language* (Cambridge: Cambridge University Press, 1969), and John R. Searle, *The Construction of Social Reality* (New York: Free Press, 1995).

19. See Daniel C. Dennett, *Consciousness Explained* (Boston: Little, Brown, 1991).

20. See Ludwig Wittgenstein, *Philosophical Investigations* (Oxford: Blackwell, 1953), for instance the important clue at I, §244.

21. See Eduard Hanslick, *On the Musically Beautiful*, trans. Geoffrey Payzant (Indianapolis: Hackett, 1986). For an informed reading of Hanslick's account, see Peter Kivy, *Sound Sentiment: An Essay on the Musical Emotions, including the complete text of The Corded Shell* (Philadelphia: Temple University Press, 1989). Kivy returns a number of times to Hanslick's thesis, as if to determine whether Hanslick ever finds an adequate clue for his restrictions. Apparently, there are none. Hanslick opposes, without clear argument, the continuity, within music, of phenomenal sound and phenomenologically perceived voice. Hanslick realized that the first could not be limited to the acoustic alone but couldn't see how the second could be incarnate in the first. To see that, you must perceive that the phenomenal is, paradigmatically, already discerned within phenomenological space—which, of course, exposes the inadequacy of classic empiricism. The knockdown evidence is already given in the indissoluble incarnation of (heard) speech in physical sound.

I should perhaps add, in passing, though I cannot do justice to the issue here, that the formula offered helps to resolve the familiar paradoxes of conceptual art—say, specimens of John Cage's "conceptual" music (Cage's sitting silently before an audience in a concert hall, without ever touching the piano). The point at stake is that what normally passes for "conceptual art" is parasitic on the very *idea* of "normal" music (Cage's cases) or else actually constitutes an artwork, as (among the visual arts) by Intentional conception addressed to a "mere" physical object (l'art trouvé, "beach art") or by conceptually "transforming" manufactured or artifactual objects into artworks (Duchamp's "readymades").

I gave a sketch of my general solution—in *Art and Philosophy* (Atlantic Highlands, N.J.: Humanities Press, 1980), ch. 2—about thirty years ago. The issue has been aired again, partly by reflecting on that rather early text, centered on the problem of an "artistic medium," in the context of both intentionalism and piecemeal reductionism, in David Davies, *Art as Performance* (Oxford: Blackwell, 2004), 56–60. I find that Davies scants the essential point of the matter by preferring distinctly marginal cases—the point being, of course, the need for a careful analysis of the metaphysical difference between physical nature and human culture *and* its bearing on what we *perceive*. I tend to favor a number of Davies's closely argued distinctions (in his chs. 2–3), but I also construe the central issues in a very different way. As far as I can see, the "anti-empiricists" (really a misnomer)—to include Levinson, Danto, and Wollheim at least—agree that "empiricist" constraints on the "ontology" of art, answering to what we appreciate in artworks, won't do sufficient justice to our conceptual needs. As I read these issues, the "anti-empiricists" (with regard to the *ontology* of artworks) tend to be "empiricists" as well about the *perception* of artworks. Hence, they become dualists, as Levinson and Danto surely are. Where a similar judgment may not be entirely clear, as in Davies and Gregory Currie and Richard Wollheim and others, it is largely because the discussants are not explicit enough. See further Gregory Currie, *An Ontology of Art* (New York: St. Martin's Press, 1989).

Put in the briefest way, Currie opposes Wollheim's theory, namely: "Where authenticity is important, the work [of art] is a physical object, and where it is not the work is a type of which there can be many tokens." (The theory is ultimately drawn from Charles Peirce's seminal distinction.) But Currie goes on to say: "It is my purpose here to attack this theory at all its crucial points. I shall argue that no work of art is a physical object; that all works of art are types. But the sense in which I affirm that works are types is not simply a generalization of the restricted sense in which that view is usually affirmed. A work is not, according to my hypothesis, a type which has as its tokens copies of books, copies of pictures or musical performances. A

work of art is rather an *action type*, the tokens of which are particular actions performed on particular occasions by particular people. The things which are the natural candidates for being regarded as the instances of a work— copies or performances—are not tokens of the type which is the work" (Currie, *Ontology of Art*, pp. 6–7).

I opposed this sort of argument a long time ago—not in terms of opposing action theory but in terms of opposing types as existing "things." I should add that I also invoke the relevance of action theory in invoking the concept of an "utterance" and in favoring Wittgenstein's account, which (you remember) Danto misreads. But I cannot see the sense in which *types* could ever be performed "on particular occasions by particular people" and so conclude that an artwork cannot be "performed" *if it is a type* and that the sense in which token performances are instances "of a type" is not a sense that requires the existence of the type. Different practices of counting or individuating things need not have any ontological import, as Hilary Putnam has very neatly shown; see Putnam's *Ethics Without Ontology* (Cambridge, Mass.: Harvard University Press, 2004). I had, forty-five years ago, drawn attention to the paradoxes of the type/token disjunction and suggested (for counting purposes) the indissoluble locution "token-of-a-type," without allowing either "token" or "type" to be used existentially apart from its conceptual mate; see my *Language of Art and Art Criticism* (Detroit: Wayne State University Press, 1965), which Currie mentions, which I brought to bear on Wollheim's theory, and which would have avoided Currie's own paradox. But, in general, of course, Currie's account is worth a careful reading inasmuch as it means to avoid (at least here) the reductionist's and dualist's threat. But would Currie say that persons or selves are types?

22. One of the best-known and most explicit specimens of this line of thinking appears in Richard Wollheim, "Art and Its Objects," in *Art and Its Objects*, 1–156.

23. For a particularly clear specimen of how to fail to escape the reductio, outside the range of the philosophy of art, see the line of reasoning pursued by

Paul M. Churchland, *A Neurocomputational Perspective: The Nature of Mind and the Structure of Science* (Cambridge, Mass.: MIT Press, 1989).

Interlude: A Glance at Reductionism in the Philosophy of Mind

1. See my *Historied Thought, Constructed World: A Conceptual Primer for the Turn of the New Millennium* (Berkeley: University of California Press, 1995).

2. See W. V. Quine, *Word and Object* (Cambridge: MIT Press, 1960); and Wilfrid Sellars, "The Language of Theories," *Science, Perception, and Reality* (London: Routledge and Kegan Paul, 1963).

3. Compare the reductionist animus expressed against "folk-theoretical" theory, the "manifest image," and "Intentionality," by Churchland, Sellars, and Dennett (respectively). See Paul M. Churchland, *A Neurocomputational Perspective: The Nature of Mind and the Structure of Science* (Cambridge, Mass.: MIT Press, 1990); Sellars, *Science, Perception, and Reality*; and D. C. Dennett, *Content and Consciousness* (London: Routledge and Kegan Paul, 1961). On Rorty, see my *Reinventing Pragmatism: American Philosophy at the End of the Twentieth Century* (Ithaca: Cornell University Press, 2003).

4. See Jaegwon Kim, *Physicalism, or Something Near Enough* (New York: Oxford University Press, 2005).

5. Compare Daniel C. Dennett, *Consciousness Explained* (Boston: Little, Brown, 1991); and Kendall L. Walton, "Fearing Fictions," *Journal of Philosophy* 75 (1978): 5–27.

6. See Arthur C. Danto, *The Transfiguration of the Commonplace: A Philosophy of Art* (Cambridge, Mass.: Harvard University Press, 1981), chs. 1–2; and "The Artworld," *Journal of Philosophy* 61 (1964): 571–584; also, Dennett, *Content and Consciousness*. See further my *Unraveling of Scientism: American Philosophy at the End of the Twentieth Century* (Ithaca: Cornell University Press, 2003).

7. Dennett, *Consciousness Explained*, 428–429.

8. Have a look, for instance, at Sellars, "Language of Theories," and Churchland, *Neurocomputational Perspective*, ch. 1.

9. See the chapter "First Words" above.

10. Dennett, *Consciousness Explained*, 275.

11. See Nancy Cartwright, *How the Laws of Physics Lie* (Oxford: Clarendon, 1983).

12. Dennett, *Content and Consciousness*, 189–190.

13. Daniel C. Dennett, "Why the Law of Effect Will Not Go Away," *Brainstorms: Philosophical Essays on Mind and Psychology* (Montgomery: Bradford Books, 1978), 82–83.

14. See, further, Judson C. Webb, "Gödel's Theorem and Church's Thesis: A Prologue to Mechanism," in Robert S. Cohen and Marx W. Wartofsky, *Language, Logic, and Method* (Dordrecht: Reidel, 1983), 309–353. Dennett cites Webb's paper, although it actually makes clear—tactfully but quite firmly—that Dennett's own arguments are less than adequate. It's intuitively clear, I would say, that *clarity* of exposition, whether in science, philosophy, or ordinary discourse, cannot expect to meet the constraints of computationality on that condition alone. To offer you a compelling example: surely the "method" of analysis Wittgenstein favors in *Philosophical Investigations* is not likely to be computable (because it is not likely to be algorithmic). But it's as "clear" as it can be.

15. I explore the main implications of this adjustment for the philosophy of art in my *Aesthetics: An Unforgiving Introduction* (Belmont: Wadsworth, 2009). I also provide there a fuller account of Danto's philosophy of art.

16. See Marjorie Grene, "People and Other Animals," in Grene, *The Understanding of Nature: Essays in the Philosophy of Biology*, ed. R. S. Cohen (Dordrecht: Reidel, 1974), 346–360.

17. See Richard Dawkins, *The Selfish Gene*, rev. ed. (Oxford: Oxford University Press, 1989).

18. For an account of the primate intelligence of *Homo sapiens*, but not reliably for a sense of the history of the self, see Michael Tomesello, *The Cultural Origins of Human Cognition* (Cambridge, Mass.: Harvard University Press, 1999).

3. Beardsley and the Intentionalists

1. For instance, in the way Arthur Danto favors in his analysis of "actions" and "movements"; see his *Transfiguration of the Commonplace: A Philosophy of Art* (Cambridge, Mass.: Harvard University Press, 1981); and chapter 1, above. I must remind you, however, that I do not regard any summary of Danto's

theory to be entirely adequate or accurate if confined to *Transfiguration* and "The Artworld" paper alone. For an ampler reckoning, see my *Aesthetics: An Unforgiving Introduction* (Belmont: Wadsworth, 2009).

2. This second formulation is, indeed, the conceptually improbable doctrine Daniel Dennett offers in his *Consciousness Explained* (Boston: Little, Brown, 1991), ch. 13. See "Interlude," above. Dennett speaks of the concept of a conscious self (in the context of the philosophy of mind), but his idea is very definitely related—unlikely though it may seem—to the proposals advanced in aesthetics by theorists like Danto and Kendall Walton. Dennett's thesis is much more extreme, of course, than theirs: it's a form of eliminationism rather than reductionism or piecemeal reductionism. But the aestheticians mean to exploit the advantages of an incomplete analysis that may be on its way to a thoroughgoing reductionism. They fail to see that they cannot gain the advantage they claim without analyzing the talents and abilities of the creative agents who first "utter" the artworks *they* mean to reduce to mere physical things. Dennett is bolder and more consistent.

The intriguing fact is that Dennett is aware of the connection between his own doctrine and an early version of Kendall Walton's account of make-believe. I've cited the pertinent passage (*Consciousness Explained*, 428–429) above in the chapter "Interlude" It makes explicit (at a stroke) the connection with Walton's early treatment of fiction in literature. On Dennett's view, as we've seen, selves are the fictitious artifacts of fictional descriptions generated by "our own" physical brains; hence, Dennett's strategy verbally escapes (though not really) the regress problem Walton and Danto have yet to address.

Dennett's difficulty is not my concern, however. Theorists like Danto and Walton (I would add Richard Wollheim and Jerrold Levinson to the company) stop well before they reach Dennett's claim—acknowledging (as they do) real selves and real physical objects. By various "rhetorical" or "fictional" or "descriptive" or "interpretive" devices, they "transfigure" (Danto's term) physical things so as to view them as artworks. I believe these maneuvers are, in the end, incoherent, but I am primarily concerned with the impoverishing effect of their application to artworks. See Kendall L. Walton,

"Pictures and Make-Believe," *Philosophical Review* 82 (1973): 283–319, and "Fearing Fictions," *Journal of Philosophy* 75 (1978): 5–27—both of which Dennett cites. The difference between Walton's and Dennett's claims comes to this: Walton says that "fictional truths" are "man-made" ("Fearing Fictions," 10); Dennett says that selves are (in effect) "brain-made" fictions. Walton generalizes so as to range over everything that falls within the terms of "make-believe." Dennett reduces (really: eliminates) the whole of the cultural world of humans (including human selves themselves). I claim you cannot make the first proposal fully coherent without addressing the second. There's the challenge we must ultimately consider.

3. In the philosophy of art, the reductio counts most heavily against Arthur Danto and Richard Wollheim; in the philosophy of mind and philosophy at large, it counts most heavily against Daniel Dennett, Paul Churchland, Jaegwon Kim, and certain texts of Wilfrid Sellars. The passage cited from Danto's *Transfiguration* appears at 33.

4. For a brief overview of Beardsley's conception, see my *Selves and Other Texts: The Case for Cultural Realism* (University Park: Pennsylvania State University Press, 2001), ch. 1.

5. See Monroe C. Beardsley, *The Possibility of Criticism* (Detroit: Wayne State University Press, 1980). The "propensities" laid out count as the assumptions of Beardsley's argument in *Possibility of Criticism*—in effect, his metaphysics. The most recent revival of intentionalism in English-language philosophies of art and interpretation is standardly associated with the publication of Steven Knapp and Walter Benn Michaels, "Against Theory," in *Against Theory: Literary Studies and the New Pragmatism*, ed. W. J. T. Mitchell (Chicago: University of Chicago Press, 1985), 11–30; and "Against Theory 2: Hermeneutics and Deconstruction," *Critical Inquiry* 14 (1987): 49–68. See also Gary Iseminger, *Intention and Interpretation* (Philadelphia: Temple University Press, 1992), which is largely occupied with the revival of intentionalism. But Knapp and Michaels are hardly piecemeal reductionists. Noël Carroll and Jerrold Levinson, who appear in Iseminger's collection, are, I think, effectively responsible for the recent flurry of discussion (along reductionist lines) in the philosophical literature. This impression is lightly confirmed by a scan of Robert Stecker,

Interpretation and Construction: Art, Speech, and the Law (Oxford: Blackwell, 2003). I mean to offer, in passing, some reasons for abandoning the entire quarrel, which, I'm bound to say, does not go beyond Beardsley's original explorations of the intentional question (apart from the reductive strategy), even though the new intentionalism is obviously very differently motivated than is—and is actually opposed to—Beardsley's thesis. Carroll's and Levinson's options make no sense, however, segregated from theories like those favored by Danto, Wollheim, and Walton.

6. This is the essential lesson of Thomas S. Kuhn's *The Structure of Scientific Revolutions*, 2nd ed. enl. (Chicago: University of Chicago Press, 1970).

7. See my "'One and Only One Right Interpretation,'" in *Is There a Single Right Interpretation?*, ed. Michael Krausz (University Park: Pennsylvania State University Press, 2002), 26–44; reprinted in my *The Arts and the Definition of the Human: Toward a Philosophical Anthropology* (Stanford: Stanford University Press, 2009), 71–96.

8. See Eduard Hanslick, *On the Musically Beautiful*, trans. Geoffrey Payzant (Indianapolis: Hackett, 1986). Hanslick's uncertainties depend on a confusion regarding the nature (dare I say "the metaphysics"?) of music. But Hanslick's difficulty draws attention to a deeper and more general confusion: the one involved in supposing that we can decide matters affecting the logic and legitimacy of interpretive options without any explicit account of the nature (or, again, the metaphysics) of artworks. The tendency is oddly pervasive at the present time—though for rather diverse reasons. I find it, for instance, in Paul Thom, *Making Sense: A Theory of Interpretation* (Lanham: Rowman and Littlefield, 2000); Michael Krausz, *Rightness and Reasons: Interpretation in Cultural Practices* (Ithaca: Cornell University Press, 1993) and *Limits of Rightness* (Lanham: Rowman and Littlefield, 2000); and Stecker, *Interpretation and Construction*. It turns up also in Richard Rorty's influential views—accordingly, in recent views advanced by Richard Shusterman. See Richard Rorty, *Consequences of Pragmatism: Essays, 1972–1980* (Minneapolis: University of Minnesota Press, 1982), ch. 8; and Richard Shusterman, *Performing Live: Aesthetic Alternatives for the Ends of Art* (Ithaca: Cornell University Press, 2000).

9. For a sense of Grice's theory, see H. P. Grice, "Utterer's Meaning and

Intention," *Philosophical Review* 78 (1969): 147–177; and "Logic and Conversation," in *Syntax and Semantics* 3: *Speech Acts*, ed. Peter Cole and Jerry L. Morgan (New York: Academic Press, 1978), 41–58.

10. Compare Monroe C. Beardsley, *Aesthetics: Problems in the Philosophy of Criticism* (New York: Harcourt Brace, 1958).

11. See, for instance, Donald Davidson, "A Coherence Theory of Truth and Knowledge" (with addendum), in *Reading Rorty: Critical Responses to Philosophy and the Mirror of Nature (and Beyond)*, ed. Alan R. Malachowski (Oxford: Blackwell, 1990); and Michael Dummett, *The Logical Basis of Metaphysics* (Cambridge, Mass.: Harvard University Press, 1991). Davidson and Dummett have been strategically important figures in managing the analytic landscape in which the recent intentionalists have settled.

12. For a recent version of Rorty's postmodernism (or "metaphilosophy"), see Richard Rorty, "A Pragmatist View of Contemporary Analytic Philosophy," in *The Pragmatic Turn in Philosophy: Contemporary Engagements Between Analytic and Continental Thought*, ed. William Egginton and Mike Sandbothe (Albany: State University of New York Press, 2004), 131–144.

13. Compare Dummett, *Logical Basis of Metaphysics*.

14. See for a fuller argument Margolis, *Selves and Other Texts*, ch. 1.

15. Let me single out Paul Thom's *Making Sense* as affording a particularly instructive example.

16. On the various fashionable forms of intentionalism, see once again Stecker, *Interpretation and Construction*, who has his eye peeled for what's "*in*"; but also Jerrold Levinson, "Intention and Interpretation in Literature," in his *The Pleasures of Aesthetics: Philosophical Essays* (Ithaca: Cornell University Press, 1996), 175–213; and Noël Carroll, "Art, Intention, and Convention," in Iseminger, *Intention and Interpretation*, 97–131. The last two papers seem to have fixed, for the present, the opposed views, respectively, of "hypothetical intentionalism" and "actual intentionalism." Have a look, also, at Monroe C. Beardsley's reflections on "the intentional fallacy," in "Intentions and Interpretations: A Fallacy Revived," in *The Aesthetic Point of View: Selected Essays*, ed. Michael J. Wreen and Donald M. Kallen (Ithaca: Cornell University Press,

1992). Beardsley notes that illocutionary acts need not be intentional (in any conscious or strongly mentalistic sense). But he does not quite see, although he touches on the matter, that literary representation is not primarily a kind of illocutionary act at all or, indeed, an act of the sort that might strengthen the claims (by the intentionalists who oppose him) to construe the objective interpretation of poetry as best analyzed on the basis of a conversational (in effect, an illocutionary) model. The strange thing is that both Beardsley and the new intentionalists tend to favor a conversational model. But this seems a mistake, for elementary reasons. For representation is not primarily or necessarily fictional (or even verbal); it is rather a construction drawn from the resources of imagination and, as such, triggers open-ended responses (on our part) conditioned by our contingent and idiosyncratic knowledge and understanding of the world depicted. It is hard to see how a specifically illocutionary or conversational model could be relied on to determine "intentionally" (say, in accord with Carroll's suggestions) or "bivalently" (in accord with Beardsley's) what could count as objectively valid in the interpretive sense.

17. See Carroll, "Art, Intention, and Conversation."

18. For a sense of the term "objectivist," see Richard J. Bernstein, *Beyond Objectivism and Relativism: Science, Hermeneutics, and Praxis* (Philadelphia: University of Pennsylvania Press, 1983).

19. Levinson, *Pleasures of Aesthetics*, 135–136. Levinson, I should add, expressly opposes my reading of the same considerations, which I introduced at least thirty years ago in a number of discussions that were collected in my *Art and Philosophy* (Atlantic Highlands, N.J.: Humanities Press, 1980). But, in returning to the issue, I trust I may treat the matter in its own terms, without reference to any further efforts at self-defense.

20. I've already mentioned (in chapter 2, note 21) that Hilary Putnam has decisively shown why the choice of counting devices need have no ontological import. On my reading, the argument relieves us of the need to commit ourselves to the existence of types. We want to avoid whatever paradoxes we can: for instance, we want to allow that artworks are created and we want to

hold that a Dürer print has the perceptible properties it has. You have only to read Wollheim to gain a sense of how impossible it is to hold on to such obvious constraints if you insist on artworks as existent types.

21. Noël Carroll, *Philosophy of Art: A Contemporary Introduction* (London: Routledge, 1999), 95.

22. See Levinson, "Intention and Interpretation in Literature."

23. Levinson, "Intention and Interpretation: A Last Look," in Iseminger, *Intention and Interpretation*, 233.

4. Intentionalism's Prospects

1. For a sense of one of the pioneer efforts in the sociological literature meant to distinguish the collective (gemeinschaftlich) and the aggregative and cooperative (gesellschaftlich) aspects of social and cultural formations—at times decidedly muddled—see Ferdinand Tönnies, *Community and Civil Society*, trans. Jose Harris and Margaret Hollis (Cambridge: Cambridge University Press, 2001). Tönnies does not quite see that every sustained "utterance" and every socially structured activity at the human level is at once, intrinsically, gemeinschaftlich and gesellschaftlich. Indeed, this marks an essential feature of my own theory of the self.

2. Gregory Currie makes a serious mistake (it seems to be a mistake, not a slip of the pen or computer) in speaking of abstractly defined, even uninstantiated genres. "Uninstantiated genres," unlike "uninstantiated predicates," is a contradiction in terms. I take this to mark as well a comparable error (or an excess of theological exuberance) in medieval theories of beauty (as, also, in their modern counterparts). I would say the same of "moral goodness." These terms are meaningless apart from their paradigmatic cases or admissible instances (which must, of course, be treated in a constructivist way). See Gregory Currie, *Arts and Minds* (Oxford: Clarendon, 2004), ch. 3, p. 48, read in the context of an otherwise very suggestive discussion.

3. See Nicholas Wolterstorff, *Works and Worlds of Art* (Oxford: Clarendon, 1980), for an unusually confident and explicit adherence to bivalence and excluded middle.

4. I greatly admire the relativism advocated by Nicholas of Cusa, which, I

would say, utterly defeats (by a long anticipation) attempts like that of Hilary Putnam to avoid objectivism and, at the same time, relativism. See Karsten Harries, *Infinity and Perspective* (Cambridge, Mass.: MIT Press, 2001).

5. See further the treatment of Hegel in my *Aesthetics: An Unforgiving Introduction* (Belmont: Wadsworth, 2009).

6. I find a trim anticipation of all of this in Marjorie Grene, "People and Other Animals," in Grene, *The Understanding of Nature: Essays in the Philosophy of Biology*, ed. R. S. Cohen (Dordrecht: Reidel, 1974), 346–360.

7. See William K. Wimsatt Jr. and Monroe C. Beardsley, "The Intentional Fallacy," in W. K. Wimsatt Jr., *The Verbal Icon: Studies in the Meaning of Poetry* (Lexington: University of Kentucky Press, 1954), 3–20; and Gary Iseminger, ed., *Intention and Interpretation* (Philadelphia: Temple University Press, 1992). For a closer sense of Hirsch's romantic theory, which offers the most sustained recent attempt to save "authorial intent," see E. D. Hirsch Jr., *Validity in Interpretation* (New Haven: Yale University Press, 1967); also Joseph Margolis, *Art and Philosophy* (New York: Humanities Press, 1980), ch. 8.

8. See Jerrold Levinson, "Invention and Interpretation in Literature," *The Pleasures of Aesthetics: Philosophical Essays* (Ithaca: Cornell University Press, 1996), 178 and note 11 (which I've run on as one statement). Levinson is generally regarded as one of the leading recent discussants of the issue.

9. For a recent example of how solipsism is implicated in a way that bears distantly on the interpretive question, see John R. Searle, *The Construction of Social Reality* (New York: Free Press, 1995). The very title of Searle's book is solipsistic, of course; furthermore, "the social construction of reality" would also produce an intolerable idealism (which is not to say that all "idealisms" are intolerable).

10. See. W. V. Quine, *Word and Object* (Cambridge, Mass.: MIT Press, 1960).

11. See, for instance, the line of reasoning (very close to Levinson's) in Robert Stecker, *Interpretation and Construction: Art, Speech, and the Law* (Oxford: Blackwell, 2003).

12. I discuss Riffaterre's view in some depth in *Interpretation Radical But Not Unruly: The New Interpretation of the Arts and History* (Berkeley: University of California Press, 1995).

13. See G. W. F. Hegel, *Aesthetics: Lectures on Fine Art*, 2 vols., trans. T. M. Knox (Oxford: Clarendon, 1975).

14. See Ernst Cassirer, *Philosophy of Symbolic Forms*, 3 vols., trans. Ralph Manheim (New Haven: Yale University Press, 1953–1957); and C. I. Lewis, "A Pragmatic Conception of the *A Priori*," *Journal of Philosophy* 20 (1923): 169–177.

15. See John R. Searle, *Speech Acts: An Essay in the Philosophy of Language* (Cambridge: Cambridge University Press, 1969).

16. See J. L. Austin, *How To Do Things with Words*, ed. J. O. Urmson (Oxford: Clarendon, 1962).

17. See, for instance, Noël Carroll, "Art, Intention, and Conversation," in *Intention and Interpretation*, ed. Gary Iseminger (Philadelphia: Temple University Press, 1992), 97–131.

18. See Alfred Tarski, "The Concept of Truth in Formalized Languages" (with postscript), *Logic, Semantics, Metamathematics*, 2nd ed., trans. J. H. Woodger, ed. John Corcoran (Indianapolis: Hackett, 1983), 152–178; and Donald Davidson, *Inquiries Into Truth and Interpretation* (Oxford: Clarendon, 1984), the first five essays.

19. See Donald Davidson, "A Nice Derangement of Epitaphs," in *Truth and Interpretation: Perspectives on the Philosophy of Donald Davidson*, ed. Ernest LePore (Oxford: Blackwell, 1986), 459–476. Here Davidson appears to abandon his well-known account, said to depend foundationally on Tarski's theory. The truth, of course, is that Davidson never actually *used* Tarski's theory in the analysis of natural language! Tarski, who was himself at first modestly optimistic about the bearing of his theory on the syntax of natural language, became increasingly pessimistic. When you consider the collapse of Chomsky's universal grammar and Davidson's "Convention T," the prospects of linguistic reduction seem bleak.

20. See Searle, *Speech Acts*.

21. See my *Unraveling of Scientism: American Philosophy at the End of the Twentieth Century* (Ithaca: Cornell University Press, 2003).

22. Searle, *Speech Acts*, 40.

23. See Noam Chomsky, *New Horizons in the Study of Language and Mind* (Cambridge: Cambridge University Press, 2000).

24. Searle, *Speech Acts*, 78.

25. Contrast Peter Lamarque and Stein Haugom Olsen, *Truth, Fiction, and Literature: A Philosophical Perspective* (Oxford: Clarendon, 1994), esp. chs. 9, 11. Lamarque and Olsen tend to favor the binary view regarding literature and science, although they may not be entirely wedded to the adequacy of a propositional strategy for capturing the meaning of a novel.

26. See Kendall L. Walton, *Mimesis as Make-Believe: On the Foundations of the Representational Arts* (Cambridge, Mass.: Harvard University Press, 1990).

27. Compare M. M. Bakhtin, *The Dialogic Imagination: Four Essays*, ed. Michael Holquist, trans. Caryl Emerson and Michael Holquist (Austin: University of Texas Press, 1981).

28. Compare Edmund Husserl, *Cartesian Meditations: An Introduction to Phenomenology*, trans. Dorion Cairns (Dordrecht: Kluwer, 1995).

29. See my *Selves and Other Texts: The Case for Cultural Realism* (University Park: Pennsylvania State University Press, 2001), ch. 2.

30. See Bakhtin, *Dialogic Imagination*.

31. See Walton, *Mimesis as Make-Believe*.

32. This bears of course on Husserl's important but utterly extravagant account of phenomenological "apperception" implicated in the "perception" of ordinary objects. There is no direct line of argument that leads from what we perceive in the ordinary sensory sense to what Husserl claims about some "originally instituted," "anticipative" grasp of the primal "type" to which (somehow) we apprehend our perception to belong, when we succeed in perceiving the object we avow we perceive. Husserl's penchant for "Platonism" is at its thinnest here. The idea of visual imagination—of the imaginative element *in* visual perception itself—suggests the need to consider Husserl's proposal seriously, but it hardly commits us to anything of his kind. See Husserl, *Cartesian Meditations*, 111–112.

33. See Thomas S. Kuhn, *The Structure of Scientific Revolutions*, 2nd ed. enl. (Chicago: University of Chicago Press, 1970), 119–122, 126, and the postscript.

34. Walton, *Mimesis as Make-Believe*, 293–294.

35. Compare Walton, *Mimesis as Make-Believe*, 88.

5. A Failed Strategy

1. From *The Complete Poetry and Prose of William Blake*, rev. ed., ed. David V. Erdman (New York: Anchor Books, 1988), 23.

2. Robert Stecker, *Interpretation and Construction: Art, Speech, and the Law* (Oxford: Blackwell, 2003), 32. The strongest advocates of actual intentionalism include E. D. Hirsch Jr., *Validity in Interpretation* (New Haven: Yale University Press, 1967), and P. D. Juhl, *Interpretation: An Essay on the Philosophy of Literary Criticism* (Princeton: Princeton University Press, 1980). For a much slimmer and more informal view, see Noël Carroll, "Art, Intention, and Conversation," in *Intention and Interpretation*, ed. Gary Iseminger (Philadelphia: Temple University Press, 1992), 97–131. It is, I admit, potentially misleading to include the hermeneuts and the new intentionalists in the same bin, but it would also be strange to ignore the hermeneuts.

3. See W. K. Wimsatt Jr. and Monroe C. Beardsley, "The Intentional Fallacy," in W. K. Wimsatt Jr., *The Verbal Icon* (Lexington: University of Kentucky Press, 1954), 3–20.

4. See Stecker, *Interpretation and Construction*, ch. 2.

5. See Noël Carroll, "Identifying Art," *Beyond Aesthetics: Philosophical Essays* (Cambridge: Cambridge University Press, 2001), 75–99. Regarding Carroll's reflections on the relation between conversation and interpreting artworks, see the papers in pt. III of *Beyond Aesthetics*. Carroll touches lightly and briefly on the ulterior issue Levinson has in mind. See Jerrold Levinson, "Defining Art Historically" and "Refining Art Historically," in *Music, Art, and Metaphysics* (Ithaca: Cornell University Press, 1990). To be perfectly candid, I find that all of this simply misses the central issue regarding the relationship between physical nature and historical culture. I wouldn't deny that all the papers referred to here support the lesson each means to render. But the failure to see the deeper issue already yields plausible evidence of an incipient disposition to favor "piecemeal" doctrines. Levinson is clearer about the difference

between actual and hypothetical intentionalism; but then, quite unaccountably, he invites a reductio of his own position. See chapter 4.

6. For an early discussion of the issue, see Joseph Margolis, *Art and Philosophy* (Atlantic Highlands, N.J.: Humanities Press, 1980).

7. See Robert Stecker, *Artworks: Definitions, Meaning, Value* (University Park: Pennsylvania State University Press, 1997), 178–179. See also the helpful criticism of Stecker's account in Peter Lamarque, "Appreciation and Literary Interpretation," in *Is There a Single Right Interpretation?*, ed. Michael Krausz (University Park: Pennsylvania State University Press, 2002), 285–306. Lamarque identifies the essential weakness in Stecker's account.

8. Stecker, *Interpretation and Construction*, 29–30.

9. Ludwig Wittgenstein, *Philosophical Investigations*, trans. G. E. M. Anscombe (New York: Macmillan, 1963), §6. I detach Wittgenstein's general lesson (here) from the fuller details of his account of the "uses" of language. Compare the discussion of the Wittgensteinian account in Patricia Hanna and Bernard Harrison, *Word and World: Practice and the Foundations of Language* (Cambridge: Cambridge University Press, 2004), pt. I.

10. The lines are cited in Gerald L. Bruns, *On the Anarchy of Poetry and Philosophy: A Guide for the Unruly* (New York: Fordham University Press, 2006), 45. The English text is given in Paul Celan, *Breathturn*, trans. Pierre Joris (Los Angeles: Sun and Moon Press, 1995). Bruns, more or less in accord with Hans-Georg Gadamer's and Jacques Derrida's reading of Celan, makes a very plausible case for the meaning of the "impenetrability" of Celan's poetry (ch. 2).

11. See Noam Chomsky, review of B. F. Skinner, *Verbal Behavior*, *Language* 35 (1959): 26–58.

12. Carroll, "Art, Intention, and Conversation," 110.

13. See Carroll, "Art, Intention, and Conversation," 106; and Monroe C. Beardsley, "Intentions and Interpretations: A Fallacy Revived," in *The Aesthetic Point of View: Selected Essays*, ed. Michael Wreen and Donald M. Callen (Ithaca: Cornell University Press, 1982), 188–207.

14. Carroll, "Art, Intention, and Conversation," 97.

15. See Carroll, "Art, Intention, and Conversation," 106, 124.

16. See Jerrold Levinson, "Intention and Interpretation: A Last Look," in *Intention and Interpretation*, ed. Gary Iseminger (Philadelphia: Temple University Press, 1992), 221–256.

17. See Jerrold Levinson, "Intention and Interpretation in Literature," in *The Pleasures of Aesthetics: Philosophical Essays* (Ithaca: Cornell University Press, 1996), 175–213. See also chapter 4, above.

18. Compare Roland Barthes, "From Work to Text," in *Textual Strategies: Perspectives in Post-Structuralist Criticism*, ed. Josué V. Harari (Ithaca: Cornell University Press, 1979), 73–81; and H. Paul Grice, "Logic and Conversation," in *Syntax and Semantics 3: Speech Acts*, ed. Peter Cole and Jerry L. Morgan (New York: Academic Press, 1975), 41–58.

19. Fyodor Dostoevsky, *Notes from Underground*, trans. Richard Pevear and Larissa Volokhansky (New York: Vintage Books, 1994), 3.

20. See for instance Mikhail Bakhtin, *Problems of Dostoevsky's Poetics*, ed. and trans. Caryl Emerson (Minneapolis: University of Minnesota Press, 1984): "The Hero, and the Position of the Hero, in Dostoevsky's Art" and "Characteristics of Genre and Plot Composition in Dostoevsky's Works." What I say here may also help to defuse the charge (against my view of interpretation) advanced by Richard Shusterman; see his "Aesthetics," in *A Companion to Pragmatism*, ed. John R. Shook and Joseph Margolis (London: Blackwell, 2006), 352–360.

21. Levinson, *Pleasures of Aesthetics*, 213; see the rest of the essay, "Intention and Interpretation in Literature." See also Stecker, *Interpretation and Construction*, ch. 2.

INDEX

imagining a Dutch interior (Vermeer),
138, 140–141, 142

In Cold Blood (Capote), 138

"institutional theory of art" (Dickie), 24

intentional attributes ("aboutness"), 49,
65–66, 117

 Brentano and Husserl, 49

 determinable, not determinate, 115–17

 naturalistic account of, 49–50

Intentional world, 50–51

intentionalism, Ch. 4 *passim*

 "actual" (Carroll) and "hypothetical"
(Levinson), 111–13, 125–27, 129,
157, 158–59; *see* Carroll; Levinson;
new (analytic) intentionalism

 analytic (new), 60–61, 105

 Beardsley on, 95–96, 97–98

 Hirsch on, 61–62, 158–160

 and Intentional features, 68–69

 and interior intentions, 108

 joined with piecemeal reductionism,
96

 Levinson on, 68, 125–27

 Romantic (hermeneutic), 61

 and song, 66–67

 speech-act (conversational) model,
105–106

 Stecker on, 155–57

 and universalism, 130

Intentional(ity), 10, 34, 49

 attributes, metaphysical constraints
on, 115–17

 and bivalence, 117

 and cultural "penetration," 49, 57

 culturally significant/significative, 49

 defining powers of cultural world, 10,
34, 45, 48–49, 57

and intentionalism, 68–69

and intentionality ("aboutness"), 49

not reducible psychologically (mental-
istically), 49–50

precludes solipsism and skepticism, 50

reductio of piecemeal reductionism,
10

two sine qua nons, 57–58

intentions

 interior (mentalistic), 108

 internal to utterance of artworks, not
causal, 59

Kant, Immanuel, 6, 118, 123, 129

Kiefer, Anselm, 140

Kim, Jaegwon, 12–13, 15, 59, 74

Kuhn, Thomas S., 27, 144

Lamarque, Peter, 62

Last Year at Marienbad (Robbe-Grillet), 139

Levinson, Jerrold

 and Carroll, 20, 62, 63, 105, 111–13,
131, 132, 173–74, 179

 "Defining Art Historically," 24–25

 definition of art, 24–25

 dualism in, 61

 "hypothetical intentionalism," 173–74,
177–79

 on institutional theory of art, 25

 as intentionalist, 20, 68, 118–19

 multiply instantiable prints, 109–10

 paintings as physical objects, 60,
108–109

 as piecemeal reductionist, 20,
24–25, 60–61

 Pleasures of Aesthetics, 60–61, 108–11,
125–27, 179

reductionism and eliminativism
 arguments by obiter dictum, 73
 difficulty in applying, to topics in
 aesthetics/philosophy of art, 72
 impossible models of science, 132
 in philosophy of mind, 9, Interlude
 passim
 and piecemeal reductionism, 9, 10,
 72–74; *see* piecemeal reductionism
 reduced confidence of, 71, 72, 74
Reid, Thomas, 6
Riffaterre, Michael, 127–28
Romantic hermeneutics (interpretation),
 61, 65, 127, 178
Rorty, Richard, 74, 103, 104, 132
Rosetta Stone, 130
Rousseau's joke, 94
Russell, Bertrand, 129

Schleiermacher, Friedrich, 61, 117
Schlick, Moritz, 21
scientism, 9–16, 22
 Chalmers, 13–16
 Kim, 12–13
 Sellars, 11–12
Searle, John, 106, 129, 130, 132, 133,
 134–36, 139, 143, 147, 151
seeing pictorial representations, 138,
 144
 Giotto, 144
 Vermeer, 146
self (selves, persons)
 Chalmers on consciousness, 13–16
 conception of, 4, 7, 10, 42
 Dennett on, 76–77
 and emergence of language, 56
 Hume and Kant on, 6, 89

Kim on mental properties, 12–13
 and mastery of a first language, 5
 metaphysics and semantics of, 103
 as "natural [hybrid] artifact" (Grene),
 7, 10, 90–91, 121
 "second-natured" utterance, 10, 124,
 181
 Sellars on, 11–12
Sellars, Wilfrid, 11–12, 16, 26, 71, 74, 83,
 86, 91, 129, 132
 "manifest image"/"scientific image,"
 11, 83
 on "person," 11–12
"Sick Rose, The" (Blake), 151–52, 155,
 165–66, 174–75
 Stecker on reading, 152–59 *passim*,
 162–63, 166, 174
 a suggestion about the meaning of,
 164–66
Skinner, B.F. (Skinnerian), 42, 122, 168
speech, as paradigm of the cultural, 58
Starry Night (Van Gogh), 140
Stecker, Robert. *See* "The Sick Rose"
 (Blake)
 and "actual" intentionalism, 155–57
 affinities with Beardsley, Carroll,
 Levinson, 154–56, 173
 Interpretation and Construction, 162–63
 reading (interpretating) a text,
 152–54, 162–63, 166–67, 169
structuralism, 128

Tarski, Alfred, 132
text, the meaning of the, 152–54,
 174–76
 and the meaning of the poem as a
 whole, 175–76, 178

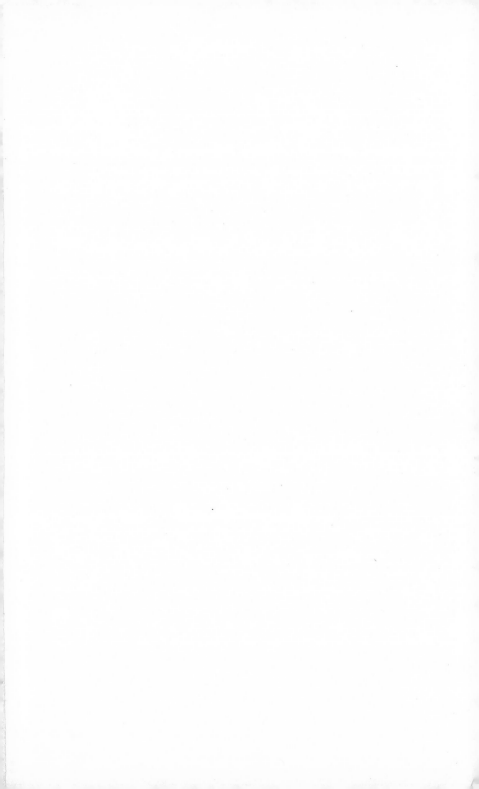